Word
for Word

Word for Word

A Writer's Life

Laurie Lisle

ARTEMIS EDITIONS

Published by Artemis Editions, Sharon, Connecticut

Edited and designed by Girl Friday Productions
www.girlfridayproductions.com

Design: Paul Barrett
Project management: Katherine Richards & Bethany Davis
Image credits: cover © Edward Spiro. Every effort has been made
to find and secure permissions from copyright owners to publish
photographs in the book. Any copyright owners not identified
are invited to come forward and be gratefully acknowledged.

ISBN (hardcover): 978-1-7359801-1-9
ISBN (paperback): 978-1-7359801-0-2
ISBN (ebook): 978-1-7359801-2-6
Library of Congress Control Number: 2020921125

First edition

CONTENTS

INTRODUCTION

This is a memoir about living a writing life—wanting to be a writer, becoming a writer, and being a writer—as acts of self-expression, self-assertion, and womanly survival.

My love of words began early, when little black squiggles in colorful picture books came alive as sentences. After mastering penmanship as a child, I learned how to write sentences and paragraphs in school; at eighteen, inspired by a creative-writing class, I penned an essay in turquoise ink declaring my desire to be a writer. In college the idea of working for a newspaper excited me as an adventurous way to earn a living as a writer. After working as a journalist, first for *The Providence Journal-Bulletin*, and finally for *Newsweek*, I wrote biographies of two legendary American women artists—Georgia O'Keeffe, a painter who boldly and beautifully rendered the world of nature, and Louise Nevelson, a sculptor who dared to turn wood fragments into massive black walls—and then three other works of more personal nonfiction. Eventually I asked myself: Why not become my own biographer?

Memoir has been called the literature of interiority. Nineteenth-century memoirist Henry David Thoreau, who

indexed his lengthy journals by hand so he could mine them for material, described the American tradition of private writing—captivity and slave narratives as well as ministers' spiritual reflections—as "a meteorological journal of the mind." Memoir also promises to be literary alchemy: even though you cannot change the past, you can enlarge your understanding of it. I wrote this memoir to ask: Why had love failed and why had it flourished? What made my words dry up and what made them flow? When emotions and experiences are pinned down on paper and put into pixels, they become a little more distanced from heart and head and, therefore, easier to understand.

The genre of memoir is inevitably about the nature of memory. Remembrance, or what is not written down, can be dreamlike—infused by imagination and fallible by definition. While memory and perception may be imperfect, what is remembered is what's most meaningful in the mind of the memoirist and is as important as fabrication in novels and facts in biography.

When writing *Word for Word*, I did not rely on memory alone but on the more than forty handwritten journals I had kept since college. I entered long passages into my computer— more than three hundred thousand words by the end—so I could easily search them to make sure my remembering and retelling were right, while reminding myself that even words written extemporaneously were impressions and interpretations of what happened. Over the years my journals became less private testimony and more about the act of writing. This has enabled me to reflect in depth on the demanding and deeply rewarding aspects of the writing life.

To jog my memory, I returned to my hometown of Providence, Rhode Island, to read newspapers and see photographs published when I lived and worked there. I looked again at old home movies, photograph albums, school reports, and family documents, including a slender pale blue volume, *Philip and Persis*, an uncle's account of the quintessential Yankee lives

of my maternal grandparents. In the libraries of New York I researched historical events—like the civil rights and women's liberation movements—I had participated in when I lived in the city. And when I moved to Connecticut, I kept a big black trunk in my barn with bundles of old letters I had saved out of affection for their senders or my respect for the written word. I had thought that as a writer I might need them someday, and I was right. What remains private are details unnecessary to tell the truth, and what has become publishable are stories essential about what really happened.

The tough task of self-examination is the dark side of memoir. As I wrote, my present self watched a past self unaware of the dangers ahead. On some days my older self liked my younger self's determination, and on others her indecision deeply distressed me. One morning, overwhelmed by pages of raw emotion about a boyfriend's abusive behavior, I slammed shut a notebook as if it were radioactive. To rid myself of angst and anger, I rushed outside to take a fast walk on a winding dirt road through the woods, and then returned home to vigorously uproot weeds in my garden until dark.

While writing *Word for Word* was introspective, it did not feel egotistical. "Having been told so often how wrong it is to write about one's self," diarist Anaïs Nin insisted that self-exploration expresses a desire to develop the personality. "The ego is exacting, not indulgent," she declared. This was my experience, too.

Working on my memoir was like writing a very long letter to myself. By the end the relationship between my younger and older selves was reciprocal: while the girl shaped my life today, the woman framed her story. That teenage girl wanted to look back at herself with compassion and what she called "illumination," and I believe this memoir would please her. Writing *Word for Word* has been an extraordinary experience of remembering, finding the right words for what happened, and making me a little wiser, then allowing the past to recede again.

PROVIDENCE

1

The Reluctant Debutante

Not so long ago I took a moment to look at a formal photograph taken in December 1961 of a dark-haired debutante dressed in a shimmering white gown. The girl is me, standing alone with my back against a wall that rises to the high ornate ceiling of the elegant ballroom crowning the Biltmore Hotel in Providence, Rhode Island, facing a photographer as the flash of the camera went off in my face. This earlier incarnation of myself makes me angry because it reminds me of how miserable I felt at that moment—as though I were a wearing a costume and acting in a charade. At nineteen I had already concluded that a debut into society was a snobbish tradition, so the expression on my face is woebegone, my shoulders are slumped, and my right wrist, adorned with a white lily, is limp. The long white leather gloves buttoned from my narrow wrists all the way up to my upper arms hid bitten fingernails, I remembered.

As I examined the enlarged black-and-white photograph, I detected a gleam of defiance in the girl's eyes. Teenagers

ordinarily face restraints as they move from childhood to adulthood, and the voice restricting me was that of my adored mother, a reluctant conformist herself, and of my conventional aunts and grandmothers in Providence, all women whose lives in the 1950s were marked by extreme decorum and domesticity. It's difficult to understand today, but at the time most mothers I knew, including mine, were housebound. Struggling to find

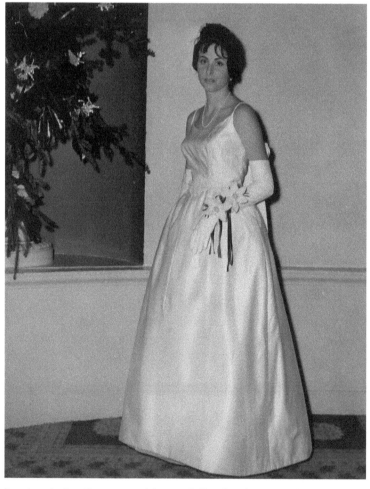

Laurie at the Providence winter debutante ball at the Biltmore Hotel in 1961.

a way to become more myself, I wanted a career—maybe as a social worker or a writer—that would enable me to earn my own money and set me free from those expectations. Gazing at the old photograph arouses my compassion for that young girl so torn about how to behave and where she belonged.

My mother had insisted on my taking part in the winter Debutante Assembly Ball for reasons I did not initially understand. The previous spring, when I was a senior at the same girls' boarding school she had attended, we had argued about it over the telephone, her voice pleading, persistent, and finally demanding. I was caught off guard by her sudden vehemence, since until then her permissiveness had allowed me to go my own way, as much as possible for a girl of my background. I was unhampered because of her innocence, even ignorance, about much of anything outside the East Side of Providence, where she had been born and brought up and still lived a privileged and protected existence within blocks of her mother and father, siblings, and in-laws. I thought that my mother—a slender woman of forty-seven, who parted her long dark brown hair in the middle and pinned it up in back—was beautiful, and I didn't want to disappoint or defy her because she was my parent, my only parent, whose love felt like bedrock to me. My father had been away from the month I was conceived, first at war and then in Vermont after my parents' postwar divorce, and my stepfather was aloof.

When I planned to leave New England for a midwestern university, my mother worried that I would move beyond her and the only way of life she knew. Her reaction was a natural desire to keep a daughter near her, and mine was an urge to become myself, the common and complicated mother-and-daughter passage about love and freedom, identification with a female parent versus finding one's own identity. Previously she had wanted the best possible schooling for me "in case something happens to your husband," as she put it,

but when I was preparing to go away to college, she became afraid that too much education might disqualify me as a wife. Though marriage had disappointed her, she and many others of her generation and class could not imagine an existence, or at least not an easy one, for a woman outside the state of matrimony. The debutante ball, of course, was an opportunity for her marriageable daughter to meet the eligible young bachelors of Providence. And her heart's desire, she had admitted to me years earlier, was that I would grow up to marry and live nearby. What she didn't yet know was that I was determined not to be a wife, at least not for a while.

Persuading me to be a debutante wasn't my mother's only attempt to turn her quiet daughter into a social creature. When I was ten, she asked me to choose between horseback riding or school. I loved reading books about horses and had just learned to canter, so I leaned toward riding. But she kept bringing up dancing school, and I went along with what she wanted that time, too. Dancing lessons turned out to be training in female submissiveness for events like the debutante ball. Little girls in satin or taffeta party dresses and boys in navy suits and maroon ties, all wearing white cotton gloves, were dropped off by their mothers at the dance hall on late afternoons to practice ballroom dancing. We were lined up on opposite sides of the room, and when boys were told to pick partners, they would race to grab the prettiest or friendliest girls. Without my glasses I couldn't see well enough to smile at boys I liked, so dancing school was an excruciating lesson in passivity instead of an exercise in mastery like riding a horse.

In the photograph taken of me at the debutante ball, it looks like I am wearing a wig. My mother had taken me to a hairdresser, who had pulled and sprayed my stubbornly straight brown hair into a French twist, arranging a few stiff strands over my forehead. Afterward I had to move gingerly so as not to mess it up. My mother had heard from another

mother about a bridal boutique in Boston where five years earlier actress Grace Kelly had bought the wedding dress for her marriage to Prince Rainier of Monaco. The store leased and sold used gowns to debutantes; the one we got had a huge satin bow with heavy streamers in back to display when a bride was at an altar. Getting dressed for the ball, I hooked on a strapless bra that forced my breasts into unnatural points, attached nylon stockings to the garter belt that held them up, and stepped into tight, pointed white satin shoes. I slowly and carefully lowered the satin gown with its scratchy tulle under-skirt over my head, and after I zipped it up, I felt as if I could hardly breathe, as though I was in a straitjacket. My mother, dressed in a long gown of her own, which I vaguely remember as dark green, pinned a white lily into my hair before we left for the downtown hotel with my tuxedo-clad stepfather, the man I called Dad.

It's obvious to me now that debutantes were supposed to look like brides-to-be in their white gowns and wrist corsages. Like all debutante balls, the occasion was a symbolic mass wedding of marriageable young females, half-aware attempts by parents to psychologically prepare daughters for the institu-tion of marriage. If the ritual was a rehearsal to make a young girl willingly enter the state of so-called wedlock—which should happen sooner rather than later in the view of the elders gathered in the ballroom that evening—I urgently wanted a way out, a way that differed from the expected domestic script.

At the rehearsal dinner I had heard that every debutante would be escorted into the ballroom by her father, as a bride is traditionally led to the altar. I had wondered from time to time which of my fathers would walk me down the aisle on my wedding day: my stepfather or the man I referred to as "my real father"? This question had immense importance to me because the answer would tell me which man was my true father. It was difficult to decide because both fathers were

remote in different ways: my stepfather was aloof and my biological father was elsewhere. The Providence father didn't really regard me as a daughter, and the Vermont father never telephoned or visited and rarely sent cards or gifts in the mail. Still, something biological won out. On my wedding day I didn't want to be on the stiff arm of Dad; in my heart of hearts I wanted to hold my other father's arm to affirm our blood bond, but I wasn't sure he would be willing, since he kept his distance from Providence. And from me. Instead of two fathers, it was as if I had none at all, an absence I now realize drove me in the direction of self-reliance.

That evening, when "Miss Laurie Lisle" was announced over a loudspeaker, I stepped into the crowded ballroom holding lightly onto Dad's arm. Members of Providence's blue bloods were gathered under crystal chandeliers, sitting on gold chairs at little tables scattered around the edges of the ballroom adorned with Christmas greenery, silvery tinsel, and glittering red and green baubles. Debutantes were expected to curtsy to everyone, I was instructed, and I managed a resentful little bob of my knees. The photographer caught me solemn and with downcast eyes, a look that expressed no desire at all to smile in response to the polite applause. With what was already the outsider's eye of a writer-to-be, I was much more interested in observing than being observed. After the name of each of the eighteen debutantes was called out, it was the custom, as at a wedding, to waltz with one's father, which I tolerated in Dad's rigid arms, as he firmly moved me around the polished parquet floor.

After the orchestra paused and Dad and I stepped away from each other, I noticed a very good-looking man in his late twenties sitting alone by the bar with a cigarette in one hand and a drink in the other. It wasn't only his dark movie-star looks that caught my attention—it was his obvious gloom that was so out of place among the partygoers. His mood riveted

me because it mirrored my own misery, and I kept throwing glances at him. Wondering if he was someone's brother who was forced to put in an appearance, I asked another debutante about him; she lowered her head and whispered that he had just returned from Vietnam. I had read in the newspaper about President Kennedy ordering the Green Berets to Vietnam and then denying at a press conference that they were engaged in warfare. Whether or not it was true, the young soldier's depression suggested that he had seen plenty of bloodshed in a part of the world far removed from the Grand Ballroom, and he was a harbinger of the angry antiwar movement that would tear apart my generation during the next decade.

It was perverse of me, an ardent pacifist, to be drawn to a military man with an aura of danger about him—a brooding man like romantic figures in English novels—the kind of male I would be drawn to again and again with disastrous results. Although I wanted to talk with him, I didn't dare. As a way of preserving my virginity, my mother had drilled into me the importance of not being too "forward" with boys. Other warnings also held me back: the appealing and erudite gray-haired German émigré who taught art history in an impassioned way at boarding school liked to tell his classrooms of teenage girls that females were never supposed to be argumentative with males. After one class I had written in my diary: "Don't talk about politics, religion, or sex with boys. Especially politics!"

The handsome soldier's presence also signified what I regarded as "the real world," a place that was much more important and interesting than anything in Providence. I knew very little about the war in Vietnam, but my political awakening was well underway. A few years earlier, the youth group leader at the Unitarian church had been a young, prize-winning reporter for *The Providence Journal*, who later became a key player in the publication of the Pentagon Papers by *The Washington Post*. One Sunday in 1957 I read two front-page

articles, one by him and another by an African American reporter, after they observed racial segregation in the South. Their side-by-side stories, and what I heard in the church hall about their radically different experiences, had been a revelation to me about racism in my country. Reading *The New York Times* for a current events class at school had taught me about the protests and violence during the early days of the civil rights movement. I knew no Negroes, as they were called then, in Providence but felt a deep concern for them because I felt like an outsider, too, both as a daughter of divorced parents and as a female in a patriarchal family. Most of the time I said little about my sense of alienation, but there were hints of it. A month before the debutante ball I had defiantly worn a black wool dress—a color worn only by beatniks and *never* by my mother except to a funeral—to our family Thanksgiving.

A Quaker family with a girl my age lived across the street, and her mother had told mine about its programs for teenagers. The summer I was sixteen, she drove me to a Quaker school in New Hampshire, where I was shocked to hear the headmaster question patriotic platitudes in an American history textbook, and a Marine turned conscientious objector call unearned income from stocks and bonds immoral. My political education continued the following summer, when I joined another Quaker youth group to construct a camp for poor children run by a peace-activist minister in southern Ohio. I wrote home expressing my indignation about a Cincinnati barber who refused to cut the hair of a tall, graceful biracial boy from Haiti, and added that our group had inadvertently desegregated a nearby lake. "Before we came here no Negro had ever dared to penetrate the invisible social barrier—and we quite unconsciously went with the three colored kids in our group and every time we go back there are more colored people," I proudly wrote.

My mother had never mentioned to me the freethinkers among her Yankee forebears, or said much about her unmarried aunt who had been a social worker in women's prisons. Was it because those kinds of people didn't especially interest her, or because she didn't want me to get any ideas about being like them? It was most likely a little of both. When I belatedly learned from others in the family about those dissident ministers, dedicated abolitionists, and leading civil libertarians, I realized that in my instinctive identification with outsiders, I was following in a long family tradition, a heritage that was the antithesis of the one I knew. Born at the end of a cautious generation but before the beginning of a braver one, I was poised to follow in the footsteps of my more rebellious relatives.

2

First Words

Among the elders to whom I was expected to curtsy at the debutante ball was my last living grandparent, my father's mother, eighty-two that winter, who was sitting with other widows, a halo of waved gray hair encircling her long face, and wearing a long lacy evening gown adorned with jewels and an orchid corsage.

Her grandchildren called her "Gaga," an absurdly infantile nickname for such a tall, willful, and dominating person. She was a grande dame who was always impeccably dressed when she went out: I especially admired a navy hat with fake red cherries she wore with one of her elegant dark blue silk dresses. In her younger years she had been a competitive athlete—a golf champion who once made the newspaper for shooting a hole in one—and a skillful amateur artist, who painted landscapes. Her forcefulness within the family derived partly from her wealth from a dowry her father gave her when she married a minister's son turned stockbroker, a position reinforced by

decades as an independent woman after her husband's death. A leather folder with photographs of her travels around the world contained an image of her on a Hollywood movie set in widow's black, along with her three sisters with whom she often traveled, posing with a grinning Clark Gable and his costar Claudette Colbert.

Widowed two years before I was born, Gaga took me under her wing, and I was often at her large brick house on Providence's East Side, where she lived with an elderly Irish maid. Weekends together in her large, shadowy home probably eased her loneliness a little, and they certainly took the edge off mine. In the mornings she would take me into her big bed and read children's books to me as the maid brought our breakfasts on a tray. While my mother was overwhelmed with housework and caring for small children, my stately grandmother appeared to me as a tower of strength, and over the years she inspired me to be like her. Once, at a time of trouble, I fantasized about putting my arms around her, laying my head on her large soft bosom and looking up into her hooded hazel eyes, hoping to summon what she called her "pep" and what I regarded as power.

I can only imagine what was on her mind that evening, as I entered the ballroom on the arm of my stepfather instead of on the arm of my father, her wayward second son. Whatever it was, her thoughts were surely laced with grief over his neglect of me. Laurence, called Larry, alone among the bankers and stockbrokers in the family, had rejected the rules of Providence. If he had known about my resentment at being a debutante, he might have understood, but we were out of touch, and it never dawned on me to ask him to support my resistance.

In a photograph album my mother made during their marriage, she had pasted pictures of a smiling fair-haired baby, a bridegroom with a happy-go-lucky grin, a hunter with a shotgun and a cigarette between his teeth at the family hunting

camp in a forested part of Rhode Island, a shirtless suntanned
sailor on a fishing boat named the *Lally L* for my mother, a
young husband roughhousing with his large English setters,
a naval officer deeply absorbed in a newspaper's war news, a
sun-bronzed soldier on leave posing for a photo with his wife
and toddler in the garden of my grandmother's summer house,
and a lieutenant commander in a life jacket with thinning pale
hair flashing a toothy grin on the deck of an amphibious ves-
sel near Okinawa. The album ends abruptly in 1944, after he
returned to Providence for a few months before I turned three
and before leaving for northern New England. Afterward,
"Vermont" became a radioactive word for me, a painful syn-
onym for the word "father."

When you risk wanting to be a writer—a risk because of
the profession's difficulty and unpredictability—it's important
to feel rooted and secure in other ways. Despite my father's
departure, my early upbringing gave me a deep sense of sta-
bility and identity. The very people I wanted to rebel against in
the hilly city my father fled lived among a handful of patrician
families who had flourished and built their fortunes for two
centuries. In 1922, the year the Biltmore opened for a thousand
guests, a social blue book was published with the names of my
relatives and other prominent families. By the time I was born,
however, the big brick hotel had become more a paean to the
past than a reflection of the present. The Great Depression hit
the city hard, then nature took its turn as hurricanes repeat-
edly flooded the hotel's lobby and the rest of downtown. When
I was growing up, many of the handsome eighteenth- and
nineteenth-century structures had peeling paint and sagging
trim. Even though the place had a distinct feeling of being left
behind, no one in my extended family had moved anywhere
else. What was called the smallest state's remaining "feudal"
wealth in a 1930s Works Progress Administration guidebook
was profitably invested by my uncles and many of the fathers

and grandfathers gathered in the ballroom the evening of my debut for the gala social event of the season.

My grandparents on both sides of the family lived comfortably but without ostentation in spacious neo-Georgian red brick houses behind sturdy brick walls. Part of a small and self-satisfied American elite that had been culturally dominant in New England for many generations, they were all members of the Agawam Hunt, a country club in East Providence, where my mother and her sister had debuts in 1933, and where my mother and father had their May wedding reception three years later. My mother's father, who had made a fortune by investing in the potential of electricity, told a florist to fill the enormous First Unitarian Church with calla lilies and ferns for the service. A Bachrach photograph shows the young bride with tightly curled dark hair posing stiffly with six bridesmaids and two flower girls. The newlyweds settled down with her trousseau of antiques and silver, some of which would eventually become mine and weigh me down when I wanted, as a writer, to be free to move around.

In September 1942 my thirty-one-year-old father was on military leave when he drove my mother and me, an infant wrapped in a hand-knitted blanket, to a little nineteenth-century house on Williams Street in Providence. A few months later, the night before his ship left San Francisco for the South Pacific, he wrote a long, heartfelt letter to his two-month-old, a letter I did not get to read until after his death four decades later. His neat and individualistic handwriting described his "appreciations" (dogs, good literature, antiques, historic houses) and offered fatherly advice (overcome any shyness, be open-minded and considerate) on the chance he would never return. Larry would write to his mother from a warship that my arrival had been "lucky for Lally's sake as well as my own," but, he added significantly, since he hadn't seen me for a year, he could hardly believe he had a daughter. It was

a disbelief based on distance, and it led to a detachment that would wound me deeply in the years ahead.

While my father was away, I was bonneted, blanketed, and tenderly cared for by my mother and a number of relatives who rallied around us during the war. Many afternoons my grandfather walked the few blocks from his house to ours, and young cousins, daughters of my mother's favorite older brother, sometimes stopped by after school. One winter an aunt with a son my age, whose husband was away in the Air Force, lived with us. My mother would push me in a carriage over the neighborhood's bumpy brick sidewalks, past old houses separated by narrow cobblestone alleys, and around the Brown University campus. Many homes were behind stone walls, high hedges, or spiked iron fences, walled off from "the people we didn't want to know," as an older lady later put it to me, expressing the exclusivity that alienated me as a teenager. My early childhood, however, was pervaded by the sweet smell drifting from a small brick bread bakery on baking days at the bottom of Williams Street, an aroma that enhanced my sense of safety and sheer pleasure in existence. Later, when a momentary flash of euphoria would flood me unexpectedly, it vividly reminded me of a better way of being—the way I had felt then. Even though the feeling was fleeting, my sense of its existence would always be a source of strength. I would always remember, and indeed depend on, this memory of an emotion that evoked the certainty of belonging and being cherished at the beginning of my life.

It was also when my mother took many black-and-white snapshots of her firstborn to mail to my faraway father. At Christmastime she propped up her baby in a miniature chair near a decorated tree and a pile of presents for a photograph. The following September she snapped pictures of my cousins and other children gathered around me for my first birthday. Sometimes she took me to a photography studio for formal

portraits of us together; there are also studio shots of me at ten weeks lying on an embroidered pillow, at eight and a half months sitting up in a smocked dress with puffed sleeves, at two holding a little doll that was once hers, and several pictures around the age of three with my straight hair carefully combed, as if my mother hoped that all the photographs would remind Larry, halfway around the world, of his wife and his daughter.

Lally and Laurie posing for Larry during World War II.

When I was beginning to use words at one and a half, my mother left me for two months with her in-laws and then with her mother and father while she joined my father at a Navy base in Virginia. She wrote in a matter-of-fact way in my photograph album that my first words were "all gone," presumably about her absence. At three, though, I was thriving in nursery school with only a hint of trouble—my incoherent speech. "Her vocabulary is good and her ideas clear, but she speaks rapidly," a teacher wrote. "This may possibly be a case of the mind being too quick for the tongue. It will probably remedy itself as she learns to speak more slowly, and as she becomes confident of the full attention of her listener." I'm not sure who was ignoring my babble, but it's obvious I didn't feel listened to, an experience that undoubtedly made words even more important to me. After I learned to write them down and string them together into sentences, I developed a preference for written words that would not be ignored or interrupted, and then, of course, I devoted my professional life to them.

After the war ended, Larry was no longer the young father who had written the long loving letter to his infant daughter, which was also a love letter to his wife, but a reckless man marked by his wartime experiences. "You are very lucky, Laurie, as you have the most wonderful mother in the world," he had written earlier, words he was unable to say easily to my mother. "Not only is she very sweet, but she has good common horse sense and is awfully smart." He went on: "I love your mother very much, and I love you very much, and I ask Laurie Dear that you love your mother as much as your little heart will stand. Be good to her always, particularly if I should not be there, for Lally loves me very much, and her need for you would be that much greater." And then he promised that when he returned to Providence, he would settle down with us and his beloved dogs and never go away again. And when he broke his promise, he ripped the letter from the album where my mother

had glued it and locked it away in a safe-deposit box for the remainder of his life.

My father's restlessness after the war was due either to his inability to settle down at a desk job or his refusal to tolerate the restrictions of marriage, or to endure the entrenched rituals of the large extended families in Providence. Maybe it was because of his risk-taking nature: a man "who had the air of a gambler who played best when the chips were down," according to a wartime article about him in *True: The Man's Magazine*. Later it became apparent that he would never be faithful to a wife. Whatever the reasons, his drinking and womanizing on his return scandalized the people of Providence. After my mother's two older brothers paid her a visit and told her to get a divorce, she reluctantly signed a divorce petition on the grounds of "extreme cruelty." She saw a psychiatrist for a while, but he lost his credibility with her when he theorized that Larry had spent evenings in his basement workshop to avoid her; her own pleasure in creating with her hands as a knitter told her the psychiatrist was wrong. Still, she was never able to tell me why the marriage had failed, and I doubt that she ever really knew why. Later my father remarked to a cousin that he and my mother could have worked out their difficulties if her family hadn't interfered, but he had a way of blaming others for his own bad behavior.

With an inheritance from his father, Larry bought a small furniture factory in a Vermont village with the intention of making replicas of antique furniture, like an elegant Chippendale corner cupboard he had made before the war. My mother had angrily demanded that he leave it behind to give me a reason to respect him, and its presence did make me proud of him, as I wondered how a stockbroker's son with an Ivy League education had taught himself to make such a handsome piece of furniture with hand tools. He was a precursor of the rebels of my generation, the college graduates of the 1960s and 1970s

who refused to work for large corporations and left for rural states like Vermont with dreams of living more authentically and working for themselves. It was an ethos—the rejection of materialism and the search for meaning—that was the subject of a number of postwar novels.

After the divorce, my mother withdrew me from the private nursery school and found a college girl finishing a painting degree at the Rhode Island School of Design to live with us and help take care of me. The young painter, nicknamed Bonnie, who became known as the ceramic artist Bacia Edelman, took the au pair position because she had no money and "your mom seemed lonely and very nice," she wrote to me decades later. My mother at thirty-two was a decade older than the art student, and she treated her like a little sister, confiding in her the deep hurt at being a divorcée at a time when divorces were rare and it was regarded as shameful for a wife to be abandoned by a husband. As the young artist graduated, my mother gave her a little black hat to match her New York job-hunting outfit, telling her it made her look like an ingénue. Bacia told me that her friendship with my mother, and the kindnesses of other family members, took "the bitter taste away from the reverse snobbism I'd harbored about upper-class Providence families." I was glad but, nonetheless, learning about my mother's anguish in the autumn of 1946 made me experience it as my own, and in a way, it was mine, too, because it marked the beginning of the end of my childhood happiness.

A year after my parents' divorce, my mother's older sister got married. A jerky black-and-white home movie of her August wedding day preserves the sight of my lovely brunette mother in a long chiffon bridesmaid's gown with flowers in her hair. I am the almost-five-year-old flower girl, in a floral headband and ruffled dress reaching to my white Mary Janes, joyfully jumping off a low stone wall with the boy cousin my age during the golden childhood era that had not yet ended for me.

When I wonder whether my memory of my youngest years is reliable or not—if my luminous recollections are real—I reread the long, thoughtful, nursery school report and realize that I am not imagining a paradisiacal time at all: it describes an agile little girl who was emotionally stable, unafraid to express herself in her own phonetic language, and absolutely fearless. By the time I became a debutante, however, my early sense of sureness had been gradually buried underneath layers of anxiety and anger.

3

Naming Myself

My mother wanted to marry again quickly to cast off the stigma of being a divorcée in the postwar era. No one blamed her for the breakup, but her in-laws didn't understand why Larry hadn't taken the two of us along with him to Vermont. Her need for another husband was also a matter of money since she had no way to earn a living. At the age of fourteen her inability to spell or write grammatically had caused the headmistress of the girls' boarding school to ask if she had ever been to school before, in that era never suspecting a learning disability. Around that time, my mother signed a letter to her parents from "your dumb daughter, Lally," and her struggles in school and failure to graduate with her class gave her a life-long sense of inferiority. My mother also wanted me to have a father. Once when we were riding in a car with a male friend of hers, I piped up from the back seat that "people will think we're a family," innocent words of a four-year-old but ones that had wounded her deeply, she later told me.

Within a year of her divorce, she became engaged to her younger brother's friend, a man from an old Providence family, who had returned to his parents' home on College Hill after serving as an Army officer in the Pacific. Overlooking the city, the family's enormous, elegant, white clapboard neo-colonial mansion, encircled by a stylish white wooden fence, was a block or so away from a street named for his ancestors. The middle son of five boys, Johns and his brothers had been raised in the manner of English aristocrats by nursemaids and nannies at arm's length from their petite, red-headed heiress mother from Boston. Each had gone to a boys' day school before being sent off at an early age to an exclusive male boarding school in Massachusetts, Saint Mark's, and then all but the youngest had gone to all-male Yale University before entering military service. After the war, Johns, like seven generations of male forebears before him, went to work at the downtown metals fabricating firm that had been in his family since the eighteenth century.

Since my father-to-be had lived in a mostly male milieu all his life, he had very little experience with females. And I had little to do with men; aside from my father's brief visits during the war, no male had lived with my mother and me in the little house on Williams Street. The gruff formality of my mother's fiancé frightened me, and I didn't know what to say to him and he certainly didn't know how to behave around a little girl. Apprehensive about his becoming my father, I was a fingernail-biting flower girl with a circlet of rosebuds over my brown bangs on the day of the wedding in April 1948, wearing the same ruffled dress—by then only reaching to my ankles—I had worn in my aunt's wedding the previous summer. I might have adjusted to my new father, but soon after the honeymoon I was sent away for the summer to an overnight camp in New Hampshire. I remember little about those eight weeks in the woods, but since I began wetting my pants, I presume that at

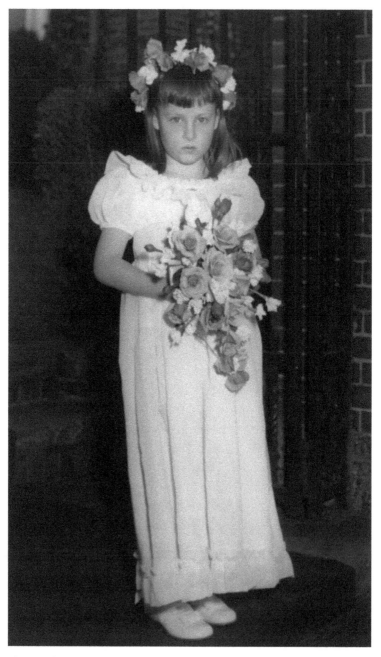

Flower girl Laurie in her mother's 1948 wedding.

not yet six, I was miserable away from my mother. By the time I returned home, the confident child who had loved picture books, and was described by her nursery school teacher as "interested, curious and observant," as well as "mentally alert, eager to learn," had regressed. When I entered first grade in September, I struggled to decipher the words in the *Dick and Jane* beginning reading books and to learn much of anything at all.

After my mother became pregnant we moved to a larger house in a newer neighborhood at the far end of long straight Angell Street that bisected the East Side. The baby girl was born with a heart defect and died soon after birth; when my mother told me and I began crying, she told me to stop being so emotional. The following year, a healthy girl was born, and two years later, a boy. I adored my little half siblings, but my place in the new family felt precarious. Sometimes in the dining room after dinner my mother would take her small son in her lap, and Dad would take his daughter in his, and I would feel very much alone. I would eye the corner cupboard my biological father had handcrafted, a glowing piece of mute mahogany, as a stand-in for him, and I would ardently long, like the mythological Electra, for a father, and mourn the absence of the idealized man who was mine. After sitting silently at the table for a few minutes, I would get up unnoticed and climb the two flights of stairs to my third-floor bedroom to do my homework.

My feelings for my faraway father were convoluted and complex, leaving me with a troublesome emotional legacy in matters of love, one that made it impossible to become happily married until midlife. Even though I longed for his affection, I acted childishly angry instead of pleasingly ingratiating on the rare occasions I saw him. Driven by an aunt and uncle to see him in Vermont when I was four or five, I had adamantly refused to call him "Daddy" despite everyone's prompting, out of anger about

his going away. When I asked my mother why I never heard from him, she said it was because he was "selfish," an explanation that mistakenly drove my hurt deeper because it suggested that his young daughter had nothing to offer him. Looking back as a writer, I realize that feeling fatherless was a painful but essential preparation for a precarious professional existence. As I got older it made me my own paternal parent, used to depending on myself. As I learned to stand on my own two feet, I liked feeling independent, and then I began to fight for my freedom. While my father's neglect allowed me to make decisions about my future, it unfortunately left me without any guidance or a sense of sureness about how to make my dreams happen.

In other ways I was made to feel an outsider in the family. When I was not born a boy to be named Laurence, as my parents had hoped, they gave me my father's boyhood nickname for a first name and, like him, no middle name. Making me his namesake was a patriarchal gesture by my mother and a way to link me to him by nomenclature, but after she remarried and her last name changed, my name became a sore spot. When grown-ups praised its alliteration, I would uncomfortably wait for the inevitable question: "Why is your last name different from everyone else's in the family?" Since I was the only pupil in my grade school class with divorced parents, I was ashamed to say why. Adding to my unease was Dad's discomfort at saying my full name when making introductions, since it so strongly evoked his predecessor, so sometimes he didn't utter it at all, making me feel nameless. It wasn't long before my mother asked me to stop mentioning my real father around my stepfather because it annoyed him, a gentle reprimand that increased my shame.

Maybe my mother asked me if I wanted to change my last name, too, but I vividly remember not wanting to because it represented a link to my real father. For a while I signed school papers with Dad's surname as a middle name, but soon I

stopped, reasoning that I didn't want or need a middle name because after I married, my maiden name would become my middle name. And since my first and last names began with the same letter, my initials on either side of the enlarged initial of my new last name would make a beautifully balanced monogram. And then, I believed, I would feel as if I really belonged to a family. What interests me now is that even at that early age it mattered to me that my birth name was my true name, and stubbornly clinging to it as a child was a way of firmly grounding myself in my own identity. Despite my fantasy about the monogram, keeping my original name was a decision I would make again and again throughout my life.

It was confusing during those years to feel privileged as part of the Protestant establishment but underprivileged as a girl. I felt there was nothing worthy about being female, except briefly, when she was a bride-to-be, but I had become so distrustful of the nuptial promise that when my father and his lady friend gave me a big bride doll enveloped in white satin and tulle, I pushed it into the back of my closet. Efforts to groom me for a restrictive female role felt smothering. I wish someone—a relative or a teacher—had told me about the brilliant feminist theoretician Charlotte Perkins Gilman, who had grown up in Providence in the late nineteenth century; it was where she married an artist and gave birth to a daughter, leading to the crisis she described in the harrowing semiautobiographical novella *The Yellow Wallpaper*, published when she was thirty-two, about the mental breakdown of a wife after being isolated and imprisoned in her bedroom for a supposed rest cure. I also wish I had read *Herland* then, her short, humorous satire about a female utopia of strong admirable women invaded by inept chauvinistic men. Little of women's history had been written down in the 1950s, so no one in Providence could tell me about a woman who was a predecessor of the second-wave feminists that would rock my generation.

I often think I stayed on the side of stoicism and sanity because of the artists I encountered during my early years in Providence. The minister of the Unitarian church wanted the Sunday-school children to learn about what he called "beauty," so we were taken for art lessons to the studio of artist Gino Conti, a lean, intense, middle-aged Italian. He taught art in a cellar carved from bedrock on steep Planet Street near the church, where rabbits, turtles, and other wild creatures roamed at will and dozed on a warm stone hearth. It was an enchanting basement and completely unlike ours on Angell Street, where Dad had built a dark, dank bomb shelter with four bunk beds for the five of us. The art teacher whom we politely called Mr. Conti admired the aesthetic imaginations of children who, with their "eyes of invisible fires," as he put it, created images on a par with works of Giotto and even Picasso. He encouraged us to paint whatever we wished with bright watercolors on rough paper; I remember making straight green slashes for grass, red dots for flowers, and yellow circles for the sun, intrigued by making pictures with bright colors.

Sometimes Mr. Conti allowed us to climb the steps of a narrow staircase to his large studio, where boldly colored abstractions were displayed on his easel, and, amazingly, the top of a large green plant was growing through a hole cut for it in the ceiling. Once I glimpsed an exotic-looking woman with very long, loose black hair looking down at us from a balcony around the studio. Was this a Native American woman he had met during one of his summers in the Southwest? Those Sunday mornings in Mr. Conti's artistic milieu gave me a glimpse of a bohemian existence devoted to creativity, an intriguing way of life that contrasted dramatically with my bourgeois household on Angell Street.

Another artist in my young life was Dad's older brother, who lived in Italy. During rushed visits to Providence to visit his parents he radiated an enormous sense of vitality. After the

war the man we called Uncle Billy had moved to the Bowery
in New York, where he painted prolifically and passionately—
including a painting I later saw reproduced in *Life* magazine
of a menacing *Black City* seen from above, with grids of dark
streets under a glowing orange moon—before moving to
Venice. "America is the land of the machine," he liked to say,
"and Italy is the realm of the spirit." High-spirited and smil-
ing, he was the epitome of everything his somber businessman
brother was not. Once this lifelong bachelor returned to his
hometown along with a handsome young gondolier, raising
questions in my mind that my mother warned me not to ask.
While my mother and stepfather indicated their incomprehen-
sion, irritation, and disapproval of Uncle Billy's emotionalism
and expressionism—including his wholehearted defense of an
entirely yellow abstract painting that my mother didn't under-
stand—I was drawn to the aura of excitement around him.

My sense of not belonging, of wanting to live differently
than my mother and the mothers of my friends, made me begin
searching for something else and another way to be. Sunday
luncheon was often at Dad's parents' impressive home, where
I would sit stiffly on a dainty chair in the formal living room,
while a maid in a black silk uniform and lacy white apron
served cocktails to the grown-ups on a silver tray. After the
meal in the dining room was over, I would escape to my fierce
step-grandfather's study and pull his pristine leather-bound
copies of *Life* from a bookcase. Wartime issues had dramatic
black-and-white photographs taken by women photojournal-
ists like Margaret Bourke-White, including one of her hold-
ing a heavy old-fashioned camera while perched perilously
on a skyscraper ledge overlooking Manhattan. It was an early
inkling for me of possible ways for a woman to be, and one of
the reasons that made me want to become a journalist.

During that difficult decade from ages five to fifteen on
Angell Street, when I walked or rode my bicycle a mile or so

along the street to my girls' grade school, I passed a very long, massively thick, eight-foot-high fieldstone wall enclosing a mysterious place known as Dexter Asylum. It was whispered that deranged people lived on the other side of the wall, so in my imagination it was a terrifying institution, definitely not where I wanted to end up. A close friend's mother was sent there from time to time because of debilitating depressions, so it was not an unrealistic possibility. Still, sometimes I would take a bus along Angell Street and into a dark tunnel to downtown Providence; blackness would envelop me for a few frightening minutes before the bus emerged into daylight, an experience that made me aware that darkness was transitory and brightness was inevitable.

Instead of falling into depression or danger or destructive behavior as a teenager, I made the deliberate decision to act normally. My mild manner and agreeableness misled my parents and teachers, who remained unaware of my longing and turmoil inside. Once I overheard Dad say he shuddered to think how harshly he had treated me but, since I had evidently survived, "the hell with it." Shocked by his callous words, I said nothing. At fourteen I was, in the eyes of my headmaster, friendly and hardworking. And at eighteen my high school headmistress remarked on my maturity, individuality, and interest in social work, the same year a Quaker work camp leader noted what he called my "gentleness, good-naturedness, and kindness." But my conciliatory persona was a mask, a way not to make waves and wait out my misery until I could find a way back to the pleasure I had experienced during the earliest years of childhood. It would be a path I would find through writing.

4

Learning to Use Words

A photograph album has snapshots of me, taken before I could walk, sitting in an upholstered armchair and engrossed in a picture book. My mother's handwriting says that after my first birthday I became very fond of books, and that at fifteen months I took a quick look at my new toys on Christmas morning, then made a beeline to the bookcase for my favorite volumes. It was a moment of revelation when I realized the squiggly black marks on brightly colored pages were words that spelled out sentences. A few years later my mother started to turn me loose in the children's room of the imposing brick library a few blocks away from our home on Williams Street whenever she searched for romance novels. A former church that had lost its steeple, the library had the soaring spaces and hushed feeling of a sanctuary, and it gave me the certainty that there was something reverent about reading.

When written words began to have meanings, I gravitated to a series of children's biographies with big black type and

bright orange covers and chose the ones about American girls who had become famous for one thing or another: Amelia Earhart, Dolley Madison, Clara Barton, Louisa May Alcott, Jane Addams, Harriet Beecher Stowe, and others. There was something about their girlhoods I wanted to know. After noticing that several were daughters of Protestant ministers, I asked Dad why that was so; he speculated, while trying to impart a lesson, that it was because they went to Sunday school. His answer didn't satisfy me, and, after pondering it for a while, I concluded that the girls had succeeded because as daughters of the New England intelligentsia they had been well educated for their eras, an observation that underscored to me the importance of getting an education.

By then, for a reason that remains mysterious to me, the appeal of words over images—the attraction of the verbal over the visual expression of ideas—had taken root. At the age of nine I spelled out in careful penmanship on writing paper with my own letterhead a note to my boy cousin, politely thanking him for a Christmas gift of two sterling-silver barrettes, then went on to write excitedly about the seven or so new books I had been given as presents, including *Lucretia Mott: Girl of Old Nantucket,* books by Lois Lenski, and three Marguerite Henry novels about horses. At the end of my letter I attempted to engage my cousin in a literary conversation by asking what I regarded as the most important question of all: "What did you get in the way of books?" but I never got an answer.

After my mother gave birth to a boy the following June, she sent me away for the summer to stay with her elderly parents in their country house, a gray-shingled farmhouse in an old fishing and farming village dominated by an enormous white Congregational church on the Rhode Island coast. My grandparents gave me my mother's former bedroom on the third floor, a large sunny room with a window seat overlooking mowed fields edged by stone walls and, in the far distance, the

straight blue line of the sea. The harsh sunlight at the beach made me squint, but I loved the light in Granny's gently shaded flower garden, which softly illuminated her roses, delphiniums, and other sweet-smelling blossoms. I remember little about those lonely summer weeks with my kindly but detached grandparents, so after days at camp I must have spent evenings in the quiet farmhouse with my nose in a book for companionship. Noticing that I was a bookworm, the following Christmas my grandmother gave me a grown-up's heavy Webster's dictionary with thousands of words printed in tiny type; she undoubtedly hoped I would learn to spell better than my mother, but by then I already did.

When I was around twelve, someone—most likely my mother—gave me as a joke an amusing little book titled *A Girl's Guide to Grown-ups*, written by a girl about my age. I used to stare at the illustration on the cover—a purple cartoonish drawing of an adolescent with wild strands of black hair pounding away on a typewriter—with wonder. What astonished me was that a young girl was saying forthrightly, in her own words, what *she* thought of *parents*, rather than the other way around. The binding of the slender, saucy book soon became tattered from my many handlings of it, and it allowed me to imagine that someday I, too, would be able to write down and publish exactly what I thought in a book of my own, but because of the repressions in my household, it wouldn't be soon.

Inside and outside our house on Angell Street, the practice of verbal restraint, and the reluctance to say what was really on one's mind, ruled. It was a matter of politesse as well as fear of violating unspoken rules that held the family together. After I told a neighbor about something that had happened at home—I don't remember what—that got back to my mother, she took me aside and told me never to tell anything like that to anyone ever again, making me feel deeply ashamed of myself. My

stepfather's sternness was more effective at silencing me than the soft reprimands of my mother. Around him it was dangerous to speak spontaneously or say anything surprising, let alone use words in a tearful, sarcastic, loud, or angry way. He exuded an air of barely restrained violence, and he enforced his will with an explosive temper. My mother remarked with surprise to me one day that he hadn't been that way during their engagement, and she didn't know what to do about it. After the time he lost his temper and slapped me on the mouth for saying something he disliked, I feared his violence for speaking up or talking back, and I learned to use words carefully and cautiously, in a subdued voice, around him. Existing in a state of verbal inhibition, I now realize, magnified the appeal of putting phrases and paragraphs safely down on paper instead of speaking them out loud.

I saved my speech for the all-girl classrooms I attended from the age of ten, especially at the boarding school where my mother and many aunts and cousins had gone. There I started to talk more openly about pacifism, the civil rights movement, and other causes I felt about so passionately. Westover, founded as a Protestant finishing school for girls by an emancipated "new woman" during the early years of the twentieth century, was designed by a female architect for around a hundred teenagers. The sheer existence of its handsome beige stucco quadrangle building gave me a subliminal message counter to the one about the insignificance of girls I was getting elsewhere. By the time I arrived in 1958, Westover had become a rigorous college preparatory school taught by highly educated women and ruled over by an imposing headmistress with iron-gray hair pulled into a bun and a PhD in French literature who, from time to time, flashed a surprisingly sweet smile. The school faced the green in a small Connecticut village, and when I went there it was a pastoral oasis where intellectual and unmarried women teachers could lead independent

lives during a culturally conservative time in the country, a community not unlike Charlotte Perkins Gilman's imaginary *Herland*. I pondered the school motto, "To Think, To Do, To Be"—inscribed in Latin over the wide dark green front door and on the brass belt buckles of our uniforms—because it seemed to question the usual expectations for a female life. *To be,* certainly, *to think,* okay, but *to do* anything other than marry and mother?

My newfound voice was not just verbal, either. Away at school I began writing in a little white leatherette diary with a tiny lock and key and a dejected cartoon character embossed on the cover, along with the words "My year . . . and how I shot it." Despite the humor, starting a diary was the beginning of an earnest adolescent conversation with myself that eventually morphed after a few false starts and stops into a life-long journal. What I committed to words in the diary made me more aware of what I liked and disliked, and why, which was invaluable training for a writer-to-be. I continued to make brief entries in the diary even after my haughty English teacher with a Yale graduate degree indicated that it was "pompous or just silly to record my thoughts," as I noted, instead of the lofty thoughts of Milton and the other nineteenth-century writers she was making us read. If she had been less censorious and more encouraging, I might have written less erratically in the diary and its red-bound successor the following year.

Luckily, another teacher, a white-haired Bryn Mawr grad-uate, gave me a different message. The same year I began the diary, the headmistress gave me permission to take an elective class called Creative Writing instead of more detested algebra. It was during those autumn months when I began to under-stand what it meant to be a writer. On the first day of class, the teacher gave every pupil a spiral-bound notebook with the school motto on the cover to be what she called "a writer's notebook," and she told us to record on its lined pages what

we were observing and overhearing as possible literary material. Next she dictated a Joseph Conrad quotation about the purpose of writing: "to make you hear, to make you feel—it is, before all, to make you see" as well as to give "that glimpse of truth for which you have forgotten to ask." Truth! Writing was about telling the truth! These were exciting words for me to hear. Next, I wrote down her rules about composing essays (including "make notes but don't rely on them") and short stories ("BE CONCRETE!!"). The notebook includes paragraphs of my prose and pages of my poetry, but no fiction at all. Even then I found it more natural and interesting to write about what I regarded as reality rather than what was imaginary. Even though I received an A for a short story, it evidently meant little to me since I didn't save it or submit it to the school literary magazine, *The Lantern*. It wasn't only my early fragments of writing that made me treasure and hold on to the notebook all my life, it was also its promise of a way to find a written voice.

Out of curiosity and as an instinctive way to gather material for the notebook, I asked the headmistress for permission to spend a long weekend at a Quaker settlement house in Harlem. After leaving the peaceful village of Middlebury for a train to New York, I admitted in my diary that I was "petrified," but it was too late to turn back. Two boys wearing American Friends Service Committee tags met my train and took me by subway to a brownstone on East 105th Street for the program to inform and awaken teenagers from outside the city to the troubles in the Spanish Harlem slum.

After meetings with social workers and some of their clients, a square dance with neighborhood Puerto Rican teenagers was held on Saturday night. Somber young men with black fedoras pulled down over their foreheads silently filed into the settlement house, along with their girlfriends with dangling earrings and elaborately waved hair. While an accordion player warmed up, the two groups eyed each other warily. As the

caller began to sing out directions, our group started to take the familiar steps; the city kids tentatively tried them as we awkwardly bumped into each other. After everyone caught on, the circles twirled faster, the caller's voice rose, the drummer thumped wildly, the accordion shrilled higher, the cymbals gave a last crash, and the music squealed to an exultant stop. Our circle staggered dizzily for a moment, then collided with another, and we fell over each other onto the floor. A neighborhood girl tittered, then others started to giggle, and everyone became convulsed with laughter. As my partner helped me up, I saw a policeman looking in a window with an incredulous expression on his face; I gasped, sensing that if I revealed his presence the hilarity would immediately end.

After I returned to Connecticut with a severe cold that sent me to the school infirmary, I struggled to make sense of what I had experienced during the weekend in Harlem. I was disturbed by my glimpse into another world, especially by a parody of the Twenty-Third Psalm an addict had handed me: "Heroin is my Shepherd: I shall always want. It maketh me to lie down in gutters," it began, and concluded: "Surely hate and evil shall follow me all the days of my life. And I will dwell in the house of misery and disgrace forever." All I knew was that everything about the weekend was extraordinary material to write about. My instincts as a neophyte writer took over, and I began to describe what I had seen, and then I gave the essay to *The Lantern* to publish. My urge to arrange words into orderly sentences, paragraphs, and then publishable narratives was quickly becoming my way to make sense of what was happening around me.

A year later, when I was given an assignment in an Introduction to Philosophy class to describe my aspirations and I put down "to write creatively," I did not mean inventing stories. I explained that I wanted to string words together, idealistic words about my beliefs and descriptive words about

the beauty of nature. Although it would be decades before I would hear the term "creative nonfiction"—using fictional techniques in factual writing—I had already discovered it in the nineteenth-century essays of Charles Lamb. Reading this Englishman's irreverent, ironic, witty words was another writerly revelation to me. He used an alter ego, Elia, to guard against the charge of self-centeredness when writing about himself, but as he elaborated about what he was experiencing, he was not self-effacing at all by the act of examining and elevating the importance of his perceptions. His empathy for outcasts and outsiders appealed to me; he wittily expressed his sympathetic attitude toward unmarried men like himself in "A Bachelor's Complaint of the Behavior of Married People." Surprised and smitten by this introspective and intimate way of writing, I would never forget it and eventually attempted to emulate it myself.

My writing teacher must have drilled into us the importance of repeatedly revising our work because my diary that year has vows to rewrite what I had written, but she also gave us an exciting exercise demanding that we write in an entirely different way. Every week we had to take a slip of paper with a topic written on it from a box in study hall and write extemporaneously about it for a half hour. Writing off the top of my head was exhilarating, I discovered, because it was an invitation to voice, in impromptu written form, ideas and impressions that up to that moment were unknown or only half-known to me. As I look back, I believe that the time limit was intended to force a connection between our conscious and unconscious minds, and to encourage genuineness by making self-censorship almost impossible. From then on I looked for a way to put that kind of voice, a voice of verity, on paper and get it into print.

My desire to be a writer, or my realization that I already was one in a way, was also due to a recognition of my own

apartness. I felt alone among my classmates with my sympa-
thies for the underprivileged and my dream about becoming a
writer. Aware of what I regarded as my maladjustment to my
milieu, I reflected in a letter to a boyfriend, according to a draft
I kept, that I could give best "indirectly—through writing,"
since "my pride and shyness somehow dissolve when I hold a
pen." Interestingly, George Orwell's essay "Why I Write" attri-
butes his becoming a writer to feeling isolated and ignored;
in addition, he cited a natural ease with words, and an abil-
ity to face unpleasant facts. My youthful drive to write also
depended on an emerging sense of self, as it has to be with any
writer. A poem of mine, written while looking out my dormi-
tory window on a winter night and published in *The Lantern*,
goes: "What matter if others ignore or glorify this silver night?
I see it as I do."

5

Loving My Language

After nine years at small girls' schools, I yearned to attend classes with boys and enrolled in Ohio Wesleyan University. It was there, in my freshman year, when I spotted a flyer about a chartered student ship going to Europe the following June, and I wanted to be on it. At around the age my mother had married, she let me go: I reassured her I would be visiting a female cousin and her family in Paris and Dad's artist brother in Italy. When she escorted me from Providence by train and taxi to the dock in New York, her permissiveness had an element of vicariousness to it, since she had never traveled far from Rhode Island or outside the country. She had never learned to type, but that summer while I was away she would laboriously peck out on an old manual typewriter copies of the exuberant letters sent home from her serious firstborn who, she guiltily indicated to me later, had never had a carefree childhood like her own.

My eagerness to see Europe was stronger than my moments of anxiety about going alone, which I got over quickly enough after settling into a small stateroom crammed with bunks for seven other college girls. I was assigned a dining table with students and scholars from India, Lebanon, and the Navajo reservation as well as a mysterious, silent, sour girl from New York wearing dark eye makeup like a beatnik. During the nine-day crossing on the old Italian hulk, I dutifully dropped in on a few French- and Italian-language classes, but I was much more interested in lectures about modern art, especially when a professor described what he called "junk sculpture," long before I saw Louise Nevelson's black assemblages made from discarded pieces of wood. My excellent boarding school instruction in art history is evident: when the boat briefly docked in southern England, I likened a windblown sky of swirling colors to paintings by J. M. W. Turner, and on the train from Le Havre to Paris, fields of orange poppies reminded me of Monet's paintings.

Traveling in Europe in the 1960s had an air of innocence and informality about it that it later lost. After a brief visit with my cousin, I moved with a cabin mate into a hotel room costing a few dollars a night on the Left Bank. From our top-floor window we could hear a pianist haltingly play a classical concerto as well as a radio blaring the popular American hit song of the summer, "Let's Twist Again," all intermingled with the sonorous bells of Notre-Dame booming on the hour. It was the cathedral's eight-hundred-year anniversary, so firecrackers in the French national colors of red, white, and blue lit up the darkening sky around it every evening, setting off fluttering flocks of white pigeons from its bell towers. After the lingering light faded around nine or ten o'clock, former wartime searchlights softly illuminated the city's heroic statues, ornate fountains, church façades, and even stately old trees, transforming

nighttime Paris into a magical place where I didn't want to sleep.

After running into an ebullient boy, a friend from the Midwest, who had dropped out of college and settled in Paris, I had another comrade. We explored the city together, going to nightclubs and performances in the opulent Paris opera house, including a Marcel Marceau pantomime we could enjoy without understanding much French. One dawn we ended up at the bustling Les Halles wholesale food market; afterward, as he drove me back to my hotel, I stood up with my head out the sunroof of his little Peugeot, exhilarated at watching a misty pink sunrise touch the wrought-iron latticework of the Eiffel Tower. On Bastille Day tricolor flags and bunting were everywhere, but I noticed that the crowd on the Champs-Élysées became ominously silent when President Charles de Gaulle's limousine passed during the military parade, presaging the violent student uprisings against the government that would erupt five years later.

My recollections of that month in Paris are not entirely from memory or letters, but also from what I was putting down in a new little notebook. As often happens when those with an inclination to write put themselves in unfamiliar places, the urge to translate new experiences into words takes over. Deliberately putting myself in a different culture stimulated a compulsion to record what I was seeing and doing in a flow of written words. I instinctively began to create another writer's notebook with potential literary material. The words written for myself in the travel notebook differed in interesting ways from those in letters to my parents; the private words were more honest and introspective, the latter more censored and humorous. Before long what I was writing about in the new notebook became as important as looking at contemporary art and the famous paintings in the Louvre.

By the end of July, when the American boy was becoming more important to me than seeing Paris, I decided it was time to go on to Italy, reminding myself that my original plan was to go back to college, not to get waylaid by a romantic relationship.

Another reason I wanted to leave was my inability to speak the maddening French language. As a better learner by eye than by ear, I could read it pretty well, but I was unable to follow or pronounce most of its tongue-twisting sounds when it was very important to me to make sense of everything said around me. Among Parisians, or anyone who did not speak my native tongue well, I felt voiceless, wordless, childlike, even stupid. I desperately missed using my own language's idioms, colloquialisms, subtleties, slang words, and endless synonyms. The experience of being suddenly muted made the English language, which of course I had always taken for granted, seem like a marvelous tool as words flowed effortlessly from my mouth around other Americans and the English boys whom I was meeting in cafés. Visiting Paris, in short, made me realize how much I loved my language. My reluctance to remain and try to become fluent in French was also the unarticulated instinct of an incipient writer wanting to envelop her ears with the sounds of familiar speech, and maybe a fear of the impossibility of developing an authentic authorial voice away from it. And although not knowing any Italian didn't stop me from going to Italy as planned, I knew I wouldn't be there for long.

When the overnight train stopped in Milan and the sleepy northern Europeans departed, their seats were filled with chattering Italians. After the train began moving again, an elegant gray-haired lady took out a cigarette, and a ripple went around the second-class compartment, as men's hands probed their pockets for lighters; the one who was quickest lit it with an elaborate gesture of courtesy as she nodded graciously. Their gestures and expressions enabled me to figure out that a "fiery (but *so* good-natured) argument" had arisen about whether

women should be allowed to smoke. As I tried to follow the debate, I glanced out the window at the passing pale green landscape dotted with olive groves and dark spikes of cypress trees as in the backgrounds of Italian Renaissance paintings, a sight as gentle as the amiable conversation going on around me. Despite my hunger and exhaustion after fifteen hours on the train, I felt a stab of elation about being in Italy.

The Italians reminded me what I liked about artists. Soon I was writing in my notebook about their evident joyousness, their easy gregariousness, and the way they took time to warmly engage each other as well as tourists like me. I also recognized an aesthetic intelligence everywhere—the way, for instance, a shapely green shrub in a terra-cotta planter was perfectly positioned in front of a bare beige façade—as beauty was valued for beauty's sake. During the following weeks, as I learned a few Italian phrases, I had to speak very simply with the Italians I was meeting in youth hostels and on the streets, but my effort to learn the language was easier than in France. I also found myself starting to express a more emotional and sensual side of myself, and soon to question my more intellectual self that now seemed too cerebral, solemn, and shy. "I have been thinking about my silly little personality," I wrote to my mother from Italy. "Little ideas have changed."

From Milan I took the train to Venice. One evening I went with a group of American graduate students to a concert on Saint Mark's Square, and I could not take my eyes off the beautifully illuminated blue-and-gold bell tower near the astonishing pink marble Doge's Palace. The tower was familiar to me from my step-uncle's expressionistic paintings, which I had seen in his recent book, *In My Disc of Gold*. A few weeks later, after visiting Florence and Rome, I boarded a bus to visit him in the little hilltop town of Assisi, where he had moved after converting to Catholicism and rendered its pale churches in fiery orangey tones, enflamed by emotion, under celestial skies.

It was a pilgrimage to see a person who was entirely different from anyone else in my family. At a time when I was trying to figure out what kind of a life to live, Uncle Billy was someone I had to see again. To him I was a family obligation, but even though I was not a blood relative, it was one he carried out good-naturedly in the welcoming way of Saint Francis, who, like him, had been born to a wealthy family before renouncing his riches. He lived in a small stone studio in an olive grove, so he put me up in a convent guesthouse. After I settled in, he took me to see the thirteenth-century Giotto frescoes in the renowned basilica, but he mostly left me on my own while he painted.

One morning while I was sipping cappuccino among pots of red and pink geraniums in the garden of the guesthouse, an elderly Italian-American priest in black began questioning me. What was a young girl doing traveling so freely in Italy, and what had brought her to the isolated town of Assisi?

After I told him why, he replied, "Oh, you're the niece of the American artist." As we talked, the hot August sun slowly evaporated the silver mist in the green valley below, revealing a lacy bell tower and pinkish houses with little gardens on the hillside.

After a few minutes, he asked, "Are you in love?"

Surprised, I laughed and said, "Not really." At least the emotion expanding inside me, and enlarging the space around my heart, was not a crush on a boy, not even the courtly young Italian man who had picked me up near the Trevi Fountain in Rome and taken me dancing on a barge gently floating on the Tiber.

"Why don't you make Italy your home, as your uncle has done, and make these people your people?" the priest asked after a while.

I thought for a moment. "I am a student in America, and that is my work."

At that explanation the old man began laughing while placing his hand on the heavy rosary around his neck. Seeing that I was puzzled, he turned his wrinkled face to me and became serious. "Soon, Laura, your ambition to be a student will be abandoned," he predicted, with a warm look in his brown eyes, "because you have been learning in Italy to become a woman. Your heart is written on your face, and it understands loving."

At that moment I had a name for what was allowing me to enjoy myself without evaluating everything. Even though I was surprised and slightly pleased that the priest had sensed my pleasure in Italy, I was annoyed that he didn't take seriously my determination to get a diploma. If I wanted a career, I had to get a college degree.

One day during lunch in an outdoor café with Uncle Billy and a dour art dealer from his gallery in New York, I ventured aloud that I wanted to become a journalist. It was a remark that set my step-uncle off about the venality of newspapermen, or maybe he meant the Italian paparazzi, but they were definitely not what I had in mind. Whatever he imagined, it made his voice louder, his ruddy freckled skin redder, and his bright blue eyes behind heavy black glasses frames flash. Intimidated by the force of his words, I didn't dare defend myself or say much of anything. I wasn't about to argue with a middle-aged man who was also my stepfather's older brother. A day or two later, after having second thoughts about his eruption, he bluntly told me I should talk more. I was astonished. No one, certainly no male in the family, had ever said that to me before. In fact, Dad had always held the exact opposite opinion. Uncle Billy's remarkable words remained with me long after he gave me a handsome illustrated copy of *The Little Flowers of St. Francis* in English translation, a book of the saint's sayings he said he was never without, and sent me on my way.

6

Reading Exciting Words

After my experiences in Italy, I wanted to dig deeper into my thoughts and feelings, so I went to the Ohio Wesleyan bookstore and bought a big, thick spiral notebook for another kind of writing. I would call it a journal rather than a diary because it would be different and more demanding than what I did in high school or while traveling. Even though it felt dangerous to anticipate writing down everything truthfully, I decided to give it a try. "To begin to write again," I noted on the first page, was because of my newfound belief after the adventurous summer that what was happening to me and around me was important enough to write about. As I open that yellowed old notebook today, my handwriting looks tiny, almost microscopic, as if I were afraid of my own words, but the little upright letters look steady and orderly as they cling to the lines on the pages—evidence that I was apprehensive but ready to risk more self-exploration.

It never crossed my mind to type those private words on the manual Olivetti typewriter I used for writing papers. Fingering a keyboard wasn't nearly as pleasurable for me as writing by hand; it felt too mechanical, and the lightweight machine bounced and clattered annoyingly when I hit its keys. Cursive was like a kind of craftsmanship and, endowed with the genes of my mother and father, I also liked creating with my hands. Penmanship felt to me like turning a strand of yarn into an intricate pattern with knitting needles the way my mother had taught me. My college studio art teacher at the time was always talking about *line* and how to evoke it in sketches, so using script to make words and sentences enabled me to make an expressive line with continuous and broken strokes that curved and straightened, curled and slashed. Over the years I would discover that a fluid, silent movement of my fingers over a piece of paper even encouraged the flow of words.

My impulse to begin a journal was also motivated by feeling a little lonely at the beginning of junior year. My sophomore-year roommates had left Ohio Wesleyan, and I had fewer friends in the dormitory with whom to talk in an intimate way, and the college boys I was dating weren't interested in that kind of conversation. I couldn't easily confide to my mother in letters or expensive long-distance telephone calls; when I was home on vacation she would listen for a while but not long enough to really hear what was on my mind, as if anything that confused or disappointed me pained her as well. In a kind of willed helplessness about understanding others, she was resistant to reflecting on her relationships—especially with her tempestuous husband—and so she didn't want me to dwell on mine. While sympathetic, she was more like a nursemaid than a mentor or a role model, a mother who made me feel deeply loved but also left me feeling a little lost. Although I loved her very much, I didn't want to be like her or have a life like hers. It was a difficult distinction for me to make—wanting to break

loose from her without knowing another way to be womanly. It would be another seven years before I would encounter a different example of womanliness in Georgia O'Keeffe. Nevertheless, at the end of the first entry in the journal, I vowed to ignore my mother's warnings, stating "I <u>will</u> write."

The national news on the black-and-white television in the lobby of the girls' dormitory often pulled me away from the desk in my room. When President Kennedy had been elected, three years earlier, I was too young to vote, but after the bland Eisenhower years Kennedy had given me and others my age enormous hope for the future. His mention of a Peace Corps in his inauguration speech—the prospect of sending young Americans around the world to do good—was especially inspiring. Other electrifying ideas were in the air. A presidential report recommending equality for women in the workplace was released in 1963 under the leadership of Eleanor Roosevelt. It described widespread gender discrimination in wages and promotions, and it went so far as to urge paid maternity leave and affordable childcare, new and radical ideas at the time, so young mothers could have careers. Also, important and provocative books were being published about poverty (*The Other America* by Michael Harrington), the environment (*Silent Spring* by Rachel Carson), and consumer rights (*Unsafe at Any Speed* by Ralph Nader). Early in November Theodore H. White, author of *The Making of the President 1960* about Kennedy's election, gave an optimistic talk at college that underscored my belief that my generation was going to make the world better. "What an exciting time to be living in!" I jotted down in my journal afterward, unaware that my hopefulness would be smashed only three days later.

When walking to class on November 22 I saw a raw and vital strength in the leafless trees overhead instead of feeling my usual gloom about bare branches and darkening days. As I got closer to the classroom building, I wondered why so many

students were whispering outside until I overheard someone say that classes were cancelled because President Kennedy had been shot. Back in my dormitory room I turned on the local radio station, which had suspended programming to play classical music, interrupted from time to time with somber reports from Dallas, and then the shocking news of the president's death. His assassination—his sudden loss—seemed like a Shakespearean tragedy, in which a young prince had needlessly and tragically died. In the days afterward it seemed as though an enormous void had opened up, as well as a terrifying end of normalcy and the beginning of something else— what, I did not know.

I sensed the existence of exterior and interior realities and began using two written voices, an aboveground one for school papers and an underground one for my journal, in which I expressed a deep discontent and angry cynicism about almost everything. I decided that professors expected their opinions parroted back to them in writing assignments for classes in exchange for good grades, and I didn't like doing that. I had wanted to go to a midwestern college to escape what I regarded as the narrow-mindedness of New England, but its attitudes and fraternity culture turned out to be too conformist and conventional for me. After going to girls' schools, I had no interest in joining a sorority. Instead, I became an "Independent," a label that fit me very well. It was independence I wanted to be myself. When the studio art teacher, a working abstract artist, advised living a life of "contemplated wildness," I was intrigued. What the concept meant to me was intense self-expression within a structured framework, something that could be applied to writing, too. Even though I wasn't the kind of college girl to break rules, like the one about being back in the women's dormitory by ten o'clock at night, my refusal to join a sorority and going around in a black Italian sweater typed me as an East Coast rebel.

My plan was to major in history, but those classrooms were full of boys and male professors pontificating about the power of kings, bishops, and presidents. Even more alienating, after attending girls' schools where we were expected to speak up, I often felt ridiculed when I raised my hand and offered my opinions. I preferred the familiar ambience of literature classes filled with girls and often taught by female scholars, so I decided to become an English major. I rationalized that it was because of my love of reading, but there was another, unspoken reason, too: before the days of gender studies, it was the best way to read the words of women. I had grown up with novels like *Little Women*, and when I got to college I wanted to read more women's writing. My greatest admiration was for the pristine, aesthetically charming style of Virginia Woolf, and after the death of President Kennedy I borrowed several of her novels from the college library to immerse myself in the subjectivity, interiority, and sensitivity of her fictional voice during Christmas vacation. One of them was *The Waves*, where I felt enraptured by the stream-of-consciousness voice, like that in a journal.

That fall I had heard about an intriguing new book, *The Feminine Mystique* by Betty Friedan, and during the holiday I made a trip to the Brown University bookstore in Providence and bought a hardback copy. Instead of being absorbed by the feminine sensibility of Virginia Woolf, I began reading Betty Friedan's didactic, fact-filled, passionate polemic about why American housewives should find fulfilling work outside the home. A groundbreaking work that heralded second-wave feminism, it set "my mind going in a million directions," my journal says.

It is difficult to understand today how different everything was when relatively few middle-class wives had careers. It was mostly an either-or choice—working or mothering—the way it had been for many generations. Almost everything I read in

the alumnae news about my boarding school classmates and older graduates was about their early marriages and newborn babies. I remember being dismayed when a college classmate acknowledged that "men have all the power" and said she wasn't going to challenge it, but it was the prevailing ethos. My resolve to hold on to my own individuality after marriage remained difficult to imagine. I wanted "to be independent for a couple of years—working—before I merge my identity with some man's," I noted, believing that despite the reforms urged by Eleanor Roosevelt it would be impossible to work outside the home and tend young children at the same time.

As I turned the pages of *The Feminine Mystique*, it was as if I were reading about my mother's homebound life: her dependency, misery, and barely concealed anger. I underlined many passages, including the shocking statement that a housewife in suburbia was actually living in "a comfortable concentration camp." My urge to find a purpose in life beyond marriage and motherhood had felt like a private quest, but now a woman was declaring that my desire for a life different from my mother's was neither aberrant nor mine alone. Friedan encouraged me to keep defying what "everyone says I should be—and keep searching for what is <u>also</u> (besides loving, home, and family) my work! I <u>do so much</u> want to have a serious commitment in some area. I would die being merely a housewife. Emotionally and mentally the whole idea PANICS me." After I finished reading the book, I gradually began trying to untangle myself from my mother's model—and her wish for me to marry and live nearby.

I underlined other parts of *The Feminine Mystique* about the modern woman needing to discover her own identity as an individual to be truly happy. When I got to the place where Friedan stated that marrying at a young age was a way of avoiding this discovery, it made me resolve once again not to rush into marriage. If I did not develop a firm identity at my

present age of twenty-one, I thought, I might have to do it at the "advanced age" of forty, when I imagined it would be more difficult.

Meanwhile, in a philosophy class I was reading John Stuart Mill's ideas about individuality in *On Liberty*. It was eye-opening to discover that Mill, also the author of the feminist treatise *The Subjection of Women*, had not excluded the female half of the human race from his definition of personhood like so many males in the past. The nineteenth-century English philosopher's thoughts underscored Friedan's twentieth-century feminist theories, notably her argument that a woman needs independence to develop an identity. And to do this, I had to think hard. Mill's thoughts made me feel the thrill of experiencing the life of the intellect. "Hovering on the edge of intellectual enlightenment is the most exciting thing in my life right now," I confided to my journal, reminding me "why the housewife syndrome literally petrifies me, and why reading *The Feminine Mystique* was so joyful."

7

Love or Liberty

Another bestselling title at the time was Helen Gurley Brown's *Sex and the Single Girl*, which gaily and glibly advocated sexual freedom and financial independence for girls like me. Whereas Betty Friedan urged us to find rewarding work, Brown wanted us to have fun and seduce rich men. It was startling advice, and I was too cautious and idealistic to take it. At twelve my romantic fantasies about older boys had made it difficult to imagine postponing lovemaking until I was married, which I thought would be around twenty-one, the age I now was. If I gave in to my erotic longings, I worried, it might open a Pandora's box of desires and dangers that would distract me from getting a diploma. I had plenty of warnings about what might happen: every one of my five older female cousins had either not entered college or had opted to leave college in order to marry. I understood that marrying could happen involuntarily, too, at a time when contraception and abortion were illegal and difficult to obtain, and pregnancy outside of marriage was regarded as

deeply shameful. A year earlier, in fact, my spirited and talented musician roommate had abruptly dropped out of Ohio Wesleyan before getting her degree, to marry her boyfriend and give birth to a son. Although I was eager to make love, I remained resistant to the idea of getting married.

I had explained to the boy in Paris that I was abstinent because I was determined to educate myself—"to develop a reservoir of mental richness to last the rest of my life"—and he had ridiculed me in a letter as "the little scholar." I ignored his teasing because of my reading, which included the idea in Plato's *Republic* about being "independent via self-discipline." At moments when I believed I was being true to myself by letting my brain rule my body, I felt "so full to the brim with joy, strength, and enthusiasm that I feel I must burst." After reading Erich Fromm's *The Art of Loving* about a satisfying sexual life being an expression of intimacy, harmony, and trust between a man and a woman, I had also told the boy that I regarded lovemaking as a serious commitment. My ideals battled with my libido, however, and I wondered if I could hold out long enough for that kind of relationship. It's not that I wanted to choose between what I described as "a dry, dead intellectual life" and a passionate love affair—I wanted all "the realms of the mind and the heart"—but it seemed impossible to have both at the same time. When the boy, who had flunked out of college, asked me to spend my spring semester with him in France, I turned him down, even though I had adored the romantic film *April in Paris.*

That winter in Ohio, desperately missing Italy, I read *The Italians* by Luigi Barzini and went to every Italian film that came to the movie theater near campus. I also signed up for a class in the Italian language and enrolled in a course about Italian literature in Vicenza the following summer. I loved the warm rhythms of the language, especially the way I was permitted to pronounce every rolling syllable. When I played Italian

opera arias on my record player, the soaring sounds made me feel unbearably restless as I struggled for the patience to ignore my dreamy yearnings and to study until I could return to Europe. "A million thoughts are going through my mind tonight, so fast I can't record them," I noted one evening in my dormitory room while going wild over words in my thesaurus and writing poetry for the college literary magazine. "I have decisions to make that take time," I later reflected, aware that I was preparing myself for something—hopefully for becoming a writer—before knowing how to make it happen.

By springtime it was even more difficult to study or even settle down and write in my journal. Many afternoons I went horseback riding with a roommate at a nearby stable, elated by moving through greening pastures and budding woodlands that were coming alive after the winter. One day there was a newborn colt in the intoxicatingly pungent barn struggling to stand beside its mother, making me forget all about what I should be reading for my classes the next morning. "Oh, the days seem to pass so slowly: day by day they plod along—when I want to fly—exalt—but am held back by time that moves slowly—forcing me to study—when I want to be," I complained in my private pages. "How am I going to endure the discipline of being a student for another year?? Somehow I must." While oddly oblivious to a long list of books I was supposed to be reading as an English major for oral examinations the following year, I maintained enough discipline to pass my spring exams. Looking back, I realize that those days in college were the beginning of the development of a diligence that would eventually mature into the drive and tenacity necessary for the writing life.

That year at Ohio Wesleyan I was dating a nice college boy with dark Italian looks who made me, an essentially fatherless daughter, reflect that "when a man shows deep tenderness and affection for me—it moves me deeply—beyond words—to the

core of my being." I tried to remember what I had read in *The Feminine Mystique* about love alone being unable to fill a woman's life, but sometimes during that spring it was difficult to believe. At other moments I was determined to pull away from him enough to return to Italy. We necked a lot but were careful not to "go all the way," the euphemism used for intercourse then. My mother had written me at college about the importance of keeping my "respectable, lovely feet on the ground" during dates, and I somehow managed to do it.

Back in Rhode Island after the semester ended, my fourteen-year-old sister, Abigail, whom I only saw on school and college vacations, trotted upstairs to my top-floor bedroom to report that she had overheard Dad tell our mother that he doubted I would ever marry. To this day I'm not sure why he said it, but it was probably because the phrase "career woman"—which he evidently understood I wanted to be—represented an epithet to old-fashioned men like him who believed that wives shouldn't work outside the home. Even though I wasn't ready to marry, like any young woman I wanted to be assured of my lovability by a man. So, his judgment was devastating to me, and my eyes brimmed with tears while I attempted to reason with myself that he was wrong.

Soon I was back in Paris for a few days en route to Italy, where a professor at Scuola Vicenza took me to the modest home of a short, balding, middle-aged artist named Giancarlo. I was a little apprehensive about staying there because I was alone with him—his wife was away, and my roommate was delayed—but as it turned out I had nothing to worry about. He displayed a gentlemanly gentleness toward me, as he talked in halting English, and I tried to turn my textbook Italian into spoken sentences. After a day of lackadaisical classes, sometimes held outside in a café in the piazza with a view of Vicenza's magnificent Palladian basilica ("like a great inspiration, a great idea suddenly looming up," I observed), I would take a bus back to

Giancarlo's house. Like other artists I had known—Mr. Conti in Providence and Uncle Billy in Assisi—he was enjoyable and even exciting to be around. In the long, light-filled evenings he would play the gorgeous sounds of Vivaldi on his record player while he boiled pasta and poured chianti for us. One night he took me on the back of his Vespa motorbike up into the softly rolling green hills around Vicenza, where he pointed out a hidden lake, and I picked orange blossoms in the moonlight. His fatherly warmth made me inexpressibly happy, and something deep inside began to heal.

One night a week or so later my roommate arrived with the news that we were going to be moved from Giancarlo's house. At that very moment, she said, the elderly Italian-American professor, who was the chairman of Ohio Wesleyan's Italian department and director of Scuola Vicenza, was on the veranda telling Giancarlo this. Astonished and upset, I hurriedly dressed and went out and, interrupting them, tearfully protested: "I don't want to leave! Why do we have to go?" It was rare for me to make an emotional scene, and I was surprised by my own impulsiveness and fury. It was all for nothing, and the next morning Giancarlo presented the two of us with signed prints made in his basement studio to remember him by, explaining that because he was an artist, separated from his wife, and with Communist sympathies, we had to go stay with other families.

At the beginning of class that day, the director stood in the elegant high-ceilinged room with a marble floor where we also met, and announced in front of everyone that he was expelling me from Scuola Vicenza. Stunned and humiliated, I realized that my act of defiance had enraged him. Maybe he thought that Giancarlo had seduced me. Certainly, he was worried about Scuola Vicenza's reputation back in the conservative Midwest. My punishment for speaking out was "so absolutely terrible that it almost amuses me," I wrote, as I tried

to protect my sense of self. It was as if this had happened "to the person the world sees me as, while the person that I know I am—or potentially am—is <u>untouched</u>." A few days later a professor intervened on my behalf and the director apologized and retracted my expulsion. I didn't know whether to remain in Vicenza, travel alone around Europe, or return to Rhode Island. My stoicism and pragmatism finally won out, and I decided to complete the course for its academic credits so I could graduate early from Ohio Wesleyan the following spring.

After the course ended, I boarded a train for a student hostel in Milan for a few days before returning to Providence. The breathtaking beauty of the long orderly row of graceful archways and rooftop row of statues in Vicenza's basilica had appeared to me as the epitome of serenity and balance, but now their memory stood in contrast to the chaos raging inside me. I was still so shaken up by what had happened at Scuola Vicenza that a young, black-robed Italian priest leaned across the aisle and asked half seriously—since I looked so sad and subdued, he said—if I was on my way to a convent. A month earlier, the boy in Paris had remarked as we strolled on the Champs-Élysées that I seemed as buoyant and free as a bird, but after the trauma in Vicenza, I felt as if my wings had been broken.

My self-discipline during the winter had mutated into self-silencing over the summer, a dangerous kind of wordless-ness for a writer. I regret now that I wrote little in my journal about my experience at Scuola Vicenza because using words might have enabled me to understand my emotions better and given me more material to write about later. At the time, how-ever, it was too threatening to think about: my outburst and then my punishment because of my friendship with an older married man. I was confused about my feelings for him; while still in Vicenza I had wondered if my desire for this unprepos-sessing artist's kindheartedness would become amorous, so I

had avoided seeing him again; the last time we met was the day he stopped his motorbike to give me a postcard from my college boyfriend. My relationship with myself—severed between an exterior persona and the real person inside—became uneasy, and enabled emotional repression. When I started the journal nine months earlier, I had wondered if I would be able to sustain the honesty it demanded; at the end of August in 1963 I wrote a final entry, then put it away for five years.

8

Reporting in Rhode Island

Back at college for my senior year, I thought there were three ways for an English major to earn a living: teaching, working in publishing, or writing for a newspaper. To me it was no contest—I wanted to be a newspaper reporter. Maybe I got the idea in childhood from a comic-book character with the same initials as mine—Lois Lane, Superman's glamorous and adventurous girlfriend—who worked at a newspaper called *The Daily Planet* in a skirt suit, pearls, and a little hat. Or perhaps it was the photographs of daring female photojournalists in *Life*. Whatever the reason, my ambition was influenced by the newsman I had known as a teenager, who had reported about racism in the South and made investigative reporters look to me like heroic truth tellers. I remembered how much I liked writing off the top of my head in high school, too, so the idea of daily deadlines didn't bother me. And reporting for a newspaper would also be a way to satisfy my intense curiosity about

what I regarded as "real life," because I believed that reporters could ask anyone about almost anything.

When I was a college freshman, my interest in journalism had motivated me to go to the editorial office of the student newspaper to ask for an assignment, but an upperclassman asked me to do something so silly—find out which sorority girls had gotten "pinned" (given a boy's fraternity pin) that week—that I didn't bother to do it. It appalls me today that I was so easily discouraged and never went back to ask for a better story to work on, but I didn't think it would make any difference. Fortunately, in junior year a friend's mother, who had heard about my interest in reporting and worked on the business side of *The Toledo Times*, took us to visit its newsroom, where the electricity in the air excited me all over again about working for a newspaper.

In senior year I mentioned my interest in journalism to my stepfather, who happened to know the publisher of *The Providence Journal.* Like all the men in my extended family, both were members of an elite gentleman's wood-paneled club in a gloomy neo-Gothic brick building in Providence, the Hope Club, where on Ladies Night wives had to enter through the back door. The club had an intimidating wall of black-and-white formal photographs of its past presidents—all unsmiling balding or gray-haired older men who looked ready to defend the privileges of patriarchy. One day when Dad was having lunch there, he asked his publisher friend about a job for me, probably motivated by his worry that I would never marry and needed to earn a living. When he telephoned me at college to say he had found me a position as a "copy girl" on the Providence paper, I was thrilled. I had no idea what a copy girl was, and I doubt he knew either, but I was glad for any job at a newspaper.

I graduated early in March 1965, eager to leave Ohio Wesleyan and begin a career in journalism after seven winters

away from Providence. I had read the city newspaper from an early age, and had also appeared in its society pages—at two with my mother at the beach, at eight with my two-wheel bicycle, and at nineteen as a debutante. Now five days a week I steered my black Volkswagen Beetle—bought secondhand with war bonds given me at birth—along Angell Street, past the frightening stone wall of the asylum, past my former girls' grade school, past the dancing-school hall, past my step-grandparents' white mansion, and, as the street began to dip, perilously close to an enormous eighteenth-century white Georgian church with a gigantic carved steeple, and down steep College Hill to the newspaper building.

Everything appealed to me about the brick building with its graceful Palladian windows, where news was written upstairs in an enormous newsroom and printed below in the basement: the pervasive smells of ink and newsprint, the sounds of the staccato clacking of manual typewriters and teletype machines interrupted by news-alert bells, even the sight of balls of crumpled newsprint scattered on the dirty floor around wire wastepaper baskets. What I liked best was the sense of urgency among the newsmen as morning and afternoon deadlines approached, and the satisfaction when the latest editions were brought upstairs. Absorbed by all the goings-on in the newsroom, I didn't even bother to go back to Ohio for my graduation day, and the diploma I had been so determined to get eventually showed up in the mail.

At fourteen I had found babysitting boring, and at eighteen I expected to raise two children before getting a job, but after I read *The Feminine Mystique*, motherhood became less important and a career more so. While the feminist manifesto had encouraged numerous college girls like me to pursue professional work, it remained a difficult and discouraging time to do it. Help-wanted newspaper advertisements listed jobs by gender, and those for women who could type were mostly

secretarial. Five years earlier, *The Providence Journal* had published an article, "Reporting Still a Man's Business," justifying why "a young lady's chances of being hired as a reporter" were "very slim" in New England. It stated that newspaper editors believed that "the nature of the work and the nature of the female" were incompatible and, even if it turned out that they sometimes were not, it would be a waste of time to train females because they would leave jobs to marry. When another girl from the East Side working at the paper that spring and summer announced her engagement and resigned, it must have affirmed the editors' expectations. And without seeing women reporters in the newsroom, I had no role models. All I had was a wavering determination.

After a few weeks of carrying typewritten "copy" from reporters' to editors' desks in the newsroom, I complained about my lowly job to a guy my age who had just been hired as a reporter. In an effort to help me, he pounded off a patronizing letter on newsprint telling me to learn the tools of the trade by reading books about journalism. He also urged me to "consciously and persistently" ask editors for a promotion, while at the same time not letting them intimidate me "however much they may try to hold you back" because procrastination would undermine my ambition. His misgivings about my resolve were evident. "If you have a real and insistent motivation, something I quite honestly doubt, then you will do this. If not, not." It was the first career advice anyone gave me and, despite his condescension, I carefully saved the letter. Unfortunately, it didn't embolden me. It's said that the lack of an engaged or encouraging father leaves daughters without the ability to confidently make their way in a male world of work, and this was certainly true in my case. A few months later my friend left Providence after getting a better job at a Connecticut newspaper, and it was the end of his misguided advice.

Luckily, the managing editor's secretary noticed that I looked out of place in the newsroom—a college graduate rushing around in a skirt and high heels along with younger copy boys—so she said something to her boss, and after a month or so I was sent to another floor as an editorial assistant to write up engagement and marriage announcements for the Women's Page. Since I found describing endless white wedding dresses and veils very tedious, I began reading and reviewing new books publishers were sending to the newspaper, especially those about wives who worked outside the home. That summer some of my book reviews were turned into feature stories and printed under my byline. Not until I left Providence was my discomfort with my name defused. Now back in my hometown, instead of my name representing the broken link to my biological father, the letters spelling out the two little words in boldface type gave it a different and much better meaning than before. A byline meant that I had written something noteworthy, and it gave me an enormous sense of pride.

It wasn't always easy for me to get one, however. The women's and arts departments shared a large room, and one day I spotted an announcement about an art exhibition in nearby Worcester, Massachusetts, by an artist represented by the same Manhattan art gallery as my step-uncle. The abstract painting on the invitation intrigued me: a large expanse of sky blue with curvaceous edges on a pure white background. I telephoned the gallery and made arrangements to see the show and interview the painter in the lobby of his hotel. The artist turned out to be an attractive man with brown eyes around the age of forty. After we had talked for a while and I had closed my reporter's notebook and was preparing to leave, he looked me in the eye and invited me upstairs to his bedroom, telling me that the bed had four posts, as if that would make it irresistible. Astonished, I stared wordlessly at him, dismayed that he hadn't taken me seriously as a reviewer.

I drove back to Providence and wrote a review of his exhibition; out of inexperience I gave the carbon copy instead of the top sheet to the tall, blond male arts editor, whose response was to announce loudly, "I never read copies." Maybe he thought I was too young or too ignorant to write about the work of an up-and-coming Minimalist artist who had recently been included in the Museum of Modern Art's prestigious "Sixteen Americans" exhibition. Whatever the reason, my article never ran, and I never attempted to review an art show or anything else for the arts editor again.

In July, after the number of weddings to write up had diminished, the Women's Page editor, a thickset older woman who always wore a hat, asked me to take over the newspaper's Inquiring Photographer column. I eagerly agreed, inspired by the pictures taken by women photographers in *Life*. Carrying a heavy news camera with glass plates, I began to explore neighborhoods in my hometown I had never seen before, even though they were not far from the East Side. After my summers in Italy, I was especially interested in the long-established large Italian section called Federal Hill. I was vaguely aware of the city's Italians because of the old hurdy-gurdy man who used to show up on Williams Street and the genial greengrocer who drove his truck to our kitchen door on Angell Street. Also, the only Italian-American girl in my grade school class always brought delectable sugary doughnuts and other pastries from her family's Federal Hill bakery to school events. Now it was where I went with my camera as well as for pizza and to drink chianti with friends.

One time on Federal Hill I interviewed Italian dance-band musicians about the annual summer Newport Jazz Festival, and I was surprised and pleased that they admired music so different from their own. As a teenager, I had been taken to the festival by my parents and other relatives as an act of daring to hear renditions of the blues by Ray Charles, Mahalia Jackson,

and other African American musicians, and soon afterward I began playing Chuck Berry recordings at boarding school. As I recall the polite adult audience in dresses and jackets and ties, I remember the mayhem only a decade later in 1969 at the Woodstock music festival during folk, rock 'n' roll, and blues performances, the huge hippie rebellion in the middle of the Vietnam War.

As I made the rounds of Providence's neighborhoods, I learned more about the underbelly of the small state where my parents and I had been born and brought up. George Washington had long ago nicknamed the state "Rogue Island" for its pirates. A senator on the take during the Gilded Age had enabled the erection of a grandiose white marble statehouse with a dome as colossal as anything in Rome. Completed in 1904, it was the same year muckraking New York newspaperman Lincoln Steffens published *The Shame of the Cities* and charged that "Rhode Island is for sale, cheap," also around the time when both sets of my grandparents settled in the state. Mobsters also moved in, some of whom became notorious throughout New England. The coexistence of large Yankee and Mafia clans in the small city now strikes me as curious. As far as I know, the families engaged in legal and illegal activities kept their distance from each other on their separate hills, but I cannot help wondering if they profited from each other's presence in some nefarious way.

The goings-on in Providence were as fascinating to me as they would be to writers like Geoffrey Wolff, the author of a novel titled *Providence*, who over the years would use the city as a backdrop for mysteries and thrillers, and an off-Broadway musical, about its gangsters, cops, brave newspapermen, and even girl reporters. Once, when reporting for the Inquiring Photographer column with notebook in hand and camera around my neck, I innocently rang the doorbell of the home of what I later realized was undoubtedly a crime family: the

dark-eyed woman who opened the door stared incredulously at my camera and me for a moment before quickly slamming the door in my face. Still, running around with my camera and notebook was wonderful training for a young nonfiction writer-to-be on the leading edge of the wave of young women of my generation who were entering the workforce in large numbers.

9

Loss of Words

It was time to finally get rid of my embarrassing state of virginity, so I talked my mother's gynecologist into giving me the new contraceptive pill. It wasn't easy, since it was only meant for married women in Roman Catholic and conservative Rhode Island, but he reluctantly gave in after I asked if, without it, he would give me an abortion. After I rented a tiny apartment on the ground floor of a run-down Victorian house in a student neighborhood on the edge of College Hill, I wrote to my college boyfriend in graduate school in New York, saying that while I didn't want to marry him, I wanted to have an affair. I had almost fallen in love with him at college, but I was bothered by his support for Senator Barry Goldwater, who opposed civil rights legislation, while I was handing out leaflets backing President Johnson's 1964 election. My bold proposal never got a reply because, I later learned, he was about to marry a blonde classmate from the Midwest.

Thanks to a brooding artist in his early thirties, whom I met at the opening of an art exhibition at the museum of the Rhode Island School of Design, I managed to get deflowered, but not in the romantic way I had hoped for. Ben was definitely not the kind of boyfriend my mother had envisioned for me the evening of the debutante ball: he was gaunt, swarthy, self-absorbed, and without the vivacity of other artists I had known, probably because he was getting divorced. Still, he was an artist as well as Italian-American, both qualities that appealed to me. What I didn't know as he drove me around town in his red Alfa Romeo convertible—including to his elderly mother's apartment on Federal Hill—was that he was about to move to Manhattan. When we lost touch a few months later, I was surprised but not very disappointed. And after his death more than three decades later, I was astonished to see examples of his work at a small midwestern college where he had taught: marvelous large pale plaster reliefs of dancing girls with long flowing locks struggling to free themselves from diaphanous veils. I idly wondered if, when talking to him about my aspirations during that summer long ago, it was how he had perceived me at the age of twenty-two, as I was trying to find my way in the world.

At the end of the summer I was inexplicitly assigned to a grubby little *Providence Journal* news bureau outside the city to answer the telephone, type up public records, write obituaries, and take care of other minor matters for the three male reporters who worked there. At a time when women were beginning to move into once all-male workplaces, it was before anyone knew what to expect. When I told my grandmother, Gaga, that I was working alongside men I didn't know socially, she was scandalized but said nothing, and her sharp hooded eyes gave me a searching look. I thought her attitude was amusingly old-fashioned, but it turned out she had reason for alarm.

Ned, the newsman in charge of the bureau, was a warm, amusing, married man about to turn forty, who called himself a swamp Yankee from Cape Cod. Eager to learn the ropes and become a reporter, I was glad when he encouraged me to do more than secretarial chores—to take photographs and write short feature stories—and when he took me along with him on reporting assignments in his little aquamarine Volkswagen Beetle. All went well until the time in the car when he put his hand on my thigh, and I understood that he had another agenda besides mentoring me in the newspaper business. Upset, I tried to ignore what the gesture meant; it was two decades before laws against sexual harassment existed, and I didn't know whether or whom to tell. I didn't want to quit the job either and, furthermore, I wanted him to recommend me to the Columbia University Graduate School of Journalism in New York, where I had applied as a way to get ahead.

Maybe word got around about his flirtatious attitude toward me because soon I was sent to a smaller suburban news bureau, where I began working as a de facto reporter. It was empowering to telephone people and tell them I was from *The Providence Journal*, so I enjoyed myself, even though I was assigned the weekend and nighttime graveyard shifts, and my interviews, photographs, reports about fires, arrests, and town meetings appeared regularly in the newspaper. But the managing editor had neither given me a raise nor promoted me, and I lacked the nerve to take my former colleague's advice and boldly walk into his office and make demands. When Columbia turned me down—I later learned it was taking fewer than one female for every ten male applicants—I began to think I should give up my ambition to be a newspaper reporter.

After volunteering with the Quakers, I had become interested in social work—and, later, inspired by President Kennedy's ideals—so I took a test for the Peace Corps in Providence's cavernous marble federal courthouse. A month or so later a letter

arrived saying I had been assigned to Guatemala, but I suddenly
felt reluctant about giving up my newfound independence—a
salary, an apartment, and a dark green Karmann Ghia, a low-
slung sports car with an elegant Italian design and a sturdy
Volkswagen engine—to face the unknown for two years. I had
struggled with French and never studied Spanish, so I worried
about becoming wordless in a strange place. Maybe I sensed
that social work would require me to turn my attention out-
ward, whereas writing was more about looking inward. A few
weeks before I was supposed to leave Providence, I crumpled up
an airplane ticket to Albuquerque for training at the University
of New Mexico. It was one of those moments, in retrospect,
when a decision makes a life's direction diverge dramatically,
and it was one I have remained uneasy about. Seven years
later, when I traveled to Guatemala at Christmastime and was
intrigued by its smoking volcanoes, deep lakes, vivid Indian
culture, and red poinsettias growing alongside mountainous
roads, my doubts were reinforced about missing that flight to
Albuquerque.

When I had returned to Rhode Island from college in
Ohio, I wanted to reach out to my father in Vermont. One
Thanksgiving at my grandmother's he had made an awkward
attempt to explain his standoffishness, stiffly saying that it was
not because of "a lack of affection." His few stilted words on
that day, undoubtedly spoken at the prodding of his friendly
new wife, had nonetheless made my eyes tear up. "He wants me
to love him, and I feel he loves me very much," I noted after-
ward, and I vowed "to try to make him realize that I love and
respect him—which I felt I really did for the first time."

When I drove to Vermont to see him, I found a depressed
man in a heavy wool woodsman's shirt who was trying to sup-
press his disappointments with alcohol. Unable to sell enough
reproductions of the New England antiques he admired, he was
manufacturing chunky chairs with hearts cut in their backs

for ski lodges. Still, I found his presence very moving. When I looked into his hazel eyes, the same color as my grandmother's and mine, I experienced a heightened emotion that felt biological in nature—like an intense awareness of our blood bond—making the air between us seem to vibrate; if he felt it, too, it evidently upset him because maybe he feared it was erotic. Dining that evening on ducks and deer he had shot, as I pulled shotgun pellets from my mouth I timidly tried probing the past. My mother had mentioned the guarded Yankee's way of making deeply hurtful remarks to her, and now it turned out to be my turn. After more than a few drinks he blurted out that he might not have left my mother and me if I had been a boy. It was such a cruel comment to make to a daughter—either grossly insensitive or subtly sadistic—that I could only interpret it as a way to silence me, which it effectively did, and I stopped going to see him for more than a decade.

While working at the *Journal* and being romanced for months by telephone calls from my former news bureau boss, I finally, against my better judgment, let him take me out for a drink. More persistent and persuasive than the guys my age I was dating, he also offered an irresistible emotional openness unlike any of them or either of my fathers. After the devastating visit to Vermont, I felt desperate for the attention of an affectionate man, especially from an older man with hazel eyes like Ned. As we went out more often, he warned me that a love affair between us would eventually have to end, but at last I was willing, partly because what I felt for him was like the sorrowful love for my biological father. Passed over for a promotion at the newspaper, Ned soon took a job as a news director for a television station in Boston, and I wanted to follow him there. After a year and a half at the newspaper, I finally went to see the harried managing editor, but it was not to ask to be named a reporter but to offer my resignation. A look of relief swept over his face, as if he hadn't known what to do with

a marriageable young female from the East Side on the staff, which confirmed my pessimism about getting a promotion.

At first our affair was nothing out of the ordinary for him—a Don Juan who should never be married, his friends said—but it deepened more than either of us expected. He would write me after it was over, "I instigated a relationship with you cynically (let me be brutally honest with us both) and with no belief in love," but "my cynicism is gone and my soul is riven with a profound love." I felt a wild joy in his arms, nourished by the intimacy and the intensity of our lovemaking. Loving and being loved by a man as never before made me feel for a while as if nothing else was necessary.

In Boston I lived with Ned on weekdays, while he returned to his nice Quaker wife and three young sons in Rhode Island on weekends. I heard about attendant jobs at McLean Hospital, a nearby private psychiatric hospital, and for reasons I cannot completely comprehend even now, I began working on its women's ward. It's true that I was still drawn to social work, but something else was also going on. The idea of insanity had frightened me in grade school when passing the impenetrable asylum wall on Angell Street, so did I want to overcome my fear of it? Or, feeling as if my brain had become suspended from my body, did I want to find out if I was crazy, too? Did I want to punish myself for the illicit affair? Whatever the reason, knowing mental patients made me ponder the line between normality and abnormality, or whatever it was that allowed me and not the girls and women on the ward to hold a large ring of keys to locked steel doors. What acts of irrationality or immorality separated me from them? Fearful of psychosis but also fascinated by it, I lingered in the office to read patients' case histories—noting that some were angry wives and others the aging wives of psychiatrists—until I was told to stop. What rules for women, written or unwritten, had they broken? Were they too outspoken? Did they use words too dangerously?

My winter months at McLean overlapped with those of a teenage patient, Susanna Kaysen, who wrote about her experience in the hospital in a memoir, *Girl, Interrupted.* I don't remember her, but I was especially disturbed by meeting those near my age. They appeared normal to me, making me wonder if they were heavily medicated or maybe misdiagnosed. "In a strange way we were free," Kaysen wrote about her time at McLean. "We'd reached the end of the line. We had nothing more to lose. Our privacy, our liberty, our dignity." It was definitely not the kind of freedom I wanted for myself. Although at moments I feared that I had lost my mind—as well as my way—the patients' imprisonment terrified me. After a young psychiatrist I had never spoken with invited me into his office one day and bluntly propositioned me, I asked myself who should be inside and who should be outside the mental hospital. I finally realized that if I wanted to stay on the side of sanity, I had to end the earthshaking affair. The ending was difficult and drawn out, but after Ned dreamed about wrecking my Karmann Ghia with me in it, he finally let me go.

Back in Providence and at a dead end, I realized I had fallen in love with the wrong man, but I had not yet learned all the reasons why. Although I didn't think about it this way then, an affair with a married man was a deliberate way to break the gender rules I was raised with and declare my freedom from them. For a while I had believed that Ned was my most trustworthy friend, but it was a false perception, and it took me a long time to understand that harm can easily occur in the guise of love. "You have both the capacity for deep love and for being easily hurt," he would later write me, still insensitive to the painful position, one of secrecy and shame, that he, as a married man, had put me in. I had wanted him to mentor me as a reporter, but he had seduced me instead. The winter in Boston was also a lost time for me as a writer. I was putting no words on paper, not even in a journal. Pages of a journal

were a place for honesty, I knew, and since I was unwilling to tell myself the truth, I stayed silent. I had damaged my dream of becoming a writer by walking away from a newspaper job where I was earning a living by writing in my own name, an opportunity I would not have again for a long time.

Nevertheless, returning to Rhode Island after college and working at *The Providence Journal* had enabled me to better understand my roots, an important deepening experience for a writer-to-be. Grasping where you are from and how you were formed is a way of solidifying an identity and establishing a strong foundation on which to build a lifetime of words. Going back home had reminded me of my early happiness on Williams Street, the old street named for Roger Williams, the state's founder. It also made me proud of my name. Most important, it helped me decide what to reject and what to revere about my background: I disliked my relatives' snobbery but admired their philanthropy; I was repelled by their Republican politics but liked their industriousness; and I wholeheartedly shared their liberal religious beliefs. Everything I had done in the six years since the debutante ball had added up to a belief that I could take risks and, if they didn't work out, I could recover and begin again.

Reflecting that I was glad to have been born and brought up in Rhode Island, I was also glad to be going. The only place to go, I decided, was New York City. Its energy had always exerted a magnetic pull on me, and while its enormous size once frightened me, it didn't anymore. It was the only place where I thought I could learn everything about whatever I wanted to know—and learn about it in extraordinary depth. The day before I departed, I drove to a grassy park on a hill overlooking downtown on the street named for my stepfather's family. I stood beside a heroic stone statue of Roger Williams with an arm outstretched, as if blessing his city. It was reassuringly recognizable: the gorgeous white wooden Georgian

church and steeple, the magnificent white marble statehouse, the high Biltmore Hotel a block away from the handsome brick newspaper building. My suitcase was packed, my furniture was stored, and I was about to leave my Karmann Ghia in my grandmother's garage. I had driven the route from Providence along the Connecticut coast to Manhattan a number of times, but I had always returned after a few days to the familiar streets of the pretty little city. That autumn as I prepared to go, a few days after my twenty-fifth birthday, it was with a stony determination to stay in New York.

MANHATTAN

10

The Making of a New York Feminist

Like so many other young Americans who over the decades had fled provincial hometowns for the promises of big metropolises, I arrived in Manhattan with high expectations. I unpacked my suitcase in a minuscule bedroom in a residential hotel, the Pickwick Arms, near my new job in midtown. Back in Providence I had pursued my interest in design and written to architecture and decorating magazines and, in my eagerness to leave Rhode Island, had taken the first job offered. It is still a mystery to me why *Interior Design* hired me so quickly, since I knew nothing about the decorating business, and I only lasted a year there.

It was exciting to be living right in the middle of the vertical city, like being inside a giant engine always revving up its motor. On my lunch hour I liked to look at the new hardback titles in Scribner's elegant art deco bookstore on Fifth Avenue, where the name of the famous publisher was inscribed in gilded letters on the façade. I also ventured up the marble steps

of the New York Public Library a few blocks away, into what felt like an enormous temple of learning. Manhattan was often visually stunning. While waiting for a downtown bus across from St. Patrick's Cathedral one late afternoon, I noticed the way the low sun washed its ornate exterior with pastel light, creating deep shadows and bright highlights, reminding me of Monet's many paintings done at different times of day of the ancient Rouen cathedral. As I walked along the crowded sidewalks looking at displays of elegant clothing in the windows of Saks and other department stores, I was elated to feel a simultaneous sense of both privacy and freedom.

After a month or so I heard about a girl, a friend of a family friend, who was looking for a roommate in her ground-floor apartment in a West 11th Street brownstone with a brick wall and a flagstone patio. I was overjoyed to move to Greenwich Village; during college a boyfriend had taken me to a dimly lit Village restaurant, Chumley's, a former speakeasy that still had no name over its door on the bottom floor of another brownstone. Inside, framed dustjackets of books by regulars hung on the brick walls, while interesting-looking men and women in dark sweaters sitting at little tables, enveloped in a smoky haze, were talking intensely to each other. As we were escorted to a table, my black mohair sweater blended right in, but not my white pleated chiffon skirt, so I was given some curious looks, but I didn't care because I was so attracted by the electrifying bohemian atmosphere.

After work I loved emerging from the din and darkness of the Fourteenth Street subway station onto the quiet tree-lined blocks of the West Village. On the walk to the apartment I passed stands offering flowers, bookstores, small shops selling baskets and handmade jewelry, and newsstands crammed with issues of *The New York Times*, *The Village Voice*, intriguing literary journals, and foreign periodicals. Little clothing shops displayed imaginative creations in their windows, too;

one Saturday I returned home with an ankle-length burgundy wool coat fastened with a single crocheted button in front and a saucy tassel on a detachable cape in back, which I thought was the perfect outfit for my new life in New York.

In the early months of 1968, headlines and front-page stories in the newspapers I was buying daily were bluntly informing me about what was happening around and beyond my peaceful Village block: protests against the Vietnam War, notably uptown at Columbia University, where hundreds of angry students took over administration buildings before police arrested them. The headquarters of the Village Independent Democrats was a few short blocks away from the apartment, and during those months I began climbing stairs to its crowded second-floor meeting room. Listening intently to the fiery debates but saying little, I learned that the leftist political club was supporting the peace platform of Senator Eugene McCarthy in a primary against President Johnson. I volunteered for the insurgent campaign, and at the candidate's Columbus Circle headquarters had the chance to shake McCarthy's hand and tell him I was glad he was running. "Thank you for saying that," was his reply, a tepid response that surprised me as a political novice.

By spring the unrest tearing the country apart intensified. In April I was horrified to read about Martin Luther King Jr.'s death—a man of peace gunned down in cold blood—and the enraged rioting in hundreds of cities around the country. Incredibly, the civil rights leader's shocking death was followed in June by the murder of Attorney General Robert Kennedy, another antiwar candidate running for president. The terrible losses of King and a second Kennedy made me feel that after the assassination of the president five years earlier, senseless violence was destroying everyone I admired in my country.

I was also reading about the women's liberation movement. While Betty Friedan had used the unfamiliar word "feminism"

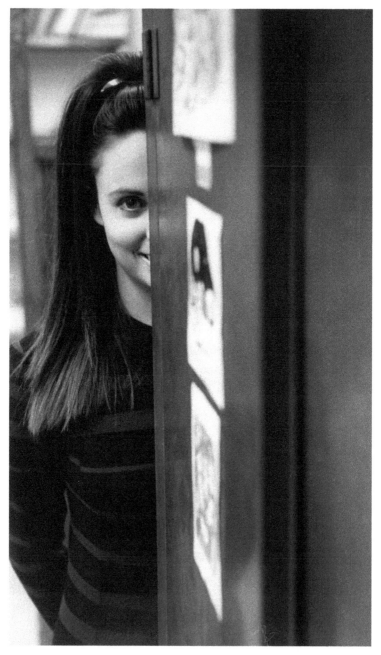

Laurie working at her editorial job in New York City around 1970.

in *The Feminine Mystique*, now I was seeing the strange term "sexism" in *The Village Voice*. While this word was also new to me, what it meant—after growing up feeling inferior because I was female—was definitely not. Looking back at my upbringing in Providence, I began to feel indignant and angry at my father and stepfather and whomever and whatever was male and exclusionary. As others of my generation have testified, it was an extraordinary and exhilarating experience to start to see everything entirely differently, as if blinders had suddenly fallen from my eyes. This explosion of understanding about traditional gender roles was also exciting to the other women my age I met at meetings of the Village Independent Democrats, as we realized that the indignities and roadblocks we had regarded in the past as personal were really not personal at all.

Since gender inequality was obviously unfair, and even against the law after the passage of the Civil Rights Act of 1964—when the word "sex" was mischievously added by a southern senator to the bill's language—I reasoned that when enough women explained this injustice to men, discrimination against us would inevitably die a natural death. After a group of feminists picketed *The New York Times* to protest its sex-segregated job listings and the practice became illegal in New York State at the end of the year, my optimism was heightened. So was my self-esteem. When the leadership of the Village Independent Democrats nominated me as corresponding secretary to be in charge of mailing out flyers, I haughtily declined because it seemed too much like secretarial work. Instead, I ran for the policymaking executive committee, but when I inevitably lost, I did what females so often do and blamed myself—for not volunteering enough and being too tongue-tied when advocating my candidacy—but vowed to try again.

About a year later I spotted a flyer about a conference of all the fledgling and established feminist organizations in the city, the Congress to Unite Women. Feminist groups were rapidly forming in 1969 as women activists quit civil rights and antiwar groups in which men were dismissive of them in leadership roles. After giving my dollar donation at the door, I attended a panel called "Love and Sex," the matters often on my mind those days. While members of the newly formed National Organization for Women advocated the reform of family roles, feminists on the panel attacked the family as an oppressive institution and urged revolution. When I remarked afterward to the panel moderator, a member of the New York Radical Feminists, that I regarded my new boyfriend as my best friend, she gave me a disgusted look. Before the end of the afternoon I took a look at some of the many mimeographed incendiary writings—the notorious "demon texts" of the time—on tables in hallways and, fascinated, I picked up a few to read later, including *Notes from the First Year* (fifty cents for women, a dollar for men), "Radical Feminism and Love," and "Fuck Marriage, Not Men."

At the time feminism meant to me more a stiffening of resolve about my rights than giving up romance with men, so what I heard that November day was both intriguing and disturbing. Right after arriving in New York, a childhood friend of my mother's, who was married to a doctor and living in a handsome brownstone on the Upper East Side, had introduced me to her stepson, a tall, blond, blue-eyed graduate of an all-men's Ivy League college, the kind of guy I was expected to marry. Reading in my girls' schools' alumnae news about my classmates' weddings and babies, I was feeling intense pressure to settle down. Interested in his eligibility, drawn to his amiability, and enjoying the embrace of his family, I began to date him. A relationship with him represented the protection of patriarchy and class privilege, but I remained ambivalent.

At moments I wanted to fall in love with him, marry, and even take his last name, but when I honestly imagined a future with him, what insistently and even annoyingly came to mind was a sense of somnolence, and I worried that as his wife I would sleepwalk through the rest of my life.

After the day of panel discussions at the Congress to Unite Women was over, I met him for dinner. Violating my teenage vow about never talking about politics with boys, I showed him in amazement one of the angry polemics, "The Politics of Housework," a vehement argument printed on pink paper about why men should do more around the house. It left him speechless, evidently with alarm, and a few months later he suddenly and unexpectedly broke off our relationship. Despite my new feminist ideas, my father's shattering early rejection had left me with a deep longing for even an imperfect man's love, and I was deeply wounded.

The breakup amplified my anger at men and my embrace of feminism, and soon I joined a sit-in at *The Ladies Home Journal*, the publication that was a paean to traditional domesticity. On a March morning in 1970, more than a hundred young women writers—mostly freelancers whose jobs would not be jeopardized by arrests—surged into the spacious corner office of its male editor in chief. Some protesters hung a banner out a window overlooking Madison Avenue proclaiming the magazine was now "the Women's Liberated Journal." Others read a list of fourteen demands to the editor in chief. A few tried to indoctrinate the female secretaries and editorial assistants, while a middle-aged editor wearing a dress and hat scolded us for our blue jeans and bad manners. By evening, after eleven hours of debate and discussion, the editor in chief finally gave in to one of the demands: allowing a group of negotiators to write and edit an eight-page insert in the lightly read August issue. Sitting on the floor of the office and listening with other women, I felt encouraged by our bold action,

but despite widespread media attention it had little immediate effect.

A little more than two years after moving to Manhattan, I wondered why everything had gone so wrong: I had been fired from a job, jilted by my boyfriend, and then priced out of the Greenwich Village garden apartment when my roommate moved in with her boyfriend. Until I could figure out what to do, I had stored my possessions and was sleeping temporarily in a tiny top-floor maid's room in the brownstone of my ex-boyfriend's parents. My second job in the city was as editor of a small trade magazine, where my low salary was suspiciously paid in cash. It was enjoyable in a way, but it didn't make me feel I was making much progress as a writer. Internalizing my disappointments, I didn't like myself very much; although I appeared self-possessed to others, I felt rigid, brittle, and parched inside, a young woman who was repressing herself as she was dismissed and discouraged by others. After throwing away my airplane ticket to Albuquerque for Peace Corps training a few years earlier, I began to imagine the southwestern city as an adventurous frontier—a place to start all over again. It's sometimes inexplicable why a certain city or landscape interlocks with a particular personality, but for whatever reason Albuquerque began to represent a fantasy, a place for me to go, to escape to, but it was a step I wasn't quite ready to take yet.

Hesitating, I realized there was little to lose from introspection and maybe something to gain, so after more than five years without writing in a journal, I went out and bought a large, narrow-lined, spiral-bound notebook. I knew, of course, that keeping a journal was a way for a writer to record raw material—impressions, ideas, information—before it is forgotten, to have it at one's fingertips when one is ready to turn it into more polished prose. I also was aware that for other reasons it was an important practice, like a way to elucidate and

elaborate in private what I really thought. On the first page of the journal I taped an article from *Mademoiselle* magazine about the person I yearned to be: "somebody with no hang-ups, really free, no longer boxed in, full of love" and able to be "really real, really honest, really giving and taking, <u>really</u> happy." I began writing in jerky and disjointed handwriting in the notebook during those unhappy months, searching for a way forward. For the rest of my life I would only pause in this effort when I was either serenely contented or unable to engage in an honest and candid conversation with myself, and I would never again abandon journal writing for so long.

11

From Nairobi to Newsweek

It was still wintery in March of 1970 in Manhattan when a very intense, wiry, tall young man, who introduced himself to me as Arthur, showed up for a party in the Greenwich Village apartment. His handsome, even, almost delicate yet manly features were set off by the way he combed his light brown wavy hair straight back from his wide forehead. That evening he talked to me almost exclusively, when his piercing dark eyes bored into mine so intently that their ferocity almost negated his sporadic wide warm smile. "I thought you were the Earth," he wrote me afterward in a six-page, single-spaced, typewritten letter; my green wool suit looked like "jungle flora" to him while my slender legs, covered in brown pantyhose with a diamondback pattern, looked to him like snakes. "I liked them," he admitted.

Along with the letter written late at night he enclosed several small, unsmiling, black-and-white snapshots of himself in a dark turtleneck and checked sports jacket holding a paperback book while standing in front of a fruit and flower

stand on Broadway on the Upper West Side. In the photos he looked like the epitome of a New York intellectual. I had never before received a letter like that—laced with numerous interesting insights and literary allusions—and I didn't know what to make of it. Quoting Camus and other highbrow writers, the letter criticized "the worm in a man's heart," making me think that the letter writer's awareness of the danger of a damaged heart must mean that his heart was different. As I reread the fascinating letter, its ardor and depth appealed to me, so I decided to ignore its strangeness and sense of self-importance, not understanding at that age the unerring veracity of first impressions.

When we went out together, Arthur told me he had moved from California to New York a few years earlier to get into publishing. Over the next few months, I would learn that he had won a prestigious poetry prize while an undergraduate at UCLA, and then a scholarship to study literature as a graduate student at Berkeley. There he and hundreds of other students were arrested in 1964 for protesting university censorship during the days of the insurrectionary Free Speech Movement. What I liked most about him was his seriousness, as well as his informed mind and mental quickness—his "intellectual power," I called it—and before long I believed he was the brightest man I had ever met. During those initial days of our relationship, I liked asking him questions and listening to his lengthy answers; he had a lot to say about politics, ideas, books, and much else, and I thought he said it impressively. When he finally revealed that he was researching and writing a novel, my admiration for him accelerated even more.

After my breakup with my former boyfriend, I was wary about becoming romantically involved again. I wanted a reliable boyfriend, and I had resolved "to judge a man's commitment and drag my scared heart along when the ground is firm," as I noted in my journal. It soon became apparent that

it was not Arthur's lack of interest in me that was worrisome; it was his temperament. He had admitted in his letter to being a "grouch," and during the next few weeks I noticed a streak of irascibility and irrationality that made me ask myself if he was "just brilliant or brilliant-crazy?" When I later reread my schoolgirl edition of Henry James's *Portrait of a Lady*, a shiver of recognition went down my spine as the fictional Isabel Archer falls in love with the arrogant Gilbert Osmond because of "the beauty of his mind." That spring, however, I ignored my doubts about my new boyfriend because it was so enjoyable to be able to talk with him about almost anything—even my anxiety about getting involved with him—and listen to his thoughtful and articulate answers. I also liked being the object of his intense attention as I answered his probing questions about myself.

The same month we met, forty-six female researchers at *Newsweek* held a press conference—on the Monday an issue with a cover story about the women's liberation movement, titled "Women in Revolt," appeared on newsstands—demanding a chance at the reporting, writing, and editing positions traditionally held by male staffers. The women also announced they were filing a civil rights complaint about sexism at the magazine—the first of many class-action lawsuits against gender discrimination in the media initiated during that decade in New York. Eager to get back into journalism, I figured that *Newsweek* might be a place for an aspiring female like me to get ahead. During an interview I learned that I would earn much more at the prestigious and prosperous national newsweekly than at the fly-by-night magazine I was editing, which was important because I was supporting myself. So, instead of taking a chance on Albuquerque, I accepted an offer to be the researcher for the Wall Street columnist as a way to get my foot in the door.

When I arranged to get five weeks off between jobs, Arthur urged me to visit California with him, but I was wary because he seemed "too overpowering." Instead, I traveled in exactly the opposite direction. My roommate the past winter, a Dutch woman a year older than me who had fled her husband and child in Kenya to follow her American lover to New York, had often described the wild and extravagant beauty of East Africa, and I wanted to see it for myself. It was the instinct of a budding writer about placing oneself in an entirely new environment in the expectation that it would stimulate a flow of words. As I packed my journal and camera along with my clothes, my adventurous plan to go to Africa alone felt less risky than falling in love. My lingering apprehension entirely dissipated on the flight over North Africa, as I watched a pink dawn slowly break over the Sahara and make it glow with a rosy luminescence. As the airplane continued southward toward Nairobi, a red ball of fire began to inch over the horizon, and the vast waves of pale sand below gave way to wide expanses of coral earth punctuated by dots of greenery. The unfamiliar beauty made me excitedly anticipate what I would discover in Kenya.

At the Nairobi airport I was met by a friend of my roommate's, a tea planter of English ancestry, who took me to lunch at the elegant Muthaiga Club, a traditional gathering place for the country's whites, but which since independence from Great Britain a few years earlier had displayed an enormous color photograph of President Kenyatta. After staying at the tea plantation for a few days, I set off in a minibus with European tourists to visit game parks, moving under the wide African sky on rutted dirt roads over vast arid highlands to lush water holes teeming with wildlife. What fascinated me more than the giraffes, antelopes, and elephants were the roaming bands of slender young Maasai males wearing sienna togas and carrying long spears accompanied by giggling girls with bright coils of beaded jewelry around their necks. For some unfathomable

reason the youths exuded a sense of extreme pride and even gaiety despite the evident hardships of their nomadic lives—astonishing demeanors that were entirely absent from faces on the sidewalks of Manhattan. Was it their freedom to roam? Their intimate connection to each other and their tribe? Their love of their beloved cattle and the empty highlands under an enormous sky? Whatever it was, I wanted to find a way to grasp that attitude, that spirit, and somehow make it mine.

One starry night, while resting under a white canopy of feathery mosquito netting in a tented camp at the foot of Mount Kilimanjaro, I realized that I was rapidly recovering from my unhappy winter in New York. My anger was gone and my uptightness diminished; I was feeling self-confident, contented, and eager to change what was wrong with my life. "The purpose of this trip—solo—is being fulfilled," I jotted down, glad that my curiosity had been stronger than my anxiety about going on my own. Meanwhile, Arthur was mailing me letters saying he missed me, and urging me to return early so he wouldn't end up in a mental hospital, a statement that seemed a bit manipulative. He also half seriously suggested that I rent one of the two rooms in his apartment on my return. "Believe it or not, you calm me. I like to have you near. I like to hold you. I like to talk to you. I like to kiss you. I even like to disagree with you (That grouch!)," he wrote. Enjoying myself thoroughly and uncertain about him, I stayed as long as I'd planned.

During my last days in Nairobi I visited the *Newsweek* bureau and chatted with the friendly American newsmen, making me excited about going to work with journalists like them back in Manhattan, and I fantasized about someday reporting from Nairobi or another overseas news bureau. Shortly after I started at the newsweekly, the women staffers withdrew their lengthy legal complaint after the executive editor signed a memorandum of understanding promising to discover "if there is an untapped reservoir of talent among women" at the

magazine. The editors assumed it was a reasonable inquiry, but it should have been evident that most of the well-educated researchers, many with as much journalistic experience as the men on staff, should be promoted. Unfortunately, the year was 1970, and expectations that males had for women as professionals still remained shockingly low.

The day the agreement with *Newsweek* management was signed, August 26, was the fiftieth anniversary of American women's winning the right to vote. To commemorate it, a march, the Women's Strike for Equality, was planned to begin a block away from the *Newsweek* building in midtown. To this day I am astounded that I hadn't heard about it, but during the month I was in Africa, I was out of touch with my feminist friends. The day was a Wednesday, and by the time I was able to get out of work, the marchers were gone. I later learned that they had been told to stay in one lane of Fifth Avenue but the thousands of marchers, holding banners and signs, had broken through police barricades, filled the entire street, and marched to Bryant Park for a rally, where Betty Friedan triumphantly declared that their numbers were "beyond our wildest dreams" because "women's consciousness is changing." The next morning, on the front page of *The New York Times* there were photographs and headlines about the exuberant women as well as articles about the largest demonstration for gender equality in America, filling me with optimism about my future as a female journalist.

That autumn, remembering my remarkable experiences in Kenya, I worked diligently on a freelance article about whether East Africa's overwhelming beauty could endure alongside its rapid development, and I impulsively sent the impassioned piece of writing to *The Village Voice*. After getting no response for a few months, I telephoned the editorial department to say I had a better way to begin the piece, but to my astonishment an editor told me how much he liked the opening and that my

article had already been set in type. When "The Last Stand of the Peaceable Kingdom" appeared in an April issue, I wrote excitedly in my journal that getting my words in print under my byline felt "like unplugging a dam." After being published in the *Voice* on my first try, I anticipated writing more articles for the weekly newspaper. It appeared possible, after all, to begin again as a writer in New York.

12

The Novelist and Me

Right after returning from Africa to New York and beginning my new job at *Newsweek*, I felt torn between going to my group summer house on Long Island or staying in Manhattan to see Arthur on weekends. One Saturday morning I impulsively went to his Upper West Side building and rang his bell just as he walked into the lobby looking tanned and handsome in a white tennis shirt. Very pleased to see me, he took me onto his lap in his apartment and smiled into my eyes, and then we spent the day talking and walking along the winding paths of a leafy, verdant Central Park.

A few days later, however, I saw the side of him that had worried me in the spring. When I talked about finding another apartment in my beloved Greenwich Village, he furiously threatened to end our budding romance because the neighborhood was so far from his place on West End Avenue. Wanting too unquestioningly to give our relationship a chance, I soon squeezed my desk and a few other possessions into a tiny

fourth-floor apartment in a brownstone on a dingy and dangerous block on West 80th Street. Years later, when reading American colonial captivity narratives, I learned that the first stage of abduction was a deliberately disorientating psychological process called "the taking," and I wondered if what I had described in my journal as my boyfriend's "terrifying behavior" during that time had traumatized me into startled submission.

As his tempestuous behavior continued, so did my gradual surrender to it. One night in a restaurant he exploded at an innocuous remark of mine and angrily threw his napkin across the table at me. As if a switch had flipped, I insisted on going home, refusing to listen to anything he said, only wanting to get away from him. What happened next revealed another side of myself, a side I didn't understand then and don't recognize now. The next day I anxiously and apologetically telephoned him twice, went with him to a party, and returned with him to his apartment afterward. As we made up, I felt my heart opening up to him, a reaction that bewildered me. "Why such a negative rejection—then such an outpouring of love?" I incredulously asked myself. The answer, of course, had to do with my family background. I decided to interpret the incident as nothing more than an innocent lovers' quarrel instead of what it really was: a violent censoring of what I had to say and my capitulation to it. It was as if I were a butterfly ensnared in an invisible net woven by something within myself, a familiar net from which I did not want to be untangled.

Earlier I had a few sessions with a psychiatrist, who had bluntly told me I was in danger of attempting to get a distant or difficult man to love me as a way to symbolically win my father's love. After I met Arthur, I thought about making another appointment with the therapist but I did not, knowing that he would definitely disapprove of my new boyfriend. Although this insight had given me a shock of recognition, I ignored it. When my former boyfriend became a banker and invited me

to lunch to apologize for what had happened between us, he seemed bland and uninteresting compared to fiery and fascinating Arthur. "I'm going to marry a man who is an artist in his soul," I had vowed in college, and my goal seemed furthered by going out with a writer. Like so many other young women of my generation with few career opportunities, I also fell into the trap of being drawn to a man who was doing what I so fervently wanted for myself.

Despite the danger signs, a relationship with Arthur was a risk I was willing to take for a number of reasons. I relished living alone on weekdays and together on weekends because it made for "a rich and intoxicating combination of stimulation and introspection." On Saturdays and Sundays we eagerly explored Chinatown and Little Italy, visited museums, browsed in bookstores, and went to films and classical music concerts. Some Sundays, however, we didn't get out of bed. We got together with friends of his from California, mostly a circle of journalists and lawyers who worked for liberal organizations like the American Civil Liberties Union. We also socialized with quirky literary types who published a little literary magazine; one liked to sell poems for five cents on the street. Everyone opposed the Vietnam War, so at last I could talk about politics without fear and at length with a highly informed boyfriend, who introduced me to I. F. Stone's left-leaning weekly newsletter, an impressive one-man act of investigative journalism.

Although he was a voluble talker, Arthur unfortunately lacked a vocabulary of affectionate words, and when I asked for them, he told me to look at his actions instead, noting that he wanted to be with me every weekend. For my part, I was relieved to be in a reliable monogamous relationship, apart from the unrestrained dating scene around me. At eighteen I knew I eventually wanted to marry "so I would not be forever alone"; by the age of twenty-eight I was ready for a committed

mate. As the months went by, I began to feel a sense of belonging and bonding with Arthur that I had never experienced before with a man. He felt a strong bond, too, and he liked it. One day, after an argument when I threatened to go back to my apartment, he grabbed the keys from my pocketbook and declared, "You belong here," coercive words, but ones that met a deep need of mine.

Arthur spent weekdays pounding out his novel on an old manual typewriter placed on a makeshift desk in his bedroom. After we had known each other for a while, he revealed that it was about the Jewish resistance movement in the Warsaw ghetto during World War II. When he told me that his father and mother had escaped the Nazis after the invasion of Poland by a desperate flight across the length of Russia to Japan and then to the United States around the time he was born, I realized that his novel originated in his family's anguish about the genocide in their homeland. As the months went by, he began eating very little and became as emaciated as his starving fictional characters in the ghetto. His malnourishment, plus a painful knee from an old basketball injury, along with bad headaches heightened his irritability, especially with any casual or nonconsequential small talk, so often I was silenced. When he dramatized the demands of writing the novel by declaring he might be dead in a year, I felt I couldn't abandon him in his heroic struggle. My admiration for the importance of what he was doing and my sympathy for his suffering kept me returning to his apartment on Friday nights after *Newsweek*'s deadline.

What my grumpy boyfriend wanted from me, he had admitted right after we met, was what he called "goodness." The message I had gotten from Christianity since childhood was the overwhelming importance of goodness, especially in a young girl. I was well indoctrinated, especially by daily morning prayers and evening vespers and Sunday church services while at boarding school. Every Westover pupil was given a

tiny blue booklet with a sermon about lovingness based on St. Paul's First Epistle to the Corinthians: "Though I speak with the tongues of men and angels, and have not Love, I am become as sounding brass, or a tinkling cymbal," it famously begins in the old St. James version of the Bible. "Love suffereth long, and is kind . . . Beareth all things, believeth all things, hopeth all things, endureth all things." In retrospect, I wonder where were the reasonable warnings to inexperienced young girls? Where were the stories in chapel, church, and classes about biblical heroines and warrior goddesses like Artemis and Athena, who knew not only how to fiercely protect themselves but also how to take revenge on abusers? When I threatened to leave Arthur, he would call me heartless, an accusation I found intolerable because I had not yet learned how to be loving while also defending myself.

The psalm and other New Testament passages instilled in me the morality of turning the other cheek to the point of self-abnegation. On the Sunday afternoons when I felt emotionally exhausted by Arthur's verbal abrasiveness, I blamed my feelings on the inevitable buffeting of intimacy. As I began to distrust them, he implied that loyalty to him was proof of my worthiness. It was devilishly clever of him. High intelligence, I later learned, can be dangerous in a young person without the empathy or ethics of maturity, and my boyfriend, born only a few months before me, was not yet thirty. Later I believed that what he meant by goodness was the gentleness he was repressing in himself, and perhaps that is why he didn't act as if he really respected it in others. And because I represented a forbidden part of his personality, my individuality was invisible to him and, therefore, unimportant.

Once a friend from Providence, who had business in New York, took me aside. He was confused, he said, because while I was the first woman he knew to be involved in the women's

liberation movement, I had a boyfriend who put me down. "Why?" he wanted to know.

Shocked by his blunt question, after a moment I mumbled something, but I was unable to articulate how difficult it was for me to bridge the gap between my New England background and my newborn feminism. Or my hopelessness about finding a better boyfriend; while young feminists like myself were becoming less like our housebound mothers, most of the men our age remained like their traditional fathers. Neither did I say anything about my worry that I would never again feel as well mentally matched. Nor my worry that I falsely feared the inevitable frictions of love. Or my belief that I had to settle for a boyfriend with a flaw, and Arthur's was his hair-trigger temper. And I was silent about my suspicion that my feminist anger meant that I perversely enjoyed an antagonistic relationship. Or that maybe being too discontented to marry him was a way to avoid the domesticity I dreaded. And I certainly said nothing to my friend about my deeply reassuring conviction that my boyfriend would never leave me.

Around the time I was elated after learning that my article about Kenya would be published in *The Village Voice*, Arthur had made a startling prediction to me: when I became surer of myself, he blurted out, I would leave him. It was a prophecy that puzzled me because I was trying so hard to make our relationship work. When I came across it in my journal forty years later, a light bulb went off in my head, and I belatedly understood my boyfriend's belittling behavior. Evidently, he had worried that if I believed anyone else would love me, I would break up with him, and if I doubted my desirability, I would stay at his side. What's so sad, in retrospect, is that our entwined pathologies indicate that we each felt unworthy of a more fulfilling kind of love.

13

Sexual Politics

Although I wanted to write again for *The Village Voice*, something stopped me from telephoning or going to see the editor with an article idea or asking for an assignment. At moments I imagined the excitement of working on a meaningful piece of work again, but the strong voice I had summoned when writing about Kenya had mysteriously disappeared. Or maybe it wasn't so baffling. It was when I was asking myself if there was enough room for two writers in the relationship with Arthur, whose volley of words inhibited mine. His way of ignoring me and interrupting me when I spoke was causing a kind of muteness, an aphonia, and my confidence plummeted about what I had to say. "Why do you let him bully you?" a female friend asked me in a tone of exasperation. As I struggled against his verbal aggressiveness, I was incredulous that a guy who had been active in the Free Speech Movement had the nerve to suppress mine. Stopping feeling censored is what I would most

like to reimagine and redo about those years, when I did not write or publish anything of importance under my byline.

It was not a new struggle or one that was mine alone, although at the time I thought it was. Years earlier Virginia Woolf noted the toll it took for a woman to continue to write when she felt slighted or opposed; in 1931 she told a group of British professional women that she doubted that she or any other woman writer had yet been able to tell the entire truth about her own experience "as a body" because of the fear of male judgment. Although Woolf acknowledged that some of those she spoke to that day had enough money for rooms of their own—essential for writers of fiction, in her view—she went on to say that "this freedom is only a beginning" because women still needed to write with more truthfulness about their lives. "The room is your own, but it is still bare," she declared.

Forty years later, the same year I felt unable to get in touch with *The Village Voice*, poet Adrienne Rich expressed similar thoughts in an essay, "When We Dead Awaken: Writing as Re-Vision," when she was teaching writing at the City College of New York:

> It's exhilarating to be alive in a time of awakening consciousness; it can also be confusing, disorienting, and painful ... For writers, and at this moment for women writers in particular, there is the challenge and promise of a whole new psychic geography to be explored. But there is also a difficult and dangerous walking on the ice, as we try to find language and images for a consciousness we are just coming into, and with little in the past to support us.

The rapidly changing politics of the era hadn't stopped her or authors of the notorious feminist demon texts, but they had

not yet enabled the majority of other women writers, including me. "What I want is to open up," I scrawled in my journal. "I want to know what's inside me. I'm like an imbecile with a can opener in his hand wondering where to begin."

That same year author Tillie Olsen also wrote about the efforts of most women to write, especially wives and mothers like herself, noting that only one in twelve writers were women because of the many ways they were emotionally undermined or hindered by domesticity. To become a writer, she wrote, takes the "conviction as to the importance of what one has to say, one's right to say it. And the will, the measureless store of belief in oneself." And this was still "almost impossible for a girl, a woman." She pointed out that even a well-respected writer like Willa Cather was silenced for a while after sending her first novel to Henry James and then getting a condescending letter indicating that he hadn't, and probably wouldn't, read her manuscript. After his dismissal she did not begin to work on another book until novelist Sarah Orne Jewett gave her some encouragement.

Living in my own apartment on weekdays with what I called a welcome "core of silence" around me before and after work was my way of survival at the time. During those hours alone I read, reflected, and wrote in my journal. It was an enriching solitude essential for restoring myself and withstanding the stresses around me, a refuge from my boyfriend and my boss at *Newsweek*. It was also a declaration of independence that protected what remained of my freedom. "How in marriage do you have delicious evenings alone? Or mornings when you can write like this?" I asked myself. It's surprising to remember that I even resented taking the time to pack my possessions during that time to move to a bigger and better apartment with a patio on the ground floor of a brownstone on quiet West 69th Street.

In 1971 I was still reading more than writing, eagerly buy-
ing first editions of all the famous feminist books published
that year: *The Dialectic of Sex* by Shulamith Firestone, *Sexual
Politics* by Kate Millett, and *Sisterhood Is Powerful* by Robin
Morgan, and finding them as exciting as reading *The Feminist
Mystique* eight years earlier. I also read Simone de Beauvoir's
The Second Sex, published two decades earlier, which noted
that gender economic and social equality would bring about
"an inner metamorphosis" in women, an optimistic prediction
I found "beautiful, inspiring."

Still, I admitted to myself that I was only "taking in—
still—not putting out in writing." Even though I admired
the way these authors explained the personal as political, I
did not dare to go public with what was in my journal. More
an aspirational than an activist or articulate feminist, I was
transfixed by ideology but remained unable to act on it. "The
pall of passivity" had me in its grip, I lamented, and I looked
to feminism as a way to somehow break through it. The bed-
room in the new apartment only had space for a narrow bed
and my desk. Why didn't I turn it into a room for writing and
sleep on the convertible couch in the larger room? And more
importantly, why didn't I return there on Fridays and work
on freelance articles Saturday mornings instead of going to
my boyfriend's apartment? I was aware that it would take a
massive act of will to overcome my resistance and release the
creativity I sensed was as powerful as erotic energy. I now
believe my passivity was enhanced by an estrogen-infused
languor about whether—and how—to be a writer and wife
and mother at the same time. It was when most of my friends
also believed that we had to choose between the metaphori-
cal baby or book.

Instead of writing personally for publication, I was report-
ing dispassionately about Wall Street for *Newsweek* and writ-
ing privately in my journal, seesawing between objective and

subjective voices. One afternoon I felt driven to leave work early and rush home to write in what I regarded as my real voice: "I have to act—write—or I will go mad," I declared that day. After opening my journal, I would gather my thoughts for a minute and then begin to write extemporaneously. When reading the published journals of other writers—Virginia Woolf, Anaïs Nin, and May Sarton—I was fascinated to see the way they used informal writing to experiment with phraseology and ruminate on what risks to take in works in progress. In mine I recorded raw emotions and first impressions, moments of exhilaration, and my ongoing misery. "This is my 'agony' book," I noted one day, when a howl of frustration and fury erupted in the private pages. This voice was audible and authentic, but only to me; still, exercising my edgy voice was a way to keep it alive. This written voice—much more voluble than my verbal one—was the important interior monologue that would endure and eventually turn into hundreds of handwritten pages.

During the autumn of 1971 I was skipping feminist and political meetings until one Sunday afternoon in December after going with Arthur for coffee at a bakery in Greenwich Village. It was when I suddenly decided to catch the end of a fundraiser—a reading of the writings of Virginia Woolf—for the feminist literary magazine *Aphra*. At a warehouse downtown on West Broadway I contributed a few dollars for admission, then settled down on cushions on the floor with a group of other young women my age and a few of their boyfriends. It felt deeply comforting to be there, and it reminded me how much I missed being with female friends. It bothered me that there didn't seem to be enough room for them in my relationship with Arthur. A fellow English major in my class at college, who liked to visit from Baltimore and go with me to the theater, had worriedly observed that I seemed subdued, with little to say around him, and probably other friends felt that

way, too. By the time I took my turn at the microphone in the warehouse that afternoon to read a few pages from *The Waves*, I didn't want the reading to end.

When I returned to my apartment, I telephoned Arthur, who was in a rage about my going to the fundraiser and staying so long. When he accused me of being a radical feminist, I thought it was ridiculous, but realized he was unrealistically worried about my becoming one. At a meeting of the New York Radical Feminists about how to relate to males, I was dismayed when a few members praised lesbianism and suggested separating from men; Adrienne Rich later wrote that her attraction to feminist ideas had awakened her erotic feeling for women, but this was not my response. When a woman at the meeting defended living with her boyfriend by saying that she turned to men for sex and to women for exciting talk, everyone burst out laughing. Although I also was amused at her reverse chauvinism, it seemed a little too cynical to me.

Unlike those proposing separation of the sexes, I *had* lived in an entirely female world for three years at boarding school, and I regarded female institutions as old-fashioned anachronisms. While the school led by so many independent and intellectual women may have been de facto feminist, I never heard the word "feminism" spoken there, probably because it was regarded as too provocative to parents. Westover was on my mind, however, and I wanted to write an article about it from a feminist perspective. My idea was to criticize the school for tolerating women's traditional roles, but when I returned to Connecticut to do the reporting, I felt a surprising nostalgia for a place where I had been physically safe, mentally stimulated, and inspired to become a writer, and, as a result, felt too confused and conflicted to complete the article. Still, I didn't want to retreat to a woman's community or even a feminist utopia like the idyllic one in Charlotte Perkins Gilman's satirical novel, *Herland*, where strong and happy

women live harmoniously together and give birth to daughters by parthenogenesis.

One early morning that winter I finished reading Sylvia Plath's *The Bell Jar*, which had recently been published in the United States. In her autobiographical novel she described her months as a patient at McLean Hospital, the same psychiatric hospital where I had briefly worked, and where she had received shock treatments after a suicide attempt. Disturbed by the despair of her young female protagonist, I felt grateful never to have experienced such debilitating depression, only mild dysthymia. As I read I was listening to the music of Bach; my eyes teared up because of the way the music's steady and sonorous rhythms sounded like the beating of a heart and reminded me that my guarded heart was only opened halfway. Closing the book, I sadly gazed out the glass doors at my wintry patio, where snow was dissolving in patches of sunlight and staying frozen in the shade.

A month later my mother and stepfather visited New York, and I introduced them to Arthur. Unsurprisingly, it did not go well. After my mother returned to Rhode Island, she wrote me a long, agonized letter on her best blue monogrammed stationery in a rare attempt to give me advice. She admitted to being puzzled by my boyfriend's mercurial personality, and his expressions that could quickly switch from an angelic smile to a devilish glare. "What a kind face Arthur has—and that was the reason I could not understand his talking so to you," she wrote. Since he was very sweet to her, she went on, she did not know if he was an actor playing a part or a malevolent Dorian Gray, a reference to the handsome youth in an Oscar Wilde novel who was so evil that he drove a young actress to suicide. My mother only wanted to understand what her "kindhearted" daughter was doing with "a prickly porcupine." Trying to keep an open mind, she wrote that "if a lovely intelligent girl like you feels it's worthwhile putting up with someone's egotistical

nastiness—you must have good reasons." He has interesting thoughts, she admitted, "but I hurt for you." She ended by saying, "I love you so very much—and pray for your happiness." Her letter made me heartsick because it made me feel that not only was I betraying her love for me, but maybe I was also betraying myself. When I told Arthur about the letter, he instantly and emphatically denied being rude to me in front of my mother and defensively dismissed my anguish as hysterical.

Over the years my mother's misery had broken my heart the way mine was now breaking hers. In her letter she made excuses for her husband's brusque behavior toward her, but it enraged her so much that during my visits she would let loose an excruciating earful of anger about him behind his back. Even so, she couldn't face the idea of another divorce and the possibility of losing her home and garden. Her inability to act—either to improve her marriage or to leave it—set a bad example. In fact, I learned about masochism from her, and that the price of love was often humiliation and anger. Recognizing her deep dependency on a man, I even resented her implicit advice that I give up mine. Meanwhile, I tried to push away the glimmer of a frightening insight: despite vowing to never have a relationship like hers, maybe I had made the same mistake.

A week later, as Arthur and I got on a subway to attend a Mozart marathon at the Brooklyn Academy of Music, I asked myself if I should regard our two years together as a time of intellectual excitement, and now find someone with whom I would be happier. "The good is, as always, the mental growth and awareness," I reflected, "but I want harmony and tenderness, too." Many years later, through a miasma of memory, I struggle to understand why I was so vulnerable to a boyfriend's constant manipulations and contradictory messages, once expressed by a poem he wrote to me and signed "Love & Hate." I rationalized that since he was frenetically trying to finish

writing his novel before his savings and borrowed funds ran out, his anxiety had made him unable to restrain his barbed tongue. I also reasoned that if I clearly and calmly explained to him how much his harsh words hurt me, he would stop using them as weapons. And I allowed myself to hope that after his novel was published everything would be better between us. Instead of breaking up with him, I resolved to go on a long-anticipated trip together in the spring, and then decide whether to leave him or not.

14

Travelers Together

Our ambitious plan was to fly to Paris in early April, take a train south to Marseilles, a boat across the Mediterranean to Tunisia, then another train westward across North Africa to Morocco. The adventure would be not only a way to sort out my conflicted feelings for Arthur but also a search for interesting material to write about. I wrote the travel editor of *The New York Times* to propose a freelance article; in preparation for the meeting, which he had oddly proposed to hold in a coffee shop, I pinned up my long hair to look as professional as possible, but after I earnestly pitched my idea and asked for an assignment, his flirtatious response was only, "Do you ever let down your hair?" I was speechless. Despite the disappointing rebuff and without the time or motivation to get in touch with other travel editors, I vowed to take notes and photographs along the way and try to publish an article after I returned.

Worrying about some male editors' reluctance to give young women assignments, I fantasized using a masculine

first name as a nom de plume—maybe my father's name, Laurence—for the same reason that nineteenth-century novelists George Sand, George Eliot, and other women writers took male pseudonyms. In the midst of the women's liberation movement, the issue of female names was in the air. Decades earlier Charlotte Perkins Gilman had proposed that daughters take their mothers' surnames, and now some feminists had rejected patrilineal family names for matrilineal ones. I toyed with the idea of adopting my mother's family name or calling myself Laurie Lallychild, or Laurie Lallydaughter, even Laurie X, or, like artist Judy Chicago, Laurie Providence. A pseudonym, however, would create impossible problems for me as a reporter. How could a journalist with a false name and gender write, telephone, and interview people? Also, by then my real name had appeared in bylines. And it was definitely more mine than derivative of my father's. When I was very young, I had liked the genuineness of my birth name before becoming embarrassed by its link to my absent father, and over time I decided that taking another professional name would not only negate my existing byline but also take endless explaining.

After an overnight flight from New York, Arthur and I landed at dawn in a cold gray Paris, both of us feeling like battered soldiers on leave from exhausting battles. During the winter he had struggled to finish writing his long novel, and I had unhappily worked for *Newsweek*'s Wall Street columnist, but the warfare between my boyfriend and me had made everything much worse. On our first day in France we argued bitterly on the Left Bank when Arthur tried to tell me how to read a map and take a photograph. I erupted in fury and threw our travel guide to the sidewalk before he backed off.

When we went to the American Hospital for cholera shots, a nurse noticed Arthur's limp—he had wrenched his bad knee on the way to the airport—and kindly gave him a cane. With his black beret and a faded green Army fatigue jacket, he would

be taken for a disabled Vietnam veteran throughout the trip. In a way, as a son of Holocaust survivors, he *had* been wounded by a war; the knowledge that few of his relatives had escaped extermination in Poland had traumatized everyone in his family.

After a few days of bone-chilling rain in Paris, alternatively giggling about finally being on vacation and snapping at each other, we decided to leave in search of desperately desired warmth and sunlight. At the Paris train station our poor French made it challenging to find our track until Arthur overheard a couple speaking Yiddish and asked in that tongue for directions, which they gladly gave him. "We are everywhere," the woman said while looking questioningly at me. Disappointed to discover more rain when we arrived in Marseilles, we immediately boarded a boat and set off on a steel-gray sea for overnight passage to North Africa.

As we neared the Tunisian coast and went out on deck the next morning, I noticed that the Mediterranean had turned a glaucous green, while the cloud cover was brighter and the air softer. We walked along a street in Tunis with our suitcases and then settled into a spacious room in a hotel. After napping and then devouring large plates of couscous and vegetables in a nearby restaurant, we began to feel as if we were coming to life again. As we spent hours in outdoor cafés sipping sweet tea and watching the exotic scene around us to rest Arthur's painful knee, I had time to take notes in my journal, as if what I didn't record on paper would become unreal to me or lost in memory and to potential readers: the fascinating little shops in the medina, alleyways with masses of wild pink roses covering broken white marble Roman columns resembling bleached bones, and much more. On the second day, a festive parade occurred along the main boulevard for the president of Algeria, when men in traditional white robes rode festooned camels and horses, musicians banged drums and played pipes, while

hundreds of uniformed school children waved little Tunisian and Algerian flags. As always happened when I put myself in a new place, the experience stimulated a flow of written words.

It continued to drizzle in Tunis, so I proposed that we go south instead of west, reasoning that we would definitely find the hot lucid light we wanted to recuperate from the winter on the edge of the Sahara. I also remembered that the *Newsweek* bureau chief in Paris had warned us about traveling through war-torn Algeria. So, after leaving most of our luggage at the hotel for what we thought would be a few days, we boarded an early morning train going southeast to the town of Gabès, where we were immensely relieved to finally find sunshine and flowers everywhere.

A snapshot Arthur took of me early in the trip haunts me today because of the way my shoulders are slumped as if expecting a blow, but Gabès was where I bought a bouquet of fragrant red carnations for our hotel room, hopeful that if I could get back my spirits in a spring-like place, maybe our relationship would strengthen, too. After two years of imagining horrible scenes in the Warsaw ghetto, Arthur became so fascinated by Tunisia that he became less argumentative, less fixated on me, and much easier to be around. Also, isolated together in a linguistic bubble from the Arabic and French speakers around us, we had no one to talk to except each other. Together we searched newsstands for anything in English and were elated to find even outdated issues of the international *New York Herald Tribune*. The newspapers were full of disturbing news about the war in Vietnam, along with exciting reports about the antiwar candidacy of George McGovern, who was winning Democratic presidential primaries back home.

After a few days we continued traveling, now south toward the Sahara, sometimes subsisting on a diet of only oranges, dates, and bread because of severely upset stomachs. Our American dollars were going far, so in a smaller town we hired

a horse-drawn carriage to show us the sights. The driver took us up a steep sandy road and reined in the horse at the top of a barren hill, then gestured below. *"C'est paradis,"* he said simply. The dry earth had cracked open to reveal a Garden of Eden: we looked down on an enormous green oasis, where a canopy of tall palm trees gently shielded groves of figs, dates, and oranges from the burning sun. Soon we took another train south to an even smaller village, where a hotel clerk with a little English arranged for a teenager with a battered Peugeot to take us around. We set out on a rutted dirt road over a flat, sunbaked plain, passing camels pulling plows, with delicate wildflowers along the roadside. After about an hour our driver abruptly braked the violently rattling vehicle and pointed toward a steep cliff with jagged boulders balanced perilously on top, and declared, "Guernessa." According to my notes and later reflections, this is what happened next:

Getting out of the Peugeot we slowly started up a rocky, steep footpath with zigzagging switchbacks. Arthur was limping a little, and it was only because of his fierce willfulness that he was able to make the climb. For some inexplicable reason, something about the tenacity of the stone and clay dwellings clinging to the side of the cliff fascinated me, and I felt an urge to explore the labyrinth of footpaths around them. It was as if the ancient hillside habitation represented to me what Anaïs Nin called her "Fez," the place that most resembled her inner self; for me it was an early inkling of my affinity for intimate and interconnected village life.

Rounding a bend, we saw a group of Berber schoolgirls walking toward us down the path to their schoolhouse below. Seeing us—two strangers, a tall thin man with a cane and a Western woman wearing trousers and a hat with a leopard fur band—they stopped and stared at us like startled deer. The tallest girl, holding a handful of purple and yellow wildflowers, was wearing a pink smock over a dress with a red-and-yellow print

and a patterned kerchief tied over her dark hair. Tentatively taking a few steps toward us, she locked her bright brown eyes into mine and ventured a *bonjour*. Intensely curious, she continued in French, asking what our names were. Were we French? When we said Americans, shyness suddenly overcame her and she bolted back to the group of smaller girls. They quickly made a wide pass around us and fled down the path with a chorus of giggling *au revoirs*, while throwing wide-eyed glances back at us over their shoulders. As we continued up the path, the oldest girl came running back up with her arm outstretched, calling "Madame! Madame!" to offer me her handful of flowers. Then, just as she reached me, she stopped, stared again, and suddenly withdrew her bouquet, turned, and with large leaps bolted back down the path again.

Near the pinnacle we approached a tiny whitewashed mosque and minaret. A boy appeared out of nowhere and began talking to us in French. He pointed to an entrance to a cave he called a *"maison de jeunes,"* and when I peered into it, a dozen or so startled boys ran out chattering excitedly. A few fluffy white clouds had quickly ballooned into gray thunderheads, and a strong wind began to blow, and as I tried to step into the cave for shelter, it made the boys' agitation grow, so I moved back into the strong wind and struggled to stand upright. When I innocently asked if I could go inside the mosque, the first boy looked startled, then shot back a firm *non* because, unknown to me, women were forbidden in the mosque.

A bold boy with flashing green eyes began batting my hat that was dancing wildly in the wind from a string around my neck. Other boys shouted. They jumped from rock to rock. They shrieked. They began to race around us in circles. Soon a savage little honor guard began forcibly escorting us back down the path. At the bottom, we waited until their raucousness died down and they accepted our handshakes and *au*

revoirs. With immense relief we got back into the Peugeot and headed back to our hotel.

The other side of adventurousness is danger, and because we were naïve and knew little French, we had endangered ourselves. Nevertheless, even though we had reached the end of the train track, we boarded an overcrowded, rickety bus going to the next village. Arthur got talking with a young medic with a few words of English, who was riding with his pregnant wife in a brightly patterned Berber robe, and who invited us to visit, so the four of us got on an even smaller bus. It wound its way along a narrow, winding dirt road to what turned out to be an extraordinary place of mostly underground dwellings carved from soft white limestone. Inside our hosts' one-room stone hut, the young wife asked if I wanted to wear what her husband translated as "Tunisian national dress"; I said *oui*, took off my khaki shirt and pants, and she dressed me in layers of glittery fabrics, pinned them together with heavy gold clasps, and handed me a scarf to hide my hair. My emergence from the hut caused great hilarity in the hamlet. When an old woman leading a burro approached, the medic lifted me onto the animal's back, and Arthur took snapshots of me looking like a Madonna on the way to a manger.

In the medic's tiny dispensary I noticed a poster urging smiling couples to have only two children. On my next birthday I would turn thirty, and marriage and motherhood were on my mind. I was reading Isak Dinesen's *Out of Africa* and daydreaming about reporting from *Newsweek*'s Nairobi bureau, but in the presence of the traditional women I was also imagining a completely different kind of existence. When giving a greeting or saying goodbye, the women would kiss one of their hands and then, in a sweetly touching gesture, would place it over their hearts. As they gathered around us, they asked me the question that was most on their minds: *"Avez-vous des enfants?"* After I shook my head and said *non*, they

looked puzzled and didn't know what to say. Noting the look of contentedness on their faces, especially those holding babies or the hands of toddlers, I found myself asking if it was possible for me, or any educated Western woman with a career, to achieve that depth of happiness along with the independence we so ardently desired.

After traveling well together for more than a month, Arthur and I inevitably became more tightly entwined than ever. Going all the way with him to the edge of the Sahara and back fed my stubborn dream about the man and woman we could ultimately be together. An imagined ideal relationship is often extremely difficult to shake, even if it differs from reality and is rarely obtained. Always deeply torn between what he regarded as the substance of New York and the superficiality of Los Angeles, he told me that Tunisia's aridity and brilliant light reminded him of southern California. It made me imagine what New Mexico must be like, and we talked about beginning another life together in the west. After we returned to New York, Arthur went on to the West Coast for a month to see his parents and old friends, writing in one of his letters to me that he sometimes felt he "could stay forever in this crazy California," but if he did, he wanted to do it with me. Sending me flowers at *Newsweek* and asking me to be understanding of his absence, he also wrote, "When I finally return, we will be together, and for a very long time to come." It was a promise that deeply pleased my hopeful heart.

15

The Jew, the Wasp, and the Writing

On a Sunday morning in late May, while Arthur was in California, I was perched on a red leather Tunisian ottoman in my apartment feeling half exuberant and half lonely while reading for the first time the two boxes of manuscript pages holding his novel. As always, I liked being by myself, but after our long harmonious trip together, I also missed him. Outside the sliding glass doors, the plants in the patio looked breathtakingly lovely in a soft spring rain, so I slid the doors open to smell the warm moist air. They were all showing signs of fresh green growth, and from time to time I looked up from a page to gaze at the delicate ferns and glossy gardenias I had potted and placed in the shade of a nearby building, as well as the yellow and pink tulips I had planted in a sunny strip of soil alongside the concrete paving.

The novel's narrative began in 1942, the year both Arthur and I were born, and the year of the Jewish uprising in the Warsaw ghetto. As I turned page after page, I thought his

description of the suffering and starvation of innocent men, women, and children trapped in the ghetto was moving and riveting. Titled *Warsaw Kaddish* for an ancient Hebrew prayer for the dead, the story was oriented around a Jewish resistance leader who was so clever and dangerous that a Nazi posing as a Jew was sent into the ghetto to search for him. Almost a thousand typewritten pages of plots and subplots, the novel was populated with so many imaginary Poles and Germans that I had to make an index to keep track of them. One of the subplots, I noted with interest, was about a couple willing to conceive a child despite all the death around them; I admired their courage and commitment to creating life and assumed that my boyfriend who had written the scene felt the same way, too.

As I kept reading, I suspected that the heroic protagonist was Arthur's fictional alter ego. While working on the novel, he had inevitably delved deeply into feelings about an atrocity that seemed to fuel his perpetual percolating anger as well as his family's grief. I would meet his parents a few years later, after his father took a leadership position with the socialist Jewish Labor Bund in New York and moved with his sad-eyed wife to the Bronx. In their apartment a large abstract painting with strident colors and sharp edges hanging prominently over the sofa looked to me like a painfully open wound. It was my impression that Arthur's stay-at-home mother remained emotionally crippled after the Holocaust had decimated her community in Poland, whereas his father did not. When we went to see them on Jewish religious holidays, I doubt that it was easy for them to wholeheartedly accept a Christian like me, and I felt grateful for the kindly way they always treated me and for how they politely spoke halting English in my presence instead of their habitual Yiddish.

Reading the boxes of manuscript, however, made me reflect on the enormous differences between my boyfriend's

and my backgrounds. We were very aware of them, of course, and they made us interesting to each other, but they also led to misunderstandings we never grappled with. My Yankee upbringing—dancing school, boarding school, the debutante ball—must have seemed as alien to Arthur as his immigrant background did to me. In 1939, when his parents made their daring and desperate flight from Poland to America, my mother and father were living a happy-go-lucky existence amid their prosperous clans in Providence, raising English setter puppies, going to parties at the Agawam Hunt Club, spending weekends at the family hunting camp, and summers at the beach and sailing in the bay. While Arthur had evidently never known his grandparents and most of his aunts and uncles, I knew three generations of my large family. When my mother's relatives gathered in 1941 for the small wartime wedding of an uncle, a color photograph taken outside on that sunny day shows the handsome bridegroom in his Air Force officer's uniform, his pretty bride wearing wartime dark blue, along with my grandmother and her five smiling daughters and daughters-in-law adorned with corsages and flowery hats, my grandfather with his three sons and his son-in-law, my father Larry, all sporting boutonnieres, and four little blonde granddaughters in party dresses sitting on the grass.

In Los Angeles my boyfriend's father had worked as a presser in a garment factory, refusing on socialist principle to be promoted to management, while both my grandfathers and other male relatives were staunchly conservative capitalists. And while Arthur had no delineated family tree, one of my mother's older brothers was dedicated to making an ancestral chart of our English ancestors going back many generations in New England. Furthermore, in my small apartment stood an inherited high, handsome, eighteenth-century American maple chest with handmade brass pulls that evoked this

heritage. It was evident to me at the time, and it's even more obvious now, why Arthur felt uneasy and even intimidated on visits to Rhode Island, especially at Christmastime, even though everyone treated him politely, despite my mother's initial hostility toward him. Still, I liked to believe that my bond with my boyfriend was strengthened by our both being outsiders in one way or another: unlike every other female in my family, I was determined to have a career, while he was driven to make his way in America.

Despite our fascination with each other's backgrounds, confusing cultural crosscurrents erupted into problems between us. The New York intelligentsia of the 1950s and 1960s was made up of many gifted Jewish writers, artists, and musicians at a time when the long-dominant Wasp establishment was being caricatured as an entitled elite of inarticulate and inhibited individuals. Yankee writer Edward Hoagland remembers being told around then that the Protestant dynasty was an obsolete "museum piece" that "lacked vitality." Feminist writer Vivian Gornick once pointed out that Jewish males' resentment of privileged gentiles emerged as misogyny in the satirical portrayals of shiksas in the novels of Saul Bellow, Philip Roth, and other acclaimed novelists. One time when I became especially annoyed by my boyfriend's intellectual arrogance, I enraged him by accusing him of "Jewish chauvinism," a charge that hit its mark. On the other hand, Arthur, who was at one time embarrassed by his father's humble job, probably envied my family's lineage or position and wanted his relationship with me to make him feel more rooted in America. As I became aware of the depth of his conflict about dating a woman regarded as a Wasp princess or a shiksa temptress—after he refused to introduce me to anyone at his mother's funeral—I understood another reason for his habitual simmering anger.

When attempting to defend myself against his verbal attacks, I held on to an idea inherent in democracy—that regardless of a person's inborn abilities, everyone was entitled to equality and respect. I also asked myself why the legacy of our nation's Anglo-Saxon founders in the Enlightenment era, and their intellectual descendants, like my grandfather's cousin, the civil libertarian Roger Baldwin (a founder and director of the American Civil Liberties Union and a pacifist ally of Emma Goldman and other reformers and radicals), was largely ignored. What about my forefathers' creation of the first constitutional democracy, and their descendants upholding the charitable tradition of noblesse oblige? What about patrician Rhode Island senator Claiborne Pell, a driving force behind government grants to the arts and scholarships for needy students? And what about my mother's father, who retired early to devote himself to good works and won an appreciative award from a Jewish men's group in Providence? And also, what about Roger Williams, whose fight for religious freedom led in 1763 to the establishment of a handsome stone synagogue in Newport?

Around that time, I learned that during World War II my artist step-uncle had entered the Bergen-Belsen concentration camp as an ambulance driver in April 1945, a few months after Anne Frank died there. "It was an insane asylum in reverse," he wrote in a long, wrenching letter to his parents back in Providence. "The insanity had been imposed upon the normal by the insane." When not carrying the sick and dying on stretchers to makeshift hospitals, he made quick charcoal sketches of them, depicting skeletal figures with huge, hollowed eyes who were often collapsed on the ground. As the strongest among them were bathed, fed, and given medicine, "the women begin to sing, pick a flower, notice men again," he wrote in the letter, and he added that couples were seen

making love in a field of flowers on the edge of an artificial lake made by the Nazis for their pleasure.

It was after this wartime experience when Uncle Billy began to undercoat his paintings with dead black pigment in his Bowery studio back in Manhattan as if to express his deep pessimism about the human race. Art dealer Betty Parsons offered him his first solo show at her gallery, where she also exhibited the work of Jackson Pollock, Mark Rothko, and other emerging abstract expressionists. My step-uncle's mother was so opposed to her second son becoming an artist that she telephoned the art dealer and told her not to exhibit his work; Parsons ignored her, every painting in the show sold, and William Congdon became regarded as one of the most promising painters of his generation.

Two decades later, during the autumn I moved to Manhattan, the gallery held its last exhibition of his paintings. After his conversion from Episcopalianism to Catholicism, his themes took on an impassioned religiosity that had met with distaste in New York; I preferred his cityscapes and landscapes myself. I felt fortunate to have a large earlier painting, *Positano*, on a windowless wall in my apartment: a rendering of a steep Italian cliff in the artist's distinctive blend of abstraction and imagery that looked like a tense brooding mass about to topple into the sea. I loved its sense of danger and daring, along with its stylistic elegance, its sensuous use of thick pigment, and its graceful incised lines made by slashes of a palette knife. Living with the intensity of the painting made me aware of another kind of consciousness, another awareness, one suggesting a deeper, truer, and more passionate way to exist. And it made me wish to be able to do with words what my step-uncle did with paint.

Working on an article about Tunisia, I wanted to spend more time on weekends writing in my apartment in an effort to publish under my byline again. Meanwhile, Arthur was

asking me to move into his apartment, split the rent, and maybe marry, but my misgivings were getting in the way. "I would feel claustrophobic," I noted. "If I've learned anything from feminism, I've learned the absolute essential need for a room of one's own." Living together in his two small rooms would mean not only giving up my solitude but also most of my possessions and my patio garden. Living on West End Avenue would be too far to walk to work in midtown through Central Park and back. Whenever I entered the park, I felt a rush of pleasure—"not an intellectual experience but a blood experience," I called it—and remembered what I was missing, even mourning, while living in the city apart from nature. Once out of earshot of traffic, I would follow a winding path lined with evergreen bushes around the Sheep Meadow lawn, then through the little zoo, before entering the noisy concrete-and-glass world again at Fifth Avenue and 59th Street.

One sunny Saturday morning we drove the Karmann Ghia to a beach on Fire Island, but it wasn't until I began to walk barefoot on a soft mossy path toward the dunes that I felt like smiling, because Arthur's grouchiness was bothering me again. Waves were breaking violently close to the shore, so I swam out beyond them to float on the gentle greenish swells. Back on the beach, we snuggled in the rosy shade under my voluminous pink Tunisian burnoose as I tried to feel close and contented. I was finding my optimism about our relationship hard to sustain, and my feelings ricocheted between hopeful-ness and fearfulness. "He enrages me, but his ultimate honesty, intelligence and solidarity are saving graces," I noted that summer. One August evening, as we parted to go back to our own apartments, he said moodily, "You can take your independence and shove it." He kept attacking my desire for my own place, and he wrote a letter accusing me of being on an "apparently inexorable march toward a parched, pyrrhic aloneness."

Despite my resolve that autumn when I turned thirty, his disturbing letter aroused my anxiety about growing old alone after I visited a cousin of my mother's, an older woman named Lois Dana who had never married and had worked for the Red Cross until her retirement. When I ask myself now why I wanted to meet her, maybe it was because I was searching for an example of a successful single woman to emulate. Glamorous feminist Gloria Steinem was in the news, but I didn't know her personally; since Lois was a relative, maybe she would become a mentor. After arriving at a subway station in Upper Manhattan's Washington Heights, I found her building and rang the bell to her apartment. When she opened the door, I got a glimpse of dirty, smelly, disheveled rooms and a frightened cat hiding in the shadows behind her. She escorted me to a nearby coffee shop for lunch, where we struggled to make small talk about relatives in Rhode Island. As we said goodbye back at her doorway, she abruptly shoved a half-dozen old family coin-silver spoons into my hands; probably she regarded it as an act of generosity, but it made me believe she never entertained, or she thought she was about to die. Instead of emboldening my desire for autonomy, meeting that aging, isolated woman terrified me about fulfilling Arthur's prophecy.

Arthur was miserable that summer and fall for reasons he refused to discuss; I gradually realized that his highly respected literary agent had not found a publisher for his novel. This was a deep disappointment for me, too—one I described as "a true tragedy"—because I wanted him to succeed as a writer. Previously he had some successful years in business, and now wanted to find a job and make money before returning to writing. When I urged him to revise his manuscript on weekends, he said sadly and angrily that it made him too depressed. His experience made me realize that becoming a writer was taking an enormous risk, because it is essential to find a way to

keep going emotionally as well as economically. As a writer, I, too, would have to face repudiation, and thus develop the important ability to distinguish the rejection of my work from rejection of myself. It was incredibly difficult to watch my extremely thin boyfriend put on a loose-fitting suit and hobble on his painful knee, without his cane, to job interviews. By November he had become a vice president of a large company in Pennsylvania, where he stoically worked before returning to New York on weekends.

16

Facing the Male Establishment

After going to work for the Wall Street columnist at *Newsweek* with high hopes of getting back into journalism, I was disappointed to discover that he had no intention of informing or mentoring me in the ways of the financial markets. Though two of my uncles ran brokerage houses in Providence, those offices were regarded as male preserves and off-limits to females in the family. I had a lot to learn on my own. A photograph of me at a press conference at the stock exchange shows a slender brunette with large horn-rimmed glasses listening intently, her long straight hair parted in the middle and drawn into a ponytail, and wearing a tailored tweed pantsuit that flattened her breasts, the manly uniform so many of us felt necessary to wear when working in male preserves during those days.

Researching, reporting, and performing secretarial and personal tasks for the columnist was discouraging for other reasons, too. The women's liberation movement irritated him, and he forbid me to use the new honorific, Ms., in my

reporting, apparently assuming it was a passing fad, and insisting instead on the traditional Miss or Mrs. "Leave your women's lib at home and do what I say!" he angrily erupted after something I did or said; he later admitted that he had almost had me fired for insubordination. Our offices were six floors above the magazine's other editorial departments, so I was unfortunately isolated from other women staffers who could have offered sympathy and support.

After returning from Tunisia, I was relieved to have my request granted for a transfer to the business department. The editor was encouraging and gave me interesting, sometimes fascinating, assignments, like reporting on Senator George McGovern's economic policies prior to the 1972 presidential election. Once I was asked to interview heavyweight boxing champion Joe Frazier about his backers, who invested his earnings for him. At his gym in Philadelphia, the muscled boxer seemed bemused by both me and my straightforward questions, as well as undecided about whether or not to make a pass at me; unlike other men I had interviewed, he restrained himself. After I stopped taking notes and closed my notebook, he kindly offered to drive me to my hotel in his white Corvette convertible. I accepted the offer and climbed in the sportscar, which had its top down; when he stopped at a red light a few blocks from his gym, an adoring crowd of youngsters gathered around to shake his hand. A block away from my hotel in downtown Philadelphia, he suddenly braked and suggested I get out and walk the rest of the way. "I don't want your old man to beat me up," he joked, evidently worried about the propriety of our being seen together.

It was becoming increasingly evident that despite the memorandum of understanding, the executive editors who had signed it two years earlier were not taking it seriously. *Newsweek* still depended on its researchers to do an enormous amount of reporting without fairly paying or promoting them

for it. When I confided to another researcher my desire to be assigned to the Nairobi or another news bureau, she gently informed me that it was unlikely to happen. When a researcher in my department who spoke a little French quit and moved to Paris to try to get assignments as a stringer, I understood why. Angry women staffers met again and decided to hire another lawyer, and a few months later I and others signed a second legal complaint about the newsweekly's ingrained gender discrimination.

It was around then, in 1973, when one of the male business writers who was sympathetic to our plight and skeptical about the editors' intentions offered to help me get a job elsewhere. "Do *now* what you want to do, don't wait for *Newsweek* to do it for you," he urged me. A Reuters newsman had given me his card at a press conference, telling me to get in touch with him if I ever got tired of *Newsweek*. I am still puzzled why I did not; I probably felt pessimistic because women at other news organizations, like *Time, Life, Fortune, Sports Illustrated,* and *The New York Times,* were also filing discrimination complaints. I wanted to win my rights where I worked rather than beat a retreat, so I ignored his offer and the advice of my colleague. Very few women actually left *Newsweek* in the early 1970s because despite everything it was an exciting and prestigious place to work.

Like other researchers, acting as a reporter early in the week and then a fact-checker at the end of the week, I was increasingly impatient. "Surprisingly," I jotted down in my journal, "the one thing I'm not insecure about is my writing." One day I walked into my editor's office and told him I wanted to try out for a position as a writer. He was willing and gave me some stories to write, and I was elated when they appeared, lightly edited, in the magazine. Suddenly, shockingly, it all ended after he was promoted to head the prestigious National Affairs department and was replaced by my old nemesis, the Wall Street columnist.

Fortunately, before long I was offered a summer reporting tryout in the Atlanta bureau. I was thrilled and immediately agreed to go, even though being offered a trial instead of the job itself was discriminatory. Instead of moving into my boyfriend's apartment that spring, I signed another two-year lease for my apartment. After driving my Karmann Ghia to Atlanta, I sublet from an Emory University professor an apartment located on the edge of a dense growth of glossy-leafed magnolia trees. Exhausted after the winter in New York, I spotted a flyer promising transcendental meditation as a way to unleash energy and clarity of mind and went to the address listed. There I found a Georgian mansion almost empty except for sparkling crystal chandeliers and languorously rotating fans above chairs placed in circles on thick dark green carpeting. It was calming to sit quietly for an hour with others while warm, moist air gently wafted through large windows in the twilight, and afterward I went home and slept deeply.

Soon the bureau chief, an affable southerner, began to send me throughout the southeastern states on a variety of assignments. It was exactly what I had dreamed about when I decided in college to become a reporter. One week I flew to Alabama for a political rally for Governor George Wallace, and another traveled to the North Carolina mountains for a music festival of old-time fiddlers. The work not only demanded skillful reporting but also immense practicality. When trying to rent a car in Florida for an important story about backlash against growth, I was appalled to learn that my New York driver's license had expired. Within a day, however, I managed to get a Florida driver's license, rent a car, and begin interviewing throughout the state from Tallahassee to Miami.

Initially, when I wanted to be by myself in the evenings instead of scouting stories in Atlanta, I wondered if I was outgoing enough to be a reporter, but by the end of the summer I believed I was. In fact, I felt so empowered by the reporting

that I felt freer to express my femininity in the way I dressed: I began to wear more jewelry and scarves, gestures that added to my wonderful feeling of wholeness that summer. At the end of August, when it was time to return to Manhattan, I felt apprehensive about what lay ahead. On my last weekend in Georgia, I tried to gather together my inner resources by meditating, listening to classical music, walking along a path in the magnolia forest, and swimming in the underlit turquoise water of the apartment complex's swimming pool, which shimmered like a jewel in the darkness at night.

The Atlanta bureau chief told me I had done well, and the magazine's writers back in New York said they liked my reporting, so it was disheartening to return to my former position. Early on an editor had remarked that my prior journalism experience didn't matter, and now even what I had done while at the newsweekly didn't matter either. A decade after gender discrimination was declared illegal, and even though *Newsweek* editors were more aware of the law than those at *The Providence Journal*, most men were still resisting women's advancement as an assault on their privileges and pocketbooks. The editor in charge of *Newsweek*'s news bureaus called my reporting "intelligent and thorough" but found ways to disparage it, too, like calling it too lengthy, a criticism I knew was not applied to male reporters. Even though I wasn't married, I felt I had to tell him I didn't plan to have children; good jobs were so hard for women to get at the time, we felt we couldn't handicap ourselves by becoming mothers.

After half a century Congress had finally passed the Equal Rights Amendment and sent it to the states for ratification, so optimism was in the air, and I remained stubbornly hopeful out of a sense of what was right instead of what was still not yet reality. Also, *Newsweek*'s owner, Katharine Graham, the publisher of *The Washington Post*, had become friends with Gloria Steinem and had told the magazine's executive editors

to settle the gender discrimination dispute once and for all. A second memorandum of understanding, this time with goals and timetables, was subsequently signed, stating that by the end of 1974, women must make up a third of the newsmagazine's writers and reporters, and a female senior editor must be named by the end of the following year.

As I impatiently waited for something to happen, a sense of recklessness took over. When a writing position opened in the business department, I asked my editor, the former Wall Street columnist, to let me try out for it, and he reluctantly agreed. As I wrote stories, I worriedly watched him interview other women from elsewhere for the job. The bitter irony was that *Newsweek* editors began looking outside the magazine to fill quotas demanded by the agreement for which we had fought. After a few weeks the inevitable happened, and the editor told me my writing had flaws and, besides, I had been "too tense and too insecure" during the tryout to get the writing job. I was incensed. The first editor for whom I had written said my writing style was stronger than its structure, and now this editor was saying the exact opposite, leaving me to conclude that neither was right.

To try to get me out of my despondency, Arthur found a light-drenched, ramshackle former greenhouse covered with honeysuckle to rent in the village of Southampton on the end of Long Island. I was immensely relieved to be outside the city and bathed in the reflected light from the surrounding sea as we rode our bicycles past flat fields and walked on long expanses of white sand. Still, his volatility and changeability from cruelty to kindness—a nasty verbal barb might be followed by an affectionate reach for my hand—continued to throw me off balance. One weekend I had enough and announced I wanted to break up. Arthur's response, as if he hadn't heard me, was to tell me to go find a judge to marry us and to buy me a bouquet of red roses. "Even if you go away," he told me, "you'll still be my sweetheart."

Dispirited and fighting despair, I eventually remembered that Virginia Woolf had regularly reread what she called her diary to better understand what had happened in the past, so I decided to read mine. Back in Providence, when I had mentioned to an elderly uncle my plan to move to New York, he had shaken his head gravely and said nothing good would come of it. The family genealogist, he was well aware that for generations the sons and daughters on my mother's side of the family had remained in New England. Maybe he had been right, I reflected, and I never should have left Rhode Island after all. I thought about returning after seven years away, moving into one of the handsome old houses near my birthplace on Williams Street, and working for *The Providence Journal* again. But I did not because Manhattan continued to act as a centrifugal force spinning me into its center, and I wasn't ready to give up on it yet.

Aware that my savings account was the key to my liberation, I decided to stay at *Newsweek* a little longer to save money during that recession year. I had always liked the newsweekly's fast pace and exacting professionalism and, during the Watergate scandal, being privy to inside information. Before long I was transferred to the "back-of-the-book" to work on interesting stories in the ideas and religion departments. Meanwhile, I enjoyed the magazine's benefits and perks, like spending a week in the Washington, DC, news bureau and attending a White House press confidence in the Rose Garden presided over by President Gerald Ford. Still, working at the newsweekly meant practicing group journalism—where an editor or two, a writer, one or more reporters, and a researcher produced a story together—preventing each one from using all his or her abilities, or experiencing creative fulfillment, or even winning a byline. So I awaited the moment when I could take a leave of absence and devote myself to writing in my own name.

17

Discovering Georgia O'Keeffe

At a writer's conference in January 1975, at the New School in Greenwich Village, I ran into a longtime friend, a genial and aspiring Nicaraguan writer; we greeted each other happily, and he asked what I was working on. In one of those rare illuminating moments, when the words emanating from one's mouth seem to emerge from elsewhere, I blurted out that I wanted to write a biography of artist Georgia O'Keeffe. I was as surprised by my words as my sudden certainty about them. As I thought about that intuitive flash during the following days, I realized that writing a book about the elderly painter, famed for her New Mexican landscapes, would liberate me from the frustration of being unable to use all my abilities at *Newsweek*, allow me to use the research and reporting abilities I had honed there, at the same time enable me to learn a lot about twentieth-century art, and, perhaps most important, give me a rationale to go "where I want, when, and alone, if I so desire."

I had first become aware of the legendary painter five years earlier when I went to a retrospective of her many years of artistic output at a time when young feminists like myself were looking for role models and inspiring predecessors. We were asking who the great women writers and the great women artists ignored by history were. On the spacious top floor of the Whitney Museum of American Art, thirty blocks up Madison Avenue from the *Newsweek* building, more than a hundred of O'Keeffe's drawings, watercolors, and oil paintings were on view in New York for the first time in decades: images of fiery storms and quiet sunrises, abstractions in rainbows of color, brilliant little washes of red poppies, animal skulls levitating in crystalline skies, fleshy pink hills dotted with sparse green scrubs, shockingly towering mesas and mountains, and much more. What riveted me most of all was the aura of both passion and peacefulness in the work. As I stood in the silence of the gallery, my excitement grew along with a strong desire to learn more about the woman artist who had conceived and created the paintings.

On the way out of the museum I bought the exhibition catalog. On the cover was a wraparound reproduction of a pellucid pale blue-and-white celestial image of the sky populated with rows of orderly clouds. I read the catalog avidly, learning about the young artist's art classes during the early years of the twentieth century, her marriage to New York photographer and art dealer Alfred Stieglitz, and her midlife gravitation to the Southwest without him. It interested me that she didn't have children. That year, when I was still in my twenties and trying to become more genuine and expressive, I had cut an article from *Mademoiselle* magazine about the importance of being "the Real You." As I read the Whitney catalog, I underlined a phrase about O'Keeffe "simply being absolutely herself, as always," while searching for insights about how, as an artist and wife, she had managed to thrive and even triumph.

I began looking for more information about this fascinating woman. The aged artist might be a living link between an earlier feminist era and the present one and, if so, her success ratified the importance of believing in second-wave feminism. Surprisingly, I found no books about her, so during the next five years I methodically went through the catalog's bibliography looking up the sources listed. I found a wealth of material, especially evocative excerpts from O'Keeffe's letters in old press releases in a clipping file in the *Newsweek* library. Along with reading articles about her and reviews of her work, with growing excitement I dipped into southwestern literature, including books about Native Americans, like *Black Elk Speaks*, and Hispanics, notably Willa Cather's *Death Comes to the Archbishop*, set in Santa Fe.

Right before the writer's conference Arthur had asked me to take my two-week vacation with him in California; I agreed but insisted on going to New Mexico by myself before meeting him in Los Angeles. Ever since throwing away my airplane ticket to Albuquerque along with the chance to join the Peace Corps nine years earlier, the Southwest had become my lodestar. It was where O'Keeffe lived and painted, so the idea of New Mexico became more intriguing than ever—a place of possibility that might be a new beginning. It was time to see it for myself.

In early February I hastily handwrote a letter to the elderly O'Keeffe, admitting that I was writing "out of the blue" as well as "taking the liberty" to ask to visit her after I got to New Mexico in ten days. I wanted to talk with her, I earnestly explained, because of my intense interest in her way of life, especially what I described as her "inspiring" devotion to painting. I imagined she understood, and even embodied, what I wanted to know about the importance of meaningful work for a woman. This issue—how much of a commitment should I make to my own work—was very important to me,

and her dedication to painting was encouraging me to bring more determination to writing. Exaggerating my credentials as a journalist a little, I promised to write an article about her for *The New York Times* or *Ms.* magazine. Unsurprisingly, she did not respond to my letter. It was, of course, presumptuous of me to ask for a famous artist's time, but in my defense, I was unaware of how many other young admirers were also reaching out to her.

Flying into the Albuquerque airport, the airplane descended through sparkling clear air to a low tan terminal building located between a bare dark mountain with a snowy summit and flat orangey mesas in the far distance. After checking into a motel, I tried to telephone O'Keeffe but discovered that her number was unlisted. Looking around at the city of my dreams, I liked the raw western look of the sun-drenched, rapidly expanding, treeless metropolis: the large new adobe-style public library downtown, and older similar buildings on the University of New Mexico campus near a slowly moving stream of muddy water, which I was surprised to learn was the famed Rio Grande. With an idea for a freelance article about mining on Native American land, I headed to the Navajo tribal headquarters in Window Rock, Arizona, but the suspicious official in charge of mineral development refused to meet with someone from *Newsweek*, so I soon moved on. In Santa Fe, when I spotted *The New Yorker* on a newsstand and heard classical music in the lobby of my hotel, I felt the city was more where I belonged. Setting off by foot, I noted more promising signs: a fine arts museum and a women's center along with a Unitarian church and a Quaker meeting house. In the public library I saw issues of *Writer's Digest* as I searched for signs that I could succeed in New Mexico as a freelance writer or, hopefully, a biographer of Georgia O'Keeffe.

Trying to find anything in print about the artist, I entered a secondhand bookshop, where a fragrant little pinyon fire

glowed in a corner adobe fireplace. After I chatted with the
proprietor for a few minutes in the empty shop, he suddenly
asked me out for a drink; surprised, I agreed. He locked the
door, and off we went. In the bar I got the impression that
he was telling me tall tales about himself, but nevertheless I
agreed to go with him to the nearby San Ildefonso Pueblo to
meet an ancient Native American woman who made black-on-
black pottery. As we drove out of Santa Fe in his sports car
into a vast ochre landscape of pale mesas and green pinyons,
I felt a shock of recognition as if I was literally inhabiting one
of O'Keeffe's paintings. The next day when I walked into a real
estate office to ask about rentals, I found a realtor so desperate
for business that he offered me his own apartment. My encoun-
ters with lonely and seemingly lost men struggling to survive
were a reality check about making a living in New Mexico. I
had visualized the state as a wide-open radiant frontier where
it might be easier to live and write and be with friends, but by
the time I left for the airport in Albuquerque, I was worried
about ending up there as a waitress instead of a writer.

Since I was in Los Angeles for the first time, Arthur asked
me what I wanted to see in his hometown. The libraries and
gardens, I told him, so he took me to the modern UCLA library
and to the extensive Huntington succulent garden. As we drove
around, I didn't see a single bookstore or neighborhood library,
although they must have existed. Compared to Manhattan or
even Santa Fe, the massive metropolis didn't look to me like a
place for a nonfiction writer, especially someone like myself
uninterested in writing screenplays. It was his idea to go for
a drink to the glamorous Polo Lounge of the pinkish stucco
Beverly Hills Hotel to catch a glimpse of movie stars. Then we
drove up the Pacific coastline, where he mused about open-
ing a bookstore in a pretty town like Carmel, which sounded
like a nice change from his latest job with a big conglomerate
involved in the business side of book publishing in Manhattan.

After my vacation was over, I flew back to New York, and soon Arthur returned, again giving up the idea of going back to California.

Almost immediately he learned that a large and reasonably priced apartment had become available in his building and suggested we rent it together. When he took me to look at it, I thought its little maid's room with a large closet and a south window, as well as a heavy old door that swung shut, would be a perfect writing room for me. It also entered my mind that if we eventually married and had a child, the maid's room could become a nursery. The unanswered question—always in the back of my mind after I turned thirty—was how to be a dedicated writer and devoted mother at the same time. It seemed impossible, especially after President Nixon vetoed a bill subsidizing daycare centers, and a nearby one closed. Until I discovered Georgia O'Keeffe, I was unable to visualize living a fulfilled womanly life without giving birth, but afterward, inspired by her example, I began to imagine the possibility.

Do I want "roots, stability and what's familiar (and sometimes painful) or the adventure—and hope—of the unknown?" I asked myself, trying to decide whether or not to live with Arthur in New York or move to Santa Fe. Exhausted by years of vacillating feelings toward him, I finally agreed to cosign the lease. O'Keeffe had spent little time in New Mexico until she was in her early forties, so at my age, thirty-two, I thought I could wait a few more years before moving there. Splitting the rent—I wanted an egalitarian relationship, symbolized by paying half our expenses, even though Arthur was earning much more than I—would still allow me to save more money than living in my own apartment and, I reasoned, might enable me to leave my job at *Newsweek* and afford to write the biography of Georgia O'Keeffe.

On a visit to Rhode Island a few months later, I mentioned my book idea to a cousin, and he advised me to talk with

Whitney Museum director Lloyd Goodrich, a family friend who was vacationing at his nearby country house. White-haired, wiry, and talkative, Goodrich informed me that it was he who had proposed O'Keeffe's retrospective, and that she had agreed to it after he promised an impressive catalog—the one I had read so excitedly—with an extensive essay about her importance in the art world. It had worked because O'Keeffe had long wanted her work to be written about at length by an art historian, but, surprisingly, it had never happened before the way she wished. He had spent five days with her in Abiquiu planning the exhibition during the summer she was executing her enormous *Sky Above Clouds IV*, the painting on the catalog cover. He affirmed my impression that O'Keeffe had, indeed, achieved a rare sense of fulfillment, a contentment that espe-cially interested me. "I never knew anyone who was more sat-isfied with her life," he stated, adding that she was also tough, forthright, and possessed of an extraordinary memory. Well aware of her position in American art, she had demanded the museum's largest, top floor, he went on, forcing the postpone-ment of the exhibition for a year. After her arrival in New York prior to the opening, she took a disapproving look at how her paintings were presented. "You hang by the idea, and I hang by the eye," she declared to Goodrich, and insisted on rehanging the exhibition herself.

After recounting O'Keeffe's reputation as a prickly recluse who had blocked other biographers, like her old art-school friend, Anita Pollitzer, who had spent a decade writing a biography of her, Goodrich nevertheless encouraged me. He offered suggestions about whom to write and where to find material, then gave me some blunt advice: since O'Keeffe's extremely controlling agent, Doris Bry, also wanted to write a book about her, be as quiet as possible about my intention until I was well underway. This warning gave me pause since I was unsure how to research and interview people about a living

person without word getting around. I stubbornly didn't want to give up the idea, however, because I sensed that O'Keeffe's story had something important to tell me at an uncertain and confused time in my life. Before the summer was over, I took a few more vacation days and flew back to New Mexico where I met my sister, an aspiring artist who had graduated from the San Francisco Art Institute and lived in California. After a few days in Santa Fe, we drove north and stopped in the village of Abiquiu, where we gazed at the high massive adobe wall around O'Keeffe's house, which looked impenetrable to me.

18

Beginning the Biography

The following summer I had a stroke of great good luck when Dad announced he would be selling the firm that had been in his family for seven generations because his son, my half brother, a craftsman in his early twenties living in Vermont, was uninterested in running it. The sale of my shares of its stock—equivalent to my yearly salary at *Newsweek*—was an unexpected gift that galvanized me into doing what I had dreamed about for so long: taking a leave of absence to write. In preparation I bought a camera and tape recorder for my new life as a freelance writer and, hopefully, as biographer of Georgia O'Keeffe.

It was not that simple, however. Three years had passed since my thirtieth birthday, and in August, the month before I was to turn thirty-four, a powerful drive to make full use of my body as well as my brain unexpectedly kicked in. "It hit me like a ton of bricks—I want to have a baby," I wrote in my journal, weighing more seriously than ever the pros and cons

of marrying and becoming a mother. When I brought the matter up with Arthur, more forcefully this time than before, he emphatically declared that he was neither interested in becoming a father nor willing to help me raise a child, a response that made me ask myself if getting pregnant would be a form of self-annihilation and an end to my aspiration to write. I also did not want to impose on a child the pain of having an uninterested father because I knew only too well what that was like. It also entered my mind that my undoubtedly estrogen-infused urge to give birth was an excuse for avoiding failure as a writer or even an escape from freedom.

In the 1970s, whether or not to become a mother was a momentous question for feminists my age, and many of my friends with careers were struggling with whether or not to continue to live lives unlike those of our mothers. It was a choice the pill had given us, an enormous power over our reproductive lives that we weren't sure how to handle. We were excited about doing wonderful things but wondered if meaningful work would be enough. Intent on equality with men, we appreciated the relative lack of traditional gendered roles in our childless relationships. So many of us were child-free that I curiously regarded a college-educated friend with a baby and no interest in a profession as a throwback to an earlier time. When another friend, a writer and editor, told me she thought about her small daughter eighty percent of the time, I interpreted it as a warning. Would there be room in my head for a baby and a book too? I didn't know whom to ask for advice—certainly not my mother—so I looked to the lives of Georgia O'Keeffe and other older women I admired, most of whom had created books or paintings instead of children, but sometimes not without regrets. A few months later I picked up Oriana Fallaci's anguished *Letter to a Child Never Born* in an attempt to reconcile myself to never giving birth.

That autumn of 1976 an enormous and expensive art book, simply titled *Georgia O'Keeffe*, was published by the artist to great acclaim. It had more than a hundred reproductions of watercolors and oil paintings printed in lavish color on heavy glossy stock, including a foldout image of the enormous sky-and-cloud painting wrapped around the cover of the Whitney Museum catalog. The volume included reflections by the artist, mostly about what she had wanted to paint and why. As I leafed through it, the descriptions of her visual memories raised more questions in my mind than they answered. The clear, guileless, almost childlike voice placed alongside the pictures about the sights and shapes that had mattered to her made me want to learn more, much more, about the person behind it, especially about her marriage to the husband whom she barely mentioned.

Around that time, I saw a brochure from a place called the Womanschool, a feminist adult education academy, offering a class about writing book proposals. I immediately signed up for it and began drafting a proposal for an O'Keeffe biography. When the instructor, a Doubleday editor, asked for a sample chapter, I took two weeks of vacation to research and write one. I had heard about the archive that O'Keeffe had established at the Beinecke Rare Book & Manuscript Library at Yale, so every few days I took the train to the contemporary white marble building in New Haven. It was electrifying to sit in its glass-walled reading room softly illuminated by daylight from a sunken courtyard with serene pale Isamu Noguchi sculptures, while reading a sampling of O'Keeffe's letters. She had sealed the voluminous correspondence with her husband, Alfred Stieglitz, but letters she had written to artists and writers in their circle were available to me. Her large upright calligraphic handwriting—the word "I" was curled in on itself until it was strongly centered—was composed of bold strokes, intricate squiggles, long wavy lines, and scattered dots, all made with

black ink from a wide-tip pen on white paper. As I read page after page of her stunning script, I found a more intense voice than what had been published in the art book, one that was more intimate, forthright, and revealing:

> Your letters are certainly like drinks of fine cold spring water on a hot day," she wrote to Anita Pollitzer. "They have a spark of the kind of fire in them that makes life worthwhile— That nervous energy that makes people like you and I want and go after everything in the world—bump our heads on all the hard walls and scratch our hands on all the briars—but it makes living great—doesn't it?—I'm glad I want everything in the world—good and bad—bitter and sweet—I want it all and a lot of it too . . .

Looking back, I realize that biography was in my blood. As a beginning reader I had devoured children's biographies of girls, and later I would read adult ones about Zelda, Frida, Isak, Sylvia, Virginia, and other women novelists and artists. Many of them, I had noticed, had been destroyed by others or had destroyed themselves. Zelda Fitzgerald went mad. Virginia Woolf killed herself at fifty-nine, Sylvia Plath at thirty-one, and Anne Sexton at forty-six. It was frightening; I definitely didn't want to join the ranks of the mentally distraught, any more than I had when passing the asylum wall in Providence or working in the psychiatric hospital near Boston.

What I wanted to know was how Georgia O'Keeffe, unlike so many other women in the arts, had managed to express herself so fully, freely, and fearlessly for so long. (Later I learned that even she had suffered a mental breakdown, but it was one she recovered from.) The question took on great importance to

me because some of her dilemmas as a young woman seemed like mine, so I developed a driving curiosity to discover how she had finessed them, as if she were my mentor. What price had she paid for intimacy, and where had independence taken her? I developed a compulsion to find out, *to feel* how her experiences had felt to her, how she had made choices about creativity and childbearing, how everything had really turned out, and especially how she ended up so supremely contented in old age.

After showing the Doubleday editor a short sample chapter, I became optimistic when she asked for a cover letter so she could submit it along with my proposal to the publishing house. A few weeks later, however, I was disappointed when she informed me that another editor had already asked someone within O'Keeffe's circle to write her biography and was awaiting an answer. By then I was so eager to write the biography that I didn't let myself become discouraged. At *Newsweek* I had learned that hours of boredom as a researcher were more exhausting than hours of excitement as a reporter, and now writing about O'Keeffe didn't seem like work at all, even if it would be more difficult and more of a gamble. "At least I'll be alive!" I jotted down in my journal. Impassioned and impatient, and before I had a literary agent, I requested and was granted a year's leave of absence from *Newsweek*, then threw a party to celebrate my liberation. Whether or not I found a publisher, I vowed to get in my Karmann Ghia and drive to New Mexico. "My fantasy of escape is with me again: taking off in the little green car with typewriter, notebooks and pens, tape recorder, sleeping bag, etc. for the Southwest," I noted. "I feel great in my ability to *leave*, my ability to say *no*, to refuse to be bored or exploited any more. Now that I've done it in one area, can I do it in others and do it again?"

Fortunately, a few weeks later I found an agent; she quickly telephoned a young woman editor at W. W. Norton who was

overjoyed at the prospect of publishing the first biography of Georgia O'Keeffe. Late one March evening, after Arthur and I had gone to bed, the telephone rang; I sat up, turned on a lamp, and answered it. It was my agent calling to say that the editor had definitely decided to offer me a contract to write the biography. Elated, I put down the receiver. Not only was it a green light to go ahead with what I so ardently wanted to do, but it was also a sign that at last I was going to be a professional writer.

When I told Arthur the wonderful news, his response was to turn his back and growl that if I didn't turn out the light, he would go sleep in another room. I had forgotten his fear that I would leave him when I became surer of myself, but his negativity at that important moment—and evidently envy, since his novel was not yet published—was deeply disturbing. I realized then that writing the biography might end our relationship, but it was a risk I was willing to take because it had been rocky for so long. During the next few weeks he repeatedly asked me to postpone my departure for New Mexico; when I refused, he tried to arouse my guilt about going, then he tried to sweet-talk me into staying, but I was used to his bursts of attention and affection not lasting very long, and I remained determined to go and maybe never return.

When I had moved with Arthur into the large apartment, my mother had asked me to take the replica Chippendale corner cupboard made by my father. After movers brought it in, I oiled the silky mahogany, working a cloth around its grooves and arched panels, cleaned its twelve mullioned glass windows, and polished its delicate brass hinges, along with a lock and filigree key, and a tiny metal plate inscribed "Laurence Lisle." When I thought about moving to New Mexico during those days, the corner cupboard and other inherited antiques felt like a restraining force. "Damn all this furniture—things would be so much easier without the expense of having to cart

it around," I complained to myself, while acknowledging that the family legacy was too meaningful to give up. Maybe it was only an excuse, I also admitted, because I didn't want to go through the trauma of breaking up and moving out instead of pouring all my time and energy into researching the biography.

After ricocheting for weeks between optimism and anxiety, worrying that the Norton offer would not materialize if Doubleday announced an agreement with another biographer, I finally signed a contract and deposited the first third of a modest advance against royalties into my bank account. On a warm spring morning, I threw open the large south window in my writing room; after a few hours at my desk I headed toward the greenery in Central Park and ran around the reservoir, moving with the spring breeze. At moments I felt flashes of fear about driving so far alone in my eleven-year-old car with its unreliable ignition, but I was fiercely motivated to leave for New Mexico.

19

Looking for Georgia O'Keeffe

Early on a morning in late May, I began packing the Karmann Ghia parked down on the street. Most of what I crammed into its small trunk was for research: maps, reporters' notebooks, lists of names, addresses, and telephone numbers, along with shoeboxes full of blank index cards on which to copy information from the notebooks, a laborious method of organizing material for manuscripts before the days of personal computers. And, of course, I packed my journal. The notebooks were for what I would be learning about Georgia O'Keeffe, while the journal would be about what would be happening to me, the ongoing bifurcation between my third- and first-person voices. My plan was to stop everywhere along the way to New Mexico in places where O'Keeffe had lived or taught in her youth to look for letters, photographs, school reports, public records, and whatever else I could find out about her. I assumed the grapevine would guide me from place to place and person to

person so I could interview anyone who had crossed her path during her long lifetime.

After crossing the George Washington Bridge and turning south in New Jersey, I drove four or so hours to the National Gallery of Art in Washington, DC, to view the key set of Stieglitz's large photographic portrait of O'Keeffe. It was fascinating to see image after sepia image of a youthful art teacher with a hint of a smile turn, over two decades in front of Stieglitz's camera, into a stern artist with head held high. In a library in Charlottesville, Virginia, I excitedly discovered a studio portrait of her at twenty-eight, posing in a stylish striped blouse, with a little dimpled smile playing around her lips, when she taught at the University of Virginia's summer school. Then I continued farther south to North and South Carolina, stopping along the way to see the nephew of the late Anita Pollitzer, who let me read overnight the manuscript of his aunt's unpublished O'Keeffe biography. Although I found it a little sentimental, it gave me invaluable information about many important matters, including her breakthrough as an artist while teaching in the South.

As I turned my little sports car west toward New Mexico, a number of hair-raising dangers almost truncated the trip. High sixteen-wheelers menaced my low-slung vehicle several times, as if it was invisible to them. When I stopped along the interstate highway across Mississippi and Louisiana, men in coffee shops often stared silently at what they saw as a girl by herself driving a foreign car with orange New York State license plates. Once I locked myself out of the car and had to appeal to strangers in a nearby bar who, luckily, rescued me by inserting a coat hanger through the window frame and releasing the door handle. When the car stalled or failed to start, I had to jump-start its manual-transmission engine by either rolling it downhill or asking bystanders for a push. Sometimes afraid of turning off its faulty ignition, I would keep the engine running

and ask someone to guard the car while I rushed in and out of a highway restroom. The dark green car lacked air conditioning, which had never bothered me in the north, but when the midday heat rose and became unbearable near Dallas, I poured water from my canteen over my head to keep from passing out. The fuel in the gas tank expanded and leaked in the heat, sending toxic fumes into the car. After the scare in the heat, I began getting up before dawn and driving in the cool and darkness, reading the road map by flashlight, to an air-conditioned motel before the daytime temperature soared again.

Suspended between what I was leaving behind and what I was moving toward, my solitary flight was fueled by dissatisfaction with my life in Manhattan and the anticipation of discovering something different in New Mexico. Still, some nights I felt frightened, like the time I read in a local newspaper about a rapist on the loose and my motel room door lacked an inside bolt. Another time my sunglasses were stolen at a rest stop. When my confidence wavered at nightfall, I would usually telephone Arthur, telling myself that someone should know where I was on the face of the earth. Once he bluntly asked me whether I would be returning at the end of the summer; I honestly replied that I really didn't know. "I don't want to hurt him, but I don't want a half-life either," I jotted down that night.

During my many long hours alone I came to the conclusion that being a little lonely did not make me unhappy. On days when driving under a crystalline sky with a strong sun behind me, I couldn't think of anything I'd rather be doing than going westward in the Karmann Ghia, even at its top speed of sixty miles an hour. I recalled reading that O'Keeffe had traveled by train with a woman friend to New Mexico during the summer of 1929, a trip that had upended her existence. Maybe it was more unusual to be going by myself, but I had read about gutsy single women travelers taking adventurous journeys, and I

didn't see why I couldn't do it, too. One early morning before daybreak in the high plains of the Texas Panhandle I detected the pungent scent of sagebrush through the open car window, and as the sky began to lighten I excitedly glimpsed the vast semiarid plain all around me.

At the Panhandle-Plains Historical Museum in Canyon, a small Texas town where O'Keeffe had taught art long ago, a librarian invited me to her home for a drink as the library closed for the day. As we talked, she admitted that she was jealous of my ability to travel, something that was impossible for her because she was raising three children on her own. I was quietly reveling in my independence, too. The year before, Adrienne Rich had published *Of Woman Born: Motherhood as Experience and Institution*, a brilliant book about mothering, in which she confessed that when her three sons were young, she had envied a woman friend without children for her "life of privacy and freedom." Rich's reaction, and my own uncertainty about remaining childless, reflected the dilemmas of so many other young women at the time, suspended between our desires for autonomy and intimacy, and unsure how to integrate them. I was intrigued by the idea that O'Keeffe might have an answer.

One afternoon in Canyon I drove the twelve miles over a flat plain to Palo Duro Canyon, an abrupt deep crevice in the ground with high rock-cliff walls. O'Keeffe had often hiked there, I had learned, and I had seen a reproduction of her depiction of the canyon—called *Painting No. 21*—rendered on a board in raw and violent tones of orange, yellow, and red pigment, where she had described terrifying steep climbs down and up its narrow sheep paths with her youngest sister, Claudia. "Often as we were leaving," she wrote poetically in her art book, they would look up and see "a long line of cattle like black lace against the sunset sky." As I neared the canyon, I saw a sign for a riding stable and joined three teenage girls

preparing to go down into it on horseback. In a thrilling and dramatic descent, the horses inched along a trail between rock walls dotted with succulents and tiny wildflowers until they stopped near a small stream and more abundant green growth at the bottom. When we rode back up the trail, I saw that the late afternoon sun had turned the rocks into the same burning shades as in the young artist's painting. It was another day when I identified with O'Keeffe—then because of our shared rapture for nature—that would last throughout the writing of the biography.

Finally, in July, I crossed over into New Mexico and was excited to drive into Santa Fe around noon.

Before leaving New York, I had begun interviewing members of the Stieglitz family, so it was impossible to keep quiet about what I was doing any longer. I wrote O'Keeffe to tell her and ask to meet when I got to New Mexico. When an elderly member of the family heard that I had received no reply, she promptly telephoned her in-law, then told me that, indeed, O'Keeffe would see me.

So right after my arrival in Santa Fe, I sent her a handwritten note but, once again, there was no response. After obtaining her unlisted telephone number from one of her friends, I got up my courage and dialed it on a Sunday. It was obviously O'Keeffe who answered. As I told her about the biography, mentioned meeting her classmates in Virginia and students in Texas, she seemed extremely interested in what I had to say. When I put down the telephone after about ten minutes, I was elated because she had said nothing about not wanting me to write the book. And when I had asked her about contacting her friends, she had not objected, even remarking that I was welcome to what I could get. Talking with them was important, I believed, because few had been interviewed about her before, and some were very elderly, like artist Dorothy Brett, who died a few weeks after I met with her in Taos. When I

asked O'Keeffe if I could visit her, however, she told me she wasn't seeing anyone that summer because she was busy with a lawsuit (I later learned she was terminating her relationship with her longtime agent, Doris Bry), but I hoped she would relent before the summer was over.

Being by myself amid the visual majesty of New Mexico was, for a mysterious reason, arousing old memories and deep emotions. On most afternoons fluffy white clouds rolled over the sky, became gray thunderheads, and let loose a cloudburst; the darkened day would appear to be over, but then the billows would dissipate, and bright clear light would appear for another few hours until sunset. After a day of working on the biography, often in the Southwest Room of the New Mexico State Library, I liked to climb the outdoor steps to the roof of my tiny rented adobe house to watch sunsets, when puffs of vapor usually turned pink and orange before darkening to purple and gray at nightfall. At moments like those I would feel a faint and fragile perception, an intimation about reaching a kind of interior bedrock inside myself. It was related, I distinctly recall, to remembering feeling treasured during childhood on Williams Street, and it promised to raise my weakened sense of self-esteem. The maddeningly elusive emotion would only hover on the edge of my consciousness, however—like a butterfly beating its wings against a windowpane—and it was too delicate to grasp or prolong.

Six weeks after talking to O'Keeffe on the telephone, I typed a letter to her saying that I was glad to be interviewing her friends, but I had driven to New Mexico to talk with her. "I don't want to take up much of your time, but when I write about someone I prefer not to depend only on the impressions of others," I explained, according to my carbon copy of the letter. Still, I heard nothing. As my rental in Santa Fe ended, I loaded up the Karmann Ghia, headed north, and drove past the village of Abiquiu to rent a room at the Presbyterian

conference center at Ghost Ranch, where O'Keeffe had a small adobe house amid the wildly beautiful landscape. The road to the ranch wound through a narrow passage of stunning ochre cliffs before dipping down into a flat valley encircled by dramatically high mesas, all under a resplendent hard blue sky that was electric with energy. Maybe I would have a better chance of meeting the subject of my biography if I were closer, I thought.

A few weeks earlier in Albuquerque I had interviewed an old friend of O'Keeffe's, Maria Chabot, who had urged me to drop in on O'Keeffe uninvited, adding that she would probably like me. One day I put on the white linen suit I had carefully packed for the occasion and, not knowing where O'Keeffe was staying, drove back to her village house. I knocked on an ancient, rough wooden door in the high adobe wall, and when a white-haired woman opened it, I introduced myself. The woman said she was O'Keeffe's sister, Claudia, and that Georgia was at the other house. Evidently a little lonely, she invited me in, and we talked for several hours about the O'Keeffe family. As we said goodbye, she asked me to return for lunch the following day, but when I did, I heard disturbing news. She had spoken to her sister about me, and she warned me darkly and without explanation that I had come to New Mexico at the wrong time.

What had happened during the weeks since I had spoken to O'Keeffe? For reasons that were unknown to me, her young assistant, Juan Hamilton, had interfered the way he did with many of her other relationships, including the one with Doris Bry. Now he was the one who wanted to produce books about the artist who employed him. When I had telephoned him a few days before for an interview, he was rude and refused to meet with me; then he called the Ghost Ranch office and told others not to talk with me either. During interviews with his acquaintances in the days ahead, they began to challenge me about how I could write the biography without O'Keeffe's

involvement and permission and, ominously, if I even should. When I confided to a young geologist at the ranch about my efforts to study what I discreetly called "a small mammal," a veiled reference to my subject, she caught on and remarked she was glad her subject was inanimate rocks.

It was not until many years later that I learned that around that time O'Keeffe had dictated a letter to me denying she had told the Stieglitz relative she would see me. It went on in an irritated way, saying she disliked "being told that someone is doing a biography of me without ever asking me in the first place," adding that she would refuse permission for me to quote her letters or reproduce images of her work. Then, worse, she threatened legal action if I went ahead anyway. "So, I think you better give your idea up," her letter concluded. It was one more effort to discourage another biographer—as she had her friend Anita Pollitzer and more recently art historian Barbara Rose—but fortunately I never received the letter that summer because it was mailed to my defunct Santa Fe address.

Meanwhile, my editor had telephoned me from New York to ask if I was going to be able to talk with O'Keeffe, making me believe I had to make a breakthrough. So, early in the morning on the last day of August, I determinedly set out by foot on the rutted dirt road lined that month with purple wildflowers leading to her home at Ghost Ranch. After about a mile I glimpsed a low tan adobe building blending into the color of the earth. I walked up to it and knocked on a screen door. A dog barked a few times and then Georgia O'Keeffe appeared on the other side of the screen with her long gray hair framing her face, wearing a red-and-white kimono, and holding a toothbrush. Nearly ninety, her wrinkled skin, hooded eyes, and heavy eyebrows were softened by the screening, so she strongly—and very movingly—resembled the much younger woman I had seen in the photographs of her at the National Gallery that Stieglitz had taken so long ago.

After I introduced myself, O'Keeffe exploded in anger. She denied giving me permission a few weeks earlier to talk to her friends, explaining that she had thought I would only be interpreting her life, not gathering facts about every part of it. Had she forgotten? Had she changed her mind? Stunned and appalled, I immediately recoiled from the doorway and began to walk leadenly away. Her rage made me feel numb, a reaction that shielded me from the reality of what had happened. Underneath, however, the rebuff was devastating because she represented to me an idealized and inspiring other mother, an older woman with the courage to live as herself in a man's world—an Artemis-like figure strong enough to express and defend herself. It was how I wanted to be, too. Now she had tried to stop and smash what I was trying to do out of pure admiration for her. I reasoned that since she didn't know me or my veneration of her, her attitude wasn't personal. I also recognized that it was her lifelong way of protecting herself. Still, I was shocked and deeply disappointed.

When I got back to my room at the ranch headquarters, I discovered that my notebooks full of notes taken on the trip were missing, evidently stolen from a room without a lock on the door, like all the bedrooms at Ghost Ranch. Even though I had already transferred their contents to index cards, I was alarmed: it would be impossible to write the biography in an atmosphere of suspicion, hostility, and even danger in New Mexico. Instead of beginning a new life in the Southwest, it suddenly was more important to be nearer my supportive agent and editor in New York as well as the research libraries in the east. I was also more hopeful again about my relationship with Arthur after being apart most of the summer. I reasoned, or rationalized, that back in the safety of my little writing room, I could tap into the power of sublimation by wishing to be but not being in New Mexico. I hurriedly packed the Karmann Ghia and left the next day.

Still, I was not about to abandon the reporting I had set out to do. After abruptly leaving Abiquiu, I drove north through Colorado, across Nebraska and Iowa toward O'Keeffe's birthplace in Wisconsin where, unknown to her, I interviewed another of her younger sisters, Catherine, a warm and welcoming woman who talked to me a little guardedly about the O'Keeffe family. I did more research in the Midwest—where I was thrilled to see O'Keeffe's gigantic *Sky Above Clouds IV* perfectly placed above an entrance to a large gallery in the Art Institute of Chicago, where she had studied as an art student.

Worried about going ahead with the biography against O'Keeffe's wishes, I also knew I had a right to do it. She was an important historic figure as well as what is legally regarded as a public one, with less right to privacy after exhibiting her paintings for more than six decades, posing for photographers, and publishing her art book. I learned she had allowed herself to be interviewed for a television documentary to be aired on her ninetieth birthday in November. She had also permitted the Metropolitan Museum of Art to plan an exhibit of Stieglitz's photographs of her—including explicit nudes—in the spring. Under the law, if an individual opens the door onto his or her personal life, others are entitled to reflect upon it. "Where I was born and where and how I have lived is unimportant," O'Keeffe had stated in her art book, but then she had gone ahead and written about them. Legalities aside, I felt a little guilty about ignoring her response to me, but I didn't believe it was justified: she was an exemplar of something important and even essential to other women. Nevertheless, I wondered if she or her lawyers would try to stop or sue me.

20

Taking a Chance on Marriage

On the road I felt much less sure of myself heading east than going west a few months earlier. With a scratchy Bach cassette on the car radio, tears rolled down my cheeks as I mourned the gap between the elation of the music and the elusiveness of the emotions it expressed. As I neared New York, my stoicism took hold while I maneuvered the Karmann Ghia through rapid traffic and toward skyscrapers enflamed by late afternoon light. After parking on West End Avenue and taking the elevator upstairs, entering the familiar apartment felt deeply reassuring after four months on the road, as I carried boxes of photographs and photocopies, index cards, cassettes of interviews, and other research materials into my little writing room.

While I was in Santa Fe, Arthur had telephoned almost every day and sent a letter saying he loved me, wanted to marry and have a child together. When he flew out to New Mexico for his vacation, I liked being with an intelligent man I had known for seven years, to whom I could talk in shorthand. Back in

New York that autumn he returned from work earlier in the evenings and was more attentive and affectionate, even asking me about my book-in-process. "I feel we're stronger together, and I see more and more how I can help him—and how he can help me," I ruminated in my journal. During past summers in Manhattan I had felt uncomfortably enclosed in the angular gray cityscape while painfully separated from what was soft, green, and growing. We had talked in the past about getting a vacation house in the country, and we began to go house hunting on weekends. While I leaned toward the rolling hills of Connecticut, he favored the seashore on eastern Long Island, which reminded him of California, and his will won out: in October he made a bid on a small, furnished white house with a rose-covered picket fence on a village street in Southampton.

My doubts about staying single arose at the same time as the Equal Rights Amendment stalled and the media—including *Newsweek*—was declaring the women's liberation movement dead. As a feminist, I regarded myself more as an independent individual than as a potential wife, but my confidence about that view was eroding. Other women were still struggling with their choices; a married college roommate with two daughters remarked to me that I was the "experiment" she was watching to see how it worked out. Ongoing social pressure existed, too. When I went to a family funeral in the stately Unitarian church in Providence and walked out of the church with my relatives, I felt hundreds of questioning eyes on me asking, "Why isn't she married yet?" I was on unsteady ground and dependent in a way I had not been before, because I planned to resign from *Newsweek* before showing any chapters to my editor, and not knowing whether the biography would really be published or not.

For years I had been ambivalent about my relationship with Arthur, wavering between gratitude for it and anger at him, and I urgently wanted to end the draining inner exhaustion.

"Maybe you have to marry to exorcise the marriage ghost," I jotted down. "If I accept his long hours and tart tongue, there's a chance I can modify what I don't like—a little." I deeply desired a partnership of depth and durability, and I had known Arthur since I was twenty-eight. Getting married, I reasoned, would merely acknowledge what already existed between us: "If I continue to live with him—as it looks like I have a need or compulsion or desire to do—we might as well be married." I believed that now I could be both a writer and a wife and reconcile the sides of myself driven toward intimacy and independence I didn't want to give up.

When Arthur and I talked about setting a wedding date, I admitted to him that at moments it felt as if a fist was gripping my fearful heart, but he did not act alarmed. While the biography would take most of my time and attention for a year or two, I hoped that after it was done there might be time for motherhood. So we chose a wedding date, and I had invitations to a wedding party printed. After I addressed them, stamped them, and put them in the mail, I placed the telephone under a pillow to muffle any rings, then threw myself into writing about the life of Georgia O'Keeffe, who didn't want to marry and give up her legal autonomy either.

When I telephoned my mother with the wedding news, she sounded alarmed and didn't know what to say. During my summer in Santa Fe, she had offered to help pay my rent if I remained there. "What did I do that made Lulu marry Arthur?" she would guiltily ask my sister later. I never wanted to tell her that living for a decade with a volatile stepfather had given me a tolerance for male irritability and for a confusing tangle of physical security without psychological safety. When I told her that Arthur was insisting on going to a judge for the shortest possible civil service without any friends or family members present, she was so devastated that she wrote me a letter in shaky handwriting begging to be at my wedding; when I reread

the letter years later, it made me weep. My kindhearted mother was always knitting sweaters for everyone in the family—soft wools and bright worsteds in intricate patterns adorned with handmade buttons—as if to enclose her children and grand-children in her warmth. Despite her misgivings about my marriage, she began to knit my husband-to-be an intricate cable-stitched mohair sweater in the same light brown color as his wavy hair as a wedding present, probably praying with every stitch that he would be good to her daughter.

On the morning of our wedding in January 1978, I noticed a brown spot on the white wool dress I planned to wear, but I put it on anyway. Taking our rings, the marriage license, and his camera, Arthur hailed a taxi to go to the address of the judge's chambers in Lower Manhattan. It wasn't until the taxi let us out that I realized that his chambers were in the criminal courthouse, a grimy and depressing edifice full of the accused awaiting court appearances. In retrospect, I suppose getting married there was fitting since I was committing a crime against myself: I had ignored what I knew about my side with the strength to stand on my own two feet. Similarly, O'Keeffe had remarked after marrying that she felt like she had lost a limb. The judge, an older man with sad brown eyes and dandruff on his collar, called in two middle-aged office workers to be witnesses and married us quickly with a few words. In the judge's eyes, I had just lost my name; to my dismay he introduced us to the men as "Mr. and Mrs.," using Arthur's first and last names, the ones I never intended to take, the words with a suffix that reduced me to the "s" in "Mrs." Once I had planned to use my birth name professionally and a married one socially but learned that if a wife used two last names, a judge could rule that her husband's surname was her legal one, and I did not want to give up the right of naming myself.

Back down on the street, Arthur asked a passerby to snap a photograph of us with his camera; when I look at the

photograph now, I see a pair of attractive, smiling newlyweds: a young woman with long loose dark hair wrapped in a voluminous brown velvet cape and wearing embroidered brown velvet boots standing alongside a tall broad-shouldered handsome man in a tan overcoat. After Arthur put the camera back in his pocket, he spontaneously suggested we have lunch in the Crystal Room of the Tavern on the Green, maybe feeling guilty about the dreary and depressing atmosphere of the courthouse. In the Central Park restaurant, still festively decorated with little white lights for the holidays, I felt for a few hours like a bride, expectant but apprehensive, not unlike the way I felt while working on an unauthorized biography of Georgia O'Keeffe.

21

Becoming a Biographer

About a month after the wedding, Arthur returned one eve-
ning with the startling news that he had taken a temporary
position in Florida as president of a discount shoe chain owned
by his company. Admittedly, we had both previously put our
careers before each other, but even so I was surprised and
momentarily wounded by his willingness to move to Miami
so soon after we had married. I said little, except that I didn't
want to leave Manhattan for an unknown length of time while
working on the biography. Now that I had returned from New
Mexico, it was important for me to be near archives and librar-
ies, especially art museum libraries, I explained, to say nothing
of people to interview in and around New York. And after the
demeaning male-dominated milieu at *Newsweek*, I wanted to
be near my agent and editor, both of whom were women, while
writing about a woman artist.

 Arthur's absence, I soon realized, would guarantee me the
time and tranquility I needed to concentrate on the biography.

After a year of taking notes, the part of my brain that composed formal sentences and paragraphs felt like a muscle gone slack. My editor was eager to read finished chapters, so I was writing every day, all day, except for a few hours for exercise and errands, and well into the evenings. It took passion as well as stubborn stoicism, but I had plenty of both. As I pounded away on an old Royal manual typewriter, I became so absorbed in the writing that I only noticed that mornings had gone by when the midday sun started to scorch the skin on my hands as it passed the window in the small room where I had camouflaged the security gate and fire escape with a cascade of green-and-white striped spider plants, and hung a poster of O'Keeffe's wide celestial cloud painting above bookcases and near the ceiling.

In early drafts I wrote in the required impersonal way I had reported for *Newsweek*, but it wasn't right. When I had lunch with my editor, she praised the enormous amount of material I had gathered but wanted it presented in a less reportorial style. "Are you cautiously hiding yourself behind the façade of journalism because the subject of your biography is living as well as litigious?" she asked. Her perceptive question was underscored when I interviewed a white-haired writer, Herbert Seligmann, who had been a younger friend of Alfred Stieglitz's and lived on the other side of Central Park. Unlike people in New Mexico, fortunately, he didn't telephone O'Keeffe for permission to talk to me. Among many other matters, I learned from him about Stieglitz's rage at O'Keeffe for leaving him for summers in the Southwest, making me realize what incredible resolve it had taken her to paint the landscape she loved. After I stopped taking notes and closed my notebook, we slowly walked along Fifth Avenue, when the old man, leaning on his cane, remarked that instead of asking him so many questions about O'Keeffe and Stieglitz, I should develop my own opinions about them.

As I began a gradual transition from journalist to biographer, it at first felt presumptuous that someone my age, writing a first book, had the right to interpret the actions and ideas of an icon like Georgia O'Keeffe. It helped when I reread my *Village Voice* article about Kenya and was surprised to realize that my point of view had been confident and courageous and could be so again. I remembered that I had disliked the parasitic part of journalism that fed off others' experiences instead of one's own. Even though a biographer evokes another personality in a third-person voice, I started to see the genre as a partial form of personal expression because of the subjective selection of facts and commentary on them. I also thought about interpreting O'Keeffe's character as a representative of other women who were reacting to her in very personal ways. And as I did, my words flowed more easily and much more enjoyably.

Before marrying I had feared what I called "the bareness, the bleakness of isolation" of a solitary writing life when living alone, but working on the manuscript instead became an enormous source of pleasure. I loved awakening early knowing I had no obligation except to immerse myself in the book-to-be. "On mornings like this I feel a kind of exultation rise up in me," I noted one dawn. Excitement would sweep over me as I vicariously followed in O'Keeffe's early footsteps from Virginia to Texas. As I wrote about her later years, I felt I understood her desire for the life of a Persephone with winters in New York and summers in New Mexico. My emotional highs were caused by the discovery of a new letter, a revealing anecdote, or an interesting insight. Meanwhile, I asked myself the same questions as a friend of hers: "I never know how to explain the kind of exhilaration Georgia O'Keeffe gives to me and to others. Is it a single-mindedness that is inspiring? A style? After all these years, I, too, wonder." Something about O'Keeffe's personality—her sense of freedom or focus on her work—thrilled

me, too. When a young poet at the MacDowell Colony later asked me condescendingly if, as a nonfiction writer, I missed the high from creativity, I told her that writing a biography *was* an act of creativity, and I had been on a creative high most of the time when working on mine.

As I worked in my room in the apartment, sounds of sirens, horns, jackhammers, and shrieks of the subway came through the window glass, and I had to wear earplugs as I typed. When I went outside, I encountered dirty sidewalks, brown air, and mentally disturbed people living on Broadway a block away. When spring arrived, I packed my red sweatpants, running shoes, journal, typewriter, research materials, and manuscript into the Karmann Ghia and moved by myself to the vacation house in Southampton. It was an immense relief to be in a silent village surrounded by flat green farm fields with only the muffled sound of the sea and pulsating cicadas at night. As I happily raked dead fall leaves around the house, I got the first glimmerings of the fact that, like my mother, I was a natural gardener. Although the house was furnished in a way I disliked, with flowery fabrics and old furniture painted white, I ignored it because I didn't want to take the time to change anything. I turned the large white dining table into a desk, and got to work. In the slower pace of the village I was glad to discover that it was easier to make friends than in Manhattan; at a meeting called "Women Talk to Women," I met the elderly widow of artist Abraham Rattner, and a few days later lunched with her in her Marcel Breuer house in East Hampton.

During those spring and summer months my young editor would arrive in Southampton by Hampton Jitney, sometimes for a day but more often overnight, to go over with me the chapters she had edited. After I had heard the Doubleday editor at the Womanschool say that editing could only improve a manuscript ten percent, I worried how much mine would do, so I was very glad to have an involved editor who was also

interested in O'Keeffe's both disciplined and pleasure-driven personality and all other aspects of her life. At the time I didn't realize how unusual this relationship with an editor was, and that it would never happen again. And she later admitted to me that she had been a little worried that I might become too bored to give the biography my last ten percent, but our anxieties were unnecessary because we both had high hopes for the first biography of Georgia O'Keeffe.

Anything that took me away from the manuscript for long made me angry. "How could I have a child feeling like this?" I asked myself. When I talked about it with older parents during those days, I was surprised when they took my side. My stepmother, the mother of another much younger half brother, observed that since I had momentum going as a writer, and motherhood would put an end to it, it would be hard to get back. If I liked children, I could borrow others' or adopt them later, she added. She had wanted to be a newspaper reporter, she told me, but she became pregnant with her daughter before getting a job in my father's furniture factory. Still, an instinct to give birth was locked into my genes through the bloodlines of generations of maternal ancestors whose old-fashioned New England names I had seen in my uncle's genealogy chart. I was aware it was an ache I had to resist if I was going to finish writing the biography, and as I did my desire to give birth to a blood-and-bones being became a fierce urge to protect my growing manuscript.

Meanwhile, O'Keeffe was like a mentor to me, an uninvolved and unwilling one, but a mentor nonetheless. What especially interested me was her statement about the importance, even the euphoria, of genuine self-expression. Sometimes the price she paid for independence alarmed me, and other times her bravery made me envious, but as I shaped her story, I was inevitably shaped by hers. "What would Georgia do?" I asked myself before deciding that what was best for me—being left

alone to work—was also best for the biography. I was aston-
ished by her willful self-creation—her feisty declaration
about deliberately deciding what kind of a person to be and
then becoming it. One day I realized that the determination I
admired in her was what I was relying on in myself to write her
story. As I wrote during those months, I felt I was preparing
myself to be another kind of person living another way of life.
"Obviously I can't become something I'm not," I jotted down,
"but I'm becoming more something than I am."

In September 1978, a year after beginning to draft the
biography, my editor telephoned to say delightedly that after
months of hard work, I had hit my stride in the latest chapters.
I felt ecstatic because it was when I knew the book would defi-
nitely be published.

Arthur and I had only seen each other in Manhattan or
Southampton on occasional weekends, and not knowing when
he would be returning, our relationship didn't feel like a mar-
riage to me. When he finally left his position in Miami and
returned to New York, I moved back from Southampton, too.
I had taken to carrying the only copy of my manuscript in a
locked metal case, protecting it as if my life depended on it,
as it did in a way. Before I left for a brief research trip to an
archive in Texas, I carefully placed the manuscript in a bank
safe-deposit box, fearful that it might be endangered in the
apartment without me to guard it. What if it disappeared or
was destroyed? In retrospect my anxiety was exaggerated, but
it reflected my realization that if a disaster happened, it would
end my start as a professional writer. After returning from
Austin I spent the winter drafting the rest of the biography. By
spring sparrows began landing on the fire escape outside the
window of my writing room, attracted by the greenery on the
other side of the glass, and their little chirps alternated with
the noise from Broadway.

Before long Arthur and I moved to Southampton for the summer. He was attempting to get his novel revised and published while looking for another job, and I was working hard on the final version of the manuscript so it could go into production ahead of its spring publication date. It was a difficult summer: he resented my absorption in the biography, and I was irritated by his interruptions. Instead of living harmoniously together as two writers, as I had wished, the tension between us was so intense that it was palpable to friends who visited on weekends. When I managed to meet the September deadline, my editor sent me a box of long-stemmed white roses, while Arthur, surprisingly sweetly, packed a celebratory picnic to take on my birthday to a sand dune at sunset.

22

Portrait of an Artist

While I was correcting page proofs during the autumn of 1979, Arthur and I were together in our Manhattan apartment almost all the time. As always, I found him either appealing or impossible—one extreme or the other—and my nerves were frayed. When I tried to talk with him about the touchy topics between us, he was unable to tolerate it; free with criticism but unable to take it, he was likely to abruptly bolt from wherever we were if I ventured a complaint. About to be dislodged from my writing room as the apartment was painted, I had arranged to go to the Millay Colony for the Arts in upstate New York. In early January I departed in my battered Karmann Ghia along with a bound galley of the biography and an armful of library books by biographers about biography. It was after-the-fact reading, of course, but I remained curious about what had possessed me during the past few years. Among my questions: Why does anyone willingly inhabit another's life instead of his or her own? Should art serve life or life serve art?

Driving north from the city, the wintry landscape lying under a low, locked, gray sky matched my mood. I was apprehensive about the publication of my account of a litigious living legend, which I had titled *Portrait of an Artist*. Still, I felt a strong sense of satisfaction about completing it in the face of Arthur's negativity and O'Keeffe's hostility. After my arrival at Steepletop, the former blueberry farm of Edna St. Vincent Millay, where she had written poetry in a little writing shed, I was taken to a bare bedroom, then shown a cavernous room with a table and chair in a drafty old barn, which would be mine during the month's residency. I tried to peer through three high, narrow windows on the rough wooden wall, but their glass was covered with thick plastic insulation against the cold, making all the leafless black branches outside look blurry, as if I were viewing them from underwater.

At dinner that evening I met the only two other residents during the midwinter month: a slight blonde novelist from Brooklyn and a black-haired musician from New Jersey. Thrown together by chance, I hoped we would get along, or else the month would be miserable. After lunch the following day the three of us tromped across a tawny field and up a little hill for a better look at where we were. I liked looking around, inhaling the sharp air, and realizing that I had landed among dormant fields edged with clumps of graceful white birches and towering dark evergreens. The muted landscape, edited by winter frosts, had the same pared-down beauty as the arid Southwest. Reading in my barn room by day I was within earshot of the faint clicks of the novelist's typewriter, which I experienced as a comforting kind of companionship. One afternoon we all drove off in my car to buy a few bottles of wine in a nearby village, and at dinner that evening, and during the following ones, our unlikely threesome often erupted in the kind of uproarious laughter that had become rare for me.

Initially, when beginning to research and write the biography, I had worried about imaginatively living another life instead of gladly living my own. The inevitable had happened, and investigating O'Keeffe's psyche had become more important than understanding my own. When one of her friends remarked to me that it was fortunate that I didn't know her personally because her powerful persona might overwhelm me, I smiled because I was already obsessed with it. By the time I arrived at the arts colony, my pleasure in vicariousness had ebbed and I was eager to expand the perimeters of my existence. In the barn, where the low sun passed the little windows and filled the makeshift room with pale light for an hour or so every day, I realized that flattening my life to write about another's had been essential, but now it had to end. Originally, I had imagined O'Keeffe as larger than life, but as my sense of achievement grew, she became more life-size in my eyes. When a friend wrote that I must miss this literary companionship now that the biography was done, I realized she was wrong: it was dawning on me that I could read, talk to people, and go places for reasons other than examining the life of Georgia O'Keeffe.

During the final feverish year of writing I had written virtually nothing in my journal, as if my interior life had indeed been hollowed out. "Sometime I have to think about and write about the experience of writing about another person— having this real/unreal person in one's imagination," I had written down before putting it away. Now I wanted to begin writing in the first person about that issue and other matters in the journal again.

Turning to the books about biography, I read that Virginia Woolf, the daughter of a biographer and a biographer herself, had called biography "a kind of superior craft," evidently to her a lesser form of literature than fiction. I didn't mind being regarded as a literary craftswoman, expected, as another

biographer wrote, to research like a scholar, dig up informa-
tion like a detective, describe the past like a historian, evalu-
ate work like a critic, and then narrate a story like a novelist.
Another author noted that a biographer sometimes explores
his or her own shadow side by writing about another life. And
André Maurois made the point that a biographer's compulsion
to understand another life as a way "to respond to a secret need
in his own nature" can cause vicariousness to infuse the work
with energy and emotion, and even turn it into autobiography
disguised as biography.

It was reassuring to read Marc Pachter in *Telling Lives*
about the biographer's right to evoke a reticent or antagonistic
individual: "Unwilling to genuflect before his subject, the biog-
rapher pulls [him or her] back into his humanity." I hoped I
had done this with O'Keeffe, who in her early forties had expe-
rienced an excruciating impasse between staying at Stieglitz's
side as his wife or following her trajectory as an artist and leav-
ing for New Mexico. The struggle had led to a mental break-
down and deep depression, debilitating physical weakness, and
an inability to paint for a year or two. After discovering this
surprising and hidden part of O'Keeffe's past, I came to believe
that awareness of her human vulnerability would soften her
invincible image.

If writing about Georgia O'Keeffe was to be more than an
exercise in vicariousness for me, it was necessary to emerge
from the emotional net of my marriage, which had entangled
me for so long. It was impossible not to worry that remaining
married would drive me into a debilitating depression the way
it had driven O'Keeffe. It had been extremely difficult for her
to pull away from Stieglitz for many reasons, including the way
he loyally backed her as an artist and exhibited her paintings
in his New York gallery every year. Likewise, it was hard for
me to act on my resolve after Arthur came home one day and
announced he had been named president of the trade book

division of a large New York publishing house. I was aston-
ished, since he was secretive about job interviews, and I was
very glad for him, since getting into the editorial side of pub-
lishing had been his ambition after leaving California a decade
earlier. I was also impressed because landing the prestigious
position was a testament to his intelligence and ability to
persuade people of his seriousness and articulateness. When
Publisher's Weekly ran an article about him, it mentioned his
marriage to the author of a forthcoming first biography of
Georgia O'Keeffe. It made the two of us look like a promising
young couple moving ahead in the publishing world, and I fer-
vently hoped that his new position would strengthen our shaky
marriage.

As I awaited the biography's April publication date, I flew
to San Francisco to see my sister and her new baby girl, whom
she had named for our mother. I was acutely aware that by
writing an admiring biography about a woman completely
unlike my mother, I had taken a very different and less accept-
able path than my sister. I fervently hoped that my mother
would not regard it as a betrayal; fortunately, she never did,
and for years afterward prominently displayed my book with
an increasingly tattered jacket on a living room table. Back in
New York, I learned that prepublication reviews and advance
orders were promising, and as a result, my publisher took out a
prominent advertisement in *The New York Times Book Review.*
Walking along Madison Avenue, I was astonished and elated
to see the biography, with its dramatic black-and-white jacket
cover photograph of O'Keeffe—posed in a black suit and sitting
under elk antlers in her Abiquiu village house—in the window
of almost every bookstore.

A year earlier, my editor had left W. W. Norton and taken
my book with her to an imprint at Playboy Press, and permis-
sive *Playboy* magazine lawyers had approved the unauthorized
manuscript with very few changes. The only question they

asked me was whether it was public knowledge that O'Keeffe and Stieglitz had lived together before they were married, and I answered affirmatively. Undoubtedly their judgment was affected by O'Keeffe's release of another book about herself, *Georgia O'Keeffe: A Portrait by Alfred Stieglitz*, with fifty-one intimate photographs of herself. I mailed her a copy of *Portrait of an Artist* with an appreciative note, but I never heard from

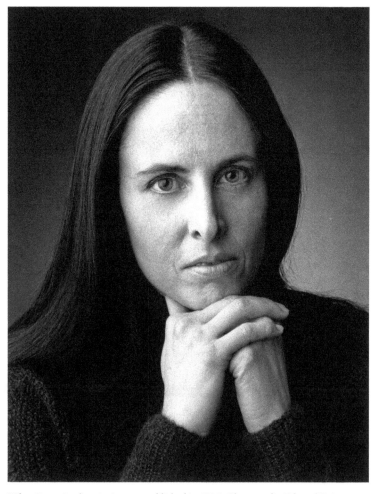

When Portrait of an Artist *was published in 1980. Photo credit: Edward Spiro*

her or, to my immense relief, her lawyers. I later heard via the grapevine that she was both annoyed and amused by what I had done, but she was virtually blind by then, and I was unsure if the biography had been read to her.

My euphoria was short-lived because I unexpectedly experienced postpublication ennui, a common reaction of even established authors. On several spring afternoons, depleted of energy, all I could do was lie on my bed and read; it made me feel better to remember that O'Keeffe had taken to her bed during exhibitions, exhausted from preparations but also apprehensive about reviews. Soon I had real reasons for despondency. A nice note arrived from the encouraging editor at *Newsweek*, but it was becoming evident that the magazine would not review my book, probably because other editors couldn't bring themselves to admit they had been wrong about me. My distress deepened when Arthur read me a brief review over the telephone to be published in *The New York Times Book Review* by a young British woman writer, who criticized the biography because it was not written by an art historian. My editor tried to cheer me up by reminding me that Joyce Carol Oates had given the biography an excellent review, and it had appeared on *The Los Angeles Times* bestseller list. Finally, in August, a review in *Smithsonian* magazine said that a young journalist had "scooped the art world" with "an impressive literary debut." I tried taking the *Times* review philosophically, writing in my journal that "perhaps it's a lesson that one cannot win every battle, and the main person to please is myself," but it took an entire year until the review felt ephemeral, and I could call my bestselling biography "a lasting thing."

23

The First Person

On a wintry weekend afternoon, Arthur and I sat on a sofa in our apartment with his arm thrown loosely over my shoulders. He was sorry I was about to fly south to another arts colony, this time on an island off the coast of Georgia. Since the germination of a new idea for a book was going excruciatingly slowly, I idly wondered if pregnancy would give me a sense of bodily creativity in the absence of the writerly kind. I yearned for the center of my being to make its way down from my head to my heart, and then to the area of my genitals and womb. To feel alive again, I wondered if I would have to either give birth to a child or find a lover.

In early February I flew from a cold, overcast New York to Savannah, then boarded a small boat along with the latest little group of professors and people in the arts for Ossabaw Island. As we motored fifteen miles southward over the water, we watched the barrier island slowly appear as a low band of golden marsh grass. After docking we climbed into an old

Volkswagen van and were driven over a flat sandy road, past lush southern greenery and under old oak trees dripping with Spanish moss, through high iron gates overgrown with thick ropes of twisted vines. The van stopped in front of a pinkish, rain-stained stucco mansion adorned with lacy iron balconies and a red tiled roof, which I would soon learn was built in the 1920s as a winter hunting lodge for a wealthy Michigan family. The arrowhead-shaped island, a little less than a dozen miles long and wide, newly purchased by the state of Georgia as a nature preserve, had a long history of occupiers: Native Americans, Spanish missionaries, African slaves; now we were the interlopers.

That evening, as venison from island deer was served at a long, candlelit manor table, I was very glad to meet Elizabeth Gray Vining, an elegant, gray-haired author from Philadelphia, who had written about tutoring a future emperor of Japan in *Windows for the Crown Prince.* It was while reading her memoir, *Being Seventy,* a few years before that I had learned about Ossabaw. In the memoir she described an earlier visit to the island, when she had awakened screaming from a vivid nightmare in the middle of the night; when she mentioned it the next morning, she learned that other newcomers to the primeval island often dreamed deeply during the pitch-black nights, when deep and disturbing memories were often aroused. Her memoir also described writing on the island as a time when her words flowed; intrigued, I eventually applied for a residency.

After dinner, when we were expected to stay seated until the colony director stood, coffee was served and classical music played in a shadowy baronial room with a balcony that resembled an abandoned old movie set. On the walls were portraits of deceased members of the Michigan family, glassy-eyed trophies of gazelles, and in a dusty corner a grotesque wastepaper basket made from an elephant's foot. A large table behind a faded sofa displayed the portfolios, books, cassettes,

articles, and photographs produced by the latest visitors to the island, including my Georgia O'Keeffe biography. As some of us gathered around a gigantic fieldstone fireplace with burning logs, the conversation inevitably turned to what each of us was working on and why. After listening for a while, I began to talk about what I was hoping to do, and was gratified that what I was saying was not being ignored or interrupted but listened to intently. Before long I was among those who lingered longest by the hearth before going to sleep.

I had been taken to what was called the Yellow Room, a spacious high-ceilinged bedroom with pale citron walls and twin beds, a chair and table with chipped ivory paint, and an adjoining old-fashioned bathroom with a large bathtub. The first night on the island I fell into a deep sleep while listening to the faint sound of water tinkling in a fountain on a terrace below my window, then awakened to the sound of thousands of twittering birds while a glittering morning star dropped out of sight. On the second day, my stress and sadness began to dissipate after I went by jeep with others to a beach littered with white shells that looked like little angel wings and twisted tree trunks resembling large silvery claws. By the third day I realized with a start that I felt safer among the strangers on the island than with my husband in our apartment. As the days went by, the constantly changing cast of characters moving on and off the island, who made unexpected entrances and exits from the mansion's many doorways and balconies, was like being in a theatrical production—like Shakespeare's *The Tempest*, also set on a remote island—where masks and pretenses were eventually cast aside. After only six days away from Manhattan I felt as if I had been existing there in a psychological straitjacket. "This strange other self has emerged: rather playful, lighthearted, and joyful," I wrote to a woman friend back in New York. "I last saw her years ago."

Another night I was awakened by a light as bright as a searchlight shining in my eyes from a brilliant white moon. Unlike Elizabeth Vining, I was not having any nightmares at all; instead, one dawn I awoke remembering a dream about finding more rooms—wonderful large, light rooms—where I lived, giving me the sharp sensation that I was discovering new parts of myself. One morning it was announced that an island party would be held that night. After dinner I walked with a few others toward a clearing in the thick, tangled growth. A bloated orange orb of a moon was emerging from the sea and rising through the darkened foliage into a starry black sky. Music blared from speakers and soon the dancing began. I found myself moving and twirling with abandon, my hair flying and my body spinning, as if throwing off everything that was keeping me from feeling fully alive.

Mornings were for writing, and after breakfast I sat down at my portable typewriter at the painted table in my bedroom. Even before beginning the O'Keeffe biography, I had wanted "to do loose writing that is me," as I put it, and now I had decided it was time to try to turn the private voice in my journal into a public one for publication; maybe it would become what I called the voice for "the necessary next book." Childhood reminiscences might be a way to begin, I thought. "I don't know where it will lead," I wrote to my mother in Rhode Island, "but I'm certain I'm on the right path." Even so, typing tentative phrases and then paragraphs in a first-person voice felt like learning to write all over again, and I worried that it would take years to earn a living while writing that way.

At the time I was rereading Katherine Anne Porter's incandescent novella *Pale Horse, Pale Rider* and working on an article about it. It was a work of "nearly pure autobiography," she said; a blend of fact and fiction, reality and imagination. Set in 1918, when she was a newspaper reporter in Denver, it evokes her love for a young soldier during the perilous influenza

epidemic sweeping the country at the time. In actuality as in the story, Porter became infected and slipped into the state of euphoria before death that Christians call the "beatific vision" before remembering that she had left behind something very valuable. The will to live reluctantly reasserted itself, and after Porter regained consciousness she learned that the soldier had died. It was the tragic, traumatic event that transformed her into a dedicated novelist, she said, when writing fiction became a vocation she was willing to die for. "Everything before that was just getting ready, and after that I was in some strange way altered, ready."

Two decades later she stoked herself with oranges and coffee in a New Orleans hotel room and wrote the short novel in a white heat. The long germination period allowed her subconscious mind to burnish and shadow what had happened so long ago. "Now and then, thousands of memories converge, harmonize, arrange themselves around a central idea in a coherent form, and I write a story," she explained. "It is like iron filings from all directions coming to the magnet." While I found the explanation of her creativity fascinating, it didn't make me want to write fiction, but it did inspire me to search for a method that would enable me to use my own experiences in a literary way. It also interested me to learn that she never had children, had married and divorced three times, and a husband had included *Pale Horse, Pale Rider* in a literary magazine before it was published with two other short novels in a book that led to her literary fame.

My thoughts at the typewriter soon settled on my conflict between creativity and child-rearing. When I had arrived on the island, I wondered if I was pregnant, and when I began to menstruate, I felt both regretful and relieved. I struck up a friendship with a painter my age who had two teenage daughters she used as models. When I asked her how she mothered and painted, she explained that her husband was an arts

administrator who was very supportive of her career. She had "wanted a life," she added, a remark that made me wonder uncomfortably if I really had one. One day on the island I was surprised to overhear another writer, Eileen Simpson, a vivacious redhead in her sixties without children, tell the childless Elizabeth Vining, who had been widowed at a young age, that friends with children had told her she was lucky not to have them. When I asked Eileen what she was working on, she told me she never talked about a work in progress; I would later learn it was a memoir, *Poets in Their Youth*, about her former marriage to poet John Berryman, which described her anguish and even astonishment at her long involvement in a disturbed relationship. It was unfortunate we didn't talk about what was on our minds because Eileen, who was also a psychotherapist, might have given me some insight about what to do about my troubled marriage.

Spring begins in Georgia in the middle of February, I heard someone say. At first it was unseasonably cool, but soon it became warm enough to eat luncheon sandwiches outside on the terrace in the shade of the glossy green leaves and swollen pink buds of big old magnolias. After lunch I liked to set out with a map of the island in hand. As I walked and jogged on the narrow sandy roads, my excess winter flesh fell off at a pound a week, making me feel as if I was shedding a skin and getting down to muscle and bone, to essentials.

One afternoon I went on a rapid eight-mile walk with an attractive professor, a fifty-year-old husband and father, over a footbridge and toward a swampy grassland, where rich dark water moved in and out with the tides. The underbrush was sparse, eaten away by abundant wildlife, so we could see past giant palmettos to where a ray of sunlight illuminated a red camellia or a motionless white egret on one foot. We had known each other for only three days, but we were able to talk openly and easily about our marriages and my effort to write

from what I called "the gut." When I mentioned my worry
about writing and mothering simultaneously, he surprised
me by saying that unless motherhood was very important to
me, I should not undertake it. Children were a distraction,
he explained, and at the age of thirty-eight I was entering the
most productive period of my writing life. Writers, he went on,
need special circumstances to survive in their demanding pro-
fession. I had never heard anyone say that before; it felt like a
shock of reassurance, while making me realize how import-
ant it was to be encouraged and how dangerous to be discour-
aged. His empathy awakened something else in me, too, and
I remembered that I was an erotic creature after all. Feeling
more possessed than loved in my marriage, I had often found
myself daydreaming about lying in the arms of a truly loving
man.

After returning to my room, I filled the big bathtub and
soaked in the warm water when the professor, whose bed-
room was next door, knocked on the wall and invited me to his
room for a drink. Wanting very much to say yes, but hesitating
because I knew what would happen, I stayed silent, and a few
minutes later he slipped an apologetic note under my door. A
day or so later, when he abruptly left the island a week earlier
than planned, I regretted my shyness or inhibition, or what-
ever it was, but I had never been unfaithful to Arthur. Still,
the feelings aroused by my brief friendship with the appealing
professor reminded me what a fearless, fullhearted love would
be like.

The day before Arthur's thirty-ninth birthday I was handed
a message to call him at noon, so I walked the mile to the
short-wave radio shed and telephoned. When he complained
about my absence, I suggested that we meet in Savannah
during the long President's Day weekend. He arrived at the
hotel exhausted and dispirited with the bad news that the best
editor had left his publishing house. I was sorry, but couldn't

help wondering if he was as hard on his women editors as he was on me. While he napped, I began to read a biography of Colette I had borrowed from the Savannah library. She was a novelist who had a child at forty and came into her own at fifty, and when she mentioned the kind of man who steals a woman from herself, I knew what she was talking about. My husband and I had little to say to each other that weekend as we browsed in a bookstore on one of the city's pretty little squares full of blossoming fruit trees. He returned to New York on an earlier flight than planned, while I went back to the island exhausted by the effort of being together.

On my last day on Ossabaw, pale pink petals from the magnolia bushes were falling messily but beautifully to the ground. As I was saying goodbye, everyone noted that I had thrived and was even transformed since my arrival on the island five weeks earlier; a playwright remarked that I no longer was the withdrawn woman he had met on the boat, someone who seemed unused to warmth and being listened to. What had happened on the island was that as my reticence began to ebb, I felt elated by a new sense of wholeness. And my recurring imaginings about another way of living had finally burst forth. I remembered that around my age Georgia O'Keeffe had experienced in New Mexico something "from which there is no return," as she put it, and now I had had a similar revelation on Ossabaw Island. I also felt certain that, if not punctured by harsh words back home, my natural ebullience would emerge. As I boarded the boat for the mainland and the flight back to Manhattan, I vowed to hold on to what I was calling "the Ossabaw feeling," a blueprint and a beacon by which I would measure my well-being in the days ahead.

24

Neith Boyce's Marriage and Mine

A framed jacket of *Portrait of an Artist* hanging on a wall of my writing room was a reminder of the importance of getting going on another book—even another biography despite my wariness about the genre's vicariousness, a worry aroused again when reading Bernard Malamud's *Dubin's Lives*, a novel about a timid biographer of D. H. Lawrence who was imaginatively enjoying his subject's life more than his own while envisioning Lawrence mocking him for it. My urge to throw myself into another book was motivated by the need to build something as my marriage disintegrated. During the summer of 1981 it often felt as if the ground under me was shaking. I became extremely thin, and a doctor told me to see a cardiologist for the arrhythmia of my heart. I felt an overwhelming desire to be alone to allow a shifting of what felt like internal gears to release and then move together in different ways. A few days before my thirty-ninth birthday I resolutely steered my car to Sag Harbor, a village near Southampton, and signed a winter

lease for a large airy white house with a little red library owned by a writer and his wife wintering in Key West.

When working on the O'Keeffe biography I had become intrigued by the married writers Hutchins Hapgood and Neith Boyce, who had gravitated to Greenwich Village at a time of social rebellion, political protest, and creativity in the arts during the early years of the twentieth century. Neith was a quiet redhead who wrote autobiographical fiction, Hutch a gregarious newspaperman who profiled immigrants, prostitutes, and other outcasts. In addition to O'Keeffe and Stieglitz, the pair had fascinating friends among the American avant-garde: writers Eugene O'Neill, Gertrude Stein, and John Dos Passos as well as bohemian socialite Mabel Dodge Luhan, art critic Bernard Berenson, radical activist John Reed, and others whom they met during their sojourns in Florence and Paris. Writing about the pair would not be overly vicarious, I told myself, because telling their story would be looking through a lens at a fascinating progressive era—one that had been dubbed America's "Little Renaissance"—and reminded me of my own exciting years in the Village.

Neith, who was the age of my grandmothers, was called a New Woman because she wrote fiction while raising a family. I admired her as a woman who had done it all two generations earlier—a prolific and popular writer in the genre of literary feminism, who was married to an interesting man, and who had four children. Among the ideas that she and Hutch believed in was the emancipation of women. Neith wrote about the ways it affected marriage, and the themes of her novels and short stories are conflicts between free love and marital fidelity, hedonism and self-sacrifice, and the pleasures and problems of parenthood. Her protagonists are women like herself in the arts or professions who search for more honest and meaningful ways to live. What appear to be maladjusted women who have love affairs, illegal abortions, and out-of-wedlock children

were actually those ahead of their time and, like the novelist herself, were struggling with issues that preoccupied me and other second-wave feminists seventy years later.

While still single, Neith had written columns for *Vogue* signed "The Bachelor Girl," a person who was reluctant to marry because of what marriage and motherhood would do to her writing. She and Hutch married after agreeing to an egalitarian marriage in which they would both write and be autonomous enough to take other lovers. Their marriage interested me for other reasons, too. Unlike in mine, they had talked and written explicitly and exhaustively about their emotional struggles with each other. In *The Story of a Lover*, Hutch's frank and confessional memoir, he described his relationship with Neith as "my great adventure." It was published anonymously, but even so it was considered so scandalous that copies were rounded up by the New York City vice squad. I also found it interesting that the couple wrote a one-act play, *Enemies*, produced by the Provincetown Players, about what Hutch called their "interesting warfare" that ends in a declaration of an armed truce. I wanted to know more about what worked and didn't work in their so-called modern marriage.

I drove to Provincetown at the tip of Cape Cod to visit one of their daughters. Warm and welcoming, Miriam, a white-haired painter of seventy-five, had a copy of *Portrait of an Artist* on a table in her seaside cottage. Living in New Mexico years earlier, she had known Georgia O'Keeffe, and the older artist's influence on the younger one was evident in a work in progress of an enlarged flower on her easel. During our three days together, Miriam became enthusiastic about my doing the biography and offered me exclusive rights to family papers. I was so eager to write what I envisioned would read like a romantic nonfiction novel set in a very exciting era that when she mentioned another writer had spent seven years failing to

get a publisher interested in her parents' "love relationship," I blithely ignored the warning.

Also, my emotional upheaval at the time made it almost impossible to imaginatively inhabit the relationship of Neith Boyce and Hutchins Hapgood. I managed to write a brief book proposal but was disappointed that the editor of my O'Keeffe biography was more interested in the breakup of my marriage than in the twists and turns of theirs. Wary about the pair's obscurity, she could only offer a small advance, not one that would support me living by myself. Editors at other publishing houses asked for a sample chapter or two, but I was too far away from large libraries during days before the internet, and too busy earning a living by reporting a few days a week for *The East Hampton Star* and teaching at the Southampton campus of Long Island University to do the necessary research.

My situation brought me face to face with an important ongoing issue: how best to persist and even thrive as a writer. In January 1982, the editor of the *Star* asked me to write the obituary of the founder of the feminist literary journal *Aphra*, who had committed suicide in her Sag Harbor studio. About a decade earlier I had gone to the journal's fundraiser, but it had ceased publication during the backlash to the women's liberation movement. It had become a demoralizing time for feminists who had been wildly hopeful a decade earlier, and evidently fatally depressing for the editor whose death I had to write about. I had fled to Sag Harbor to save myself, and her suicide symbolized the risk I was taking—the failure to survive on my own. It was the coldest winter in fifty years, and one night the wind blew so hard that my bed shook, and then the furnace died and I endured hours of existential terror while cowering under a voluminous down comforter that Arthur had given me on a birthday. I remembered Henry James's American girl in *Portrait of a Lady*, who thought she loved liberty above all else, but inexplicitly entered a marriage that felt like "a dark, narrow

alley with a dead wall at the end." I was determined that would not be my fate. Miraculously, I awoke in the morning feeling internally ordered and even with a surprising pang of joy about the possibility of being free.

What I had learned from O'Keeffe's marriage to a man she would describe as being like "something hot, dark, and destructive . . . hitched to the highest, brightest star" was to be wary of danger in a relationship. For a decade O'Keeffe had worked well at the dominating Stieglitz's side, but then troubles arose between them as she desired more freedom and bought a Ford Model A with her earnings. When she wanted to return to New Mexico during the summers despite his fierce opposition, she stopped eating and sleeping, as if she would prefer death to giving up the beloved high desert country that inspired her creativity. But she didn't want to lose him, either. "I'm frightened all the time," she had declared, words that came back to me then. "Scared to death. But I've never let it stop me. Never!" After her recovery, and with Stieglitz's grudging approval, she resumed her stays in the Southwest. Her yearly absences turned their relationship into a respectful companionship, but it endured. It was a lesson to me about how difficult it was to reconcile intimacy and independence, and a reminder that I had not done it. Now it was imperative for me to decide what was most important to me as a writer and a woman: financial or emotional well-being.

On a sunny, windy March day in Sag Harbor, Arthur and I walked on a path through tangled brush to a beach on a slender peninsula extending out into the bay. It was a place I had often gone alone, where tiny tame yellow-and-black chickadees alighted on my hat and ate sunflower seeds from my hands. As we walked, he asked me to forget the past and focus on the present and future, but the past kept flashing into my mind as a warning. "Can I have a direct, open, from-the-heart relationship with him? Or will he squeeze the life out of me again?"

I asked myself. Walking alone there a few weeks later, after a sudden spring blizzard, an outburst of green appeared as tips of bulbs pushed out of the softening soil and faint glimmers of yellowish green appeared in the trees. I realized that my marital unhappiness had finally alchemized into something fierce and unforgiving—an anger laced with apologies, but an impervious anger nevertheless. What I had discovered during my months alone in Sag Harbor was that my vitality, not my marriage, was my real security. After I wrote Arthur that I would not be returning, he sent me a sad note saying "We belong together," soon followed by a coldly formal letter stating he was filing for divorce.

25

Last Words

After my biological father began to see my name in print, he mailed me Christmas and birthday cards more often, but made no attempt to see me, staying behind when his wife made her spring pilgrimages to Manhattan. One autumn I tagged along with some cousins planning to spend a weekend with them in Vermont. My motivation was, as always, reconciliation with the man who was my real father. "It would be such a relief to finally heal that wound," I noted. As a little girl I had fantasized that my missing father and I belonged together; it was an intuition that turned out to have some truth to it when as a teenager I noticed our likeness—our affinities for books, aesthetics, and the fields and forests of New England. But that weekend when I tried to engage him in conversation, he was unable to say much to me or even look me in the eye for long.

A few years later I noticed the year of his birth engraved on a boyhood silver porringer in the corner cupboard and realized he was about to turn seventy. As a birthday gift I mailed him a book

about American history, and his thank-you card encouraged me to see him again when I was visiting friends in Vermont. This time he kept throwing me intense glances, as if my presence aroused deep emotions, but he stayed silent and avoided being alone with me. In the evening, after more than a few drinks, he blurted out boastfully that it had taken "guts" for him to leave Providence—and, implicitly, my mother and me—so long ago. Hurt, angry, and discouraged again about becoming closer, after returning to Sag Harbor I had a prescient dream about him dying; it was a little more than a year before his death from liver cancer, undoubtedly brought on by his alcoholism.

Shortly before my father died, my stepmother telephoned to say he wanted to see me, and on the drive to Vermont I hoped again that we would finally find the right words to say to each other. He had recently sent me a card with a long reflective note for my fortieth birthday; although most of it, and an enclosed snapshot of himself with a large trout, were about his summer of fishing, he was genuinely reaching out to me.

Tethered to an intravenous line in his hospital bed, however, he murmured that he was too weak to speak. When I said I was sorry we never had a real father-and-daughter relationship, he uttered the word "circumstances," a vague response I took to mean he didn't blame himself, but he didn't blame me, either. As I sat in a chair beside his bed reading and waiting for another word or two from him, he summoned the strength to tell me to raise the window shade so I could see my book better. And when he struggled to get to the bathroom, I took his cold hands in mine to help him sit up; as he kicked off the sheet, I was embarrassed to glimpse his genitals as his hospital gown opened, but later I was glad for the moment of inadvertent intimacy. At the end of the day, as I said goodbye, I kissed his forehead and, thinking of the handsome corner cupboard he had finished the year I was born, I told him I was proud to be his daughter, and he whispered that he was proud of what I

had done. As I left, I smiled and gave him a little wave, and he smiled and waved back.

During the following days, while waiting for him to die, I stayed with my stepmother, stepsister, and younger half brother, who told me how savagely Larry had criticized them through the years. Even on his deathbed my father managed one last cruelty; when I was standing at the foot of his hospital bed with my much taller siblings, he managed to say that "the smallest one is the smartest of all" presumably because I had written a book. I was aghast at the insult. In childhood I would have eagerly exchanged a flesh-and-blood father for a mahogany stand-in, but during those days I realized that the elegant cupboard represented the best of him—an everlasting reminder of artistry and accomplishment. It was when I became glad not to have grown up with him after all. I felt a rush of appreciation for my gentlemanly if reserved and remote stepfather, who felt honor bound to uphold the rules of Providence. When I had a chance to tell him this at Christmastime, he gravely thanked me for saying so. I also belatedly understood that the lack of involvement of my fathers in my life had probably given me more freedom than daughters with doting or demanding fathers.

I did not discover my father's early love for me until after his death. After the funeral, my stepmother mailed me the long loving letter that as a thirty-one-year-old naval officer he had addressed to his infant daughter, the letter he had torn from the album my mother made for me, when he left Providence and locked away in a safe-deposit box for the remainder of his life. I noticed with a writer's eye that the letter was well written, and that his handwriting was distinctive. One sentence even reminded me of our smiles and waves as we said goodbye in the hospital: "Some people, but not Lally, might be foolish enough to tell you that you have never seen your Daddy, but don't let them fool you," he had written. "They told me you couldn't see, but I know better than they do, for you looked

right at me and smiled and then you winked—and I winked back." The letter's revelations about my father's "appreciations" and aspirations for me if he never returned from war moved me at first but then angered me because he had deprived me of the thoughts and feelings in it for forty years. Forty years when I never knew about his love for my mother and me.

Afterward, on a mild February day in Sag Harbor, I walked by myself through the thicket with the chickadees and along the sandy peninsula. Winter storms had washed tree trunks onto the beach, but that day the water was still and the sky enveloped everything in a soft peachy glow. My overriding reaction to my father's death had resolved itself into a feeling of relief, because his passing ended my longing for what could never be. If his death ended one thing, my impending divorce ended something else. A few months after my father's funeral and two and a half years after leaving the Manhattan apartment, I arranged to have the corner cupboard and the rest of my possessions moved to a small, unfurnished rented house in Sag Harbor.

Around the age of forty, when a life is about half over, it often breaks apart when a person is driven to become more him or herself. Maybe in my own quiet way I was a radical feminist after all in my refusal to be dominated and insistence on self-determination as a matter of inner dignity. I had learned in a roundabout way that ambivalence in love should be regarded as a flashing red light. I had gotten involved with a certain kind of man in an unconscious effort to erase a paternal wound, and he had loved me. This realization left me with the question about how much my distrust of his love originated in my disappointment in my father, whose smile and wave on the last day of his life had been nice, but not nearly enough to eliminate four decades of heartache. Once I had craved belonging more than anything else, but the marriage gradually felt like a form of bondage, and now I wanted to belong to myself. I was past the age to give birth to another easily, so I decided it was time to give birth to a reborn self and my voice as a writer.

SHARON

26

Finding a Place to Write

In March 1983 I left Sag Harbor in a windy northeaster for the MacDowell Colony in New Hampshire for six weeks, driving the long way through New York City because the ferry from the end of Long Island to eastern Connecticut was cancelled on account of the storm. It was still wintry and bleak in northern New England, where patches of snow hid piles of pine needles in the shade of the tall evergreen trees. I settled into a tiny bedroom with a narrow bed and cheerful flowery wallpaper in the main house and into a rustic cabin in the woods, a studio named for author Katherine Mansfield, with a working fieldstone fireplace and a screened porch with a view of Mount Monadnock. It was a welcome retreat at exactly the right moment. My father had died, and I was about to be divorced. In a state of suspension between the past and the future, I needed to be by myself to rest and, more important, to reflect. During the long days alone—a box lunch was quietly dropped off at my cabin at midday—I worked diligently on my new book, the first

biography of sculptor Louise Nevelson, and I was surprised and pleased at how much I could do without interruptions. In the evenings I returned to the cabin because I felt compelled to peruse earlier passages in my journal to understand better why I had upended my existence during the past few years, and what it was I really wanted to do now.

In the 1970s, walking to work through Central Park, I had seen the large thrusting angles of Nevelson's powerful black steel sculpture *Night Presence IV* gradually emerge into sight on its pedestal near Fifth Avenue. It fascinated me because it refuted everything most people assumed about women artists—that their work would be too inwardly focused, or oversensitive, or too small and delicate. At the same time, I was noticing newspaper and magazine photographs of the artist making dramatic appearances at museum openings flamboyantly decked out in ultrafeminine arrays of jewelry, ruffles, tulle, furs, and false eyelashes like an ancient queen from some faraway land. Who was this amazing personage, I asked myself, so manly in her work and so womanly in her appearance? A few years later at the publication party for my O'Keeffe biography, a friend had asked me what I was going to write next, and I had offhandedly replied, "Well, there's always Louise Nevelson." I was not especially enthusiastic about the idea, and I set it aside for a while.

After I left my marriage, however, I had to sign another book contract to survive on my own as a writer, so one spring day I telephoned Nevelson and made an appointment to see her. When I rang the bell by a door with elaborate ironwork at her address in Lower Manhattan at the appointed time, I waited and waited until a passing delivery boy pointed around the corner where I could hear the sound of hammering. When I knocked on a screen door, a tall woman with strong cheekbones and a hammer in her hand looked up, startled; it was obviously Nevelson. When I explained who I was and why I

was there, she told me to return to the other door in ten min-
utes. By the time she opened it, she had pulled a knitted cap
over her cropped gray hair and thrown a lavishly embroidered
blue kimono over her denim work shirt, which still had little
black finials protruding from a pocket. She led me up a steep
flight of stairs into a shadowy room, where a black cat moved
silently among tall, inky black sculptures in dark corners, and
she pointed to a wooden chair for me to sit on.

At the age of eighty-one, Nevelson's tawny skin was lined
but unwrinkled, and she moved with muscular vigor. By then I
knew that she had played an important role in the renaissance
of American sculpture in the mid-twentieth century and, like
O'Keeffe, was one of the few women of her generation who
had triumphed as an artist. Brought as a young child from a
vibrant Jewish shtetl in Russia to an insular Protestant town
in Maine, she had suffered by being an outsider—linguistically
as well as religiously—and then, in the 1940s and 1950s, as an
ambitious female artist in the male-dominated New York art
world. It wasn't until she was almost sixty that she finally made
a breakthrough with her creation of ingenious black wooden
boxes filled with black wooden fragments, which she went on
to stack and make into walls with the same monumentality
as the oversize macho paintings of the abstract expressionists.

As she spoke in the flat vowels of Maine and the staccato
rhythms of Manhattan, I sensed both vulnerability and steely
armature in her personality as she jumped from personal rev-
elations to grand philosophical pronouncements. Eventually
she told me she had read *Portrait of an Artist* and indicated
that she was willing to let me write her biography because of
the way I had written dispassionately about O'Keeffe's egotism.
Her honesty startled me, but I also liked it.

Nevertheless, after driving to an arts colony in Virginia
surrounded by verdant southern growth, I had to make a
determined effort to keep my mind on Nevelson because of

my resistance to undertaking another biography. Did I really want to again risk making someone else's life more important than my own? Yet I liked the idea of writing another initial biography, especially of a willing figure. I decided that after giving this biography three years, the time it had taken to do the O'Keeffe one, I would write about what mattered to me more, maybe an issue based on my own experience, which I had longed to do for a while. A new literary agent arranged an auction among several publishing houses vying for the biography, which I had tentatively titled *A Royal Voyage*, and when it sold to Viking Penguin, she told me that editors stood up and applauded. Whether I liked it or not, I was on my way to writing another biography about a woman artist.

Back in Sag Harbor trying to work in a tiny upstairs bedroom of my small rented house, I realized it was time to find a home of my own. I wanted one with a wonderful room for writing, where I would spend most of my waking hours. In my mind's eye this room, unlike the one in the New York apartment, would be full of light and large enough for my desk, books, filing cabinets, and a comfortable chair for reading. It was becoming increasingly unlikely that I would find such a space in Sag Harbor. The spacious white house with the little red library I had rented for two winters had gone on the market at a price I couldn't afford, and smaller houses for sale that spring and summer only had cramped bedrooms for writing. It was very discouraging. At times I became tearful at the thought of leaving my new author and artist friends on the East End for some spot where I knew nobody. "Where is my place?" I repeatedly asked myself. Around my age O'Keeffe had found hers in Abiquiu, but New Mexico was no longer a destination for me. Manhattan wasn't, either. The metropolis had lived up to most of my hopes, but as I got older and increasingly sought a sense of interiority instead of information, it had gradually lost its grip on me. Instead, I yearned for a location

where I would feel rooted as in Rhode Island, expansive as in the Southwest, and embraced as on Ossabaw Island.

Remembering the gentle Connecticut hills from my high school years, especially the stunning beauty of the green hockey field surrounded by flaming orange and yellow foliage in the fall, one day I got in the silver Volkswagen Rabbit bought after the Karmann Ghia finally gave out, and drove past New York City to Litchfield County in the rural northwestern corner of the state. Its New England villages felt reassuringly familiar to me, and they looked astonishingly lovely that autumn day. In December a real estate agent showed me a small white clapboard colonial on Main Street facing the village green in the town of Sharon with exactly what I was looking for: an ample downstairs room for writing flooded with morning light from two large windows facing east and south, a long windowless wall for my desk and bookcases, and double doors to the rest of the rooms that could be firmly slid shut. I immediately wanted the pretty little house, and miraculously I managed to get it at an affordable price.

Its location was remarkably nice. When I walked out on Main Street and went to the right, I passed Town Hall on the next block; if I walked across the green, I got to a little stone library. If I turned left, in ten minutes I arrived by foot at a post office, a grocery store, and a pharmacy. A short drive north to Salisbury, I soon discovered, took me to the start of a steep trail to a rocky pinnacle overlooking a panorama of glistening ponds, mowed pastures, thick woodlands, and rounded hills pierced by white steeples. Although I had been raised in coastal Rhode Island, I realized that my real affinity was for the hills and woods of New England. Before long I learned that a twenty-minute drive to the south took me to a train station and, a couple of hours later, to Grand Central Station and the libraries and museums in Manhattan. The village of Sharon

appeared to be a perfect place for a writer—not too isolated and not too active.

Laurie and her cocker spaniel, Daisy, in the 1990s. Photo credit: Robert Kipniss

Owning a house would tie me down, I vaguely understood, but what surprised me was the way ownership immediately gave me a sense of belonging. The house's hardwood floors, heavy wooden doors, and solid plaster walls made it feel protective as well. And something indescribable about the way daylight entered through the big windows made everything about my existence seem better than before. Then I did something I had wanted to do for a while. Within weeks of arranging the corner cupboard and the other furniture in my new rooms, I brought home a brown cocker spaniel puppy and named her Daisy. The adorable little creature romped alongside me on hikes, slept in a corner of my bedroom, napped in a patch of sunlight in my writing room, and walked on a leash with me around the village wagging her tail at everyone. And because the house was

mine, it promised to let me live the way I wished, making me feel both secure and free at the same time, a sensation that was not contradictory at all. That first year in Sharon, I believed I had found my place, and I vowed never to live anywhere else, a feeling that never wavered during the following decades.

Moving to a historic house in the heart of the village, which the historical society called the "Academy" since its oldest section was supposedly once a schoolhouse, made me known in town, and I felt welcome and found friends wherever I went. After giving a talk about O'Keeffe to the Sharon Women's Club, I met a woman my age, a garden historian, who became a lifelong friend. At the hardware store an author of children's books introduced herself, and we became close friends. And at a gathering of Litchfield County women in the arts I met a smiling, friendly woman, a New Yorker who was staying with her parents while finishing a dissertation about Edna St. Vincent Millay.

Before long I heard that the novelist Philip Roth owned an old farmhouse in the nearby village of Warren, which he had bought in his thirties, probably after selling film rights to his novel *Portnoy's Complaint.* At first I wondered why a relatively young man had wanted to live on a hard-to-find road in the country, and eventually I learned that after achieving notoriety he had wanted privacy and the ability to write undisturbed. When I read about his impressively long days of writing and evenings of reading as an older author, I assumed that he hired others to do his housework and yardwork, and he presumably had the help around the house of his companion, actress Claire Bloom.

One day I encountered him in a rug store in Cornwall Bridge, the town between our villages, and he gave me a long appraising stare. I had just read about the young Louise Nevelson's refusal to meet Picasso in Paris when she was beginning to seriously embark on a career. It was an unusual

response for a beautiful and flirtatious woman, but I thought I understood it. A relationship between a young woman and a powerful man in her field can be a double-edged sword: either enabling because of his encouragement or destructive by being in his shadow. My reluctance about greeting the famous novelist was an overreaction, I believe in retrospect, but when I imagined telling Roth, "I'm a writer, too," it seemed ridiculous, laughable, even embarrassing, and maybe dangerous as an author of only one book. I was also wary because of his reputation for misogyny in his novels. Would he be respectful or critical of me as a fellow author? What I wanted was an egalitarian relationship with another writer, and the intensity of his gaze was like a warning. So I refused to meet his eyes, turned away from him, and began to look at the rugs.

My initially idyllic life in Connecticut was not without complications, however. Once I had feared drowning in domesticity, and I had avoided a lot of housework while living in apartments and rented houses. Now, not only did I have a room of my own, as Virginia Woolf had famously advised women writers, but a house of my own, along with a large barn and a long backyard. Entirely unexpected were their demands on my writing time. While unpacking I had seen the preview issue of the feminist magazine *Ms.* with its red cover and a female figure with four pairs of arms holding a typewriter, a steering wheel, an iron, a mirror, and other such objects; perhaps she was supposed to resemble a powerful multiarmed Hindu goddess, but she looked to me like an overwhelmed woman like myself.

When I had first seen the property in winter, all I could see out the windows was snow. As it melted, I excitedly turned my attention to making the yard into a garden. Along the sunny side of the barn I planted large white daisies my mother brought me from her garden, together with marigolds, petunias, and other annuals I found at garden centers. While writing draft

after draft of my book gave me a slow sense of satisfaction, my enjoyment when going out into the garden was instantaneous. "Once I get outside, I forget all else," I noted ecstatically that April. I reveled in the physicality and creativity of gardening, and from the time the snow melted until it snowed again, my backyard became a place of pleasure and playfulness that gave me the patience to wait for the delayed gratification of polishing a final draft. I rationalized that my gamble of giving many hours to the wholesomeness of gardening might mean, if I was lucky, that I would end up with more years to write. In the meantime, I needed a strategy to stay inside my office longer, and I didn't have one yet.

Wanting to be part of the life of the town, I joined the volunteer ambulance squad to transport the ill and injured to nearby Sharon Hospital. With my social-worker instincts I liked helping and getting to know town residents from every walk of life. Living around the corner from where the ambulance was parked in the firehouse became a problem, however. Members of the squad didn't understand why going on a morning ambulance call ruined a day of writing for me, so after a few years I regretfully resigned. I remained a member of village groups—the garden club, the Democratic town committee, the library board—that met evenings or weekends. My way of getting another biography written with so much to do around the house and yard was to gradually establish uninterrupted morning hours for writing and afternoons and evenings for everything else. This pattern turned into an exquisite balance of brain and body that over the years enabled me to write my books, care for my home, and tend to the rest of my life.

27

Two Writers Together

While I was at the MacDowell Colony, a black-haired, bearded playwright called Dan was writing me enchanting letters. Working on another biography, I was worried that a magnetic figure might monopolize my life again; he reassuringly wrote me that Louise Nevelson was merely my companion and only a part-time one at that. I thought it was the perfect thing to say. And when I worried about relating to a personality so different from mine, he wrote back that Nevelson was like "the steel in which she works—hard, big, enduring, but beneath all this she is a woman. Find her! You can do it! She is an opportunity for you to get to another level of your own perception of life. Take the facts, the story, the items of the life and tell a wonderful story. She won't take you over. Believe me." He encouraged me as a writer in other ways as well: "I love the image of you at work, pursuing a project; no, not pursuing, but developing it, shaping it, and making it live." He kindly thanked me for my letters, telling me that they had an enormous effect on him.

After I admitted my wish to write from my own experience, he replied, "When you're through with the biography, I want you to write something from the heart." What I wanted for myself was what he wanted for me, too—"a bursting to be reborn in you that I want very much to help to happen, so take a deep breath and be alive and full and blossom like spring, and when you are fully bloomed, I'll pluck you." His words delighted me.

After a summer of seeing each other, on the evening before my forty-first birthday, Dan took a Hampton Jitney to Sag Harbor after work to be with me the next day. Around ten o'clock in the evening I left my house on foot, a little late to meet him at the bus stop a few blocks away, and we joyfully met on the sidewalk. He took me in his arms and gave me a long warm embrace. We talked late into the night, and I continued to find his perceptiveness, expressiveness, and emotional availability unlike anything I had experienced with a man before. It was as though I had reclaimed my natural language, an emotive, direct, and honest one, and my words flowed as they were heard, understood, appreciated, and even celebrated. The following morning, I told him that "sweet men seem like miracles to me" as we made blueberry pancakes and then went to swim in the ocean off a wide stretch of sandy beach. In the afternoon we took a long walk along the narrow peninsula full of nesting birds that extended out into the bay. It was when he told me that he loved my spirit—"my wings," he called it—and didn't want to do anything to restrain it. "Can this be possible in marriage?" I asked myself. Then I jotted down something—"He says he can break old patterns"—that at the time I didn't understand but now seems ominous. After he boarded a jitney back to New York at the end of the day, I felt deeply nourished and reflected that "I felt his sweet emotional support all day—which was his real and precious gift to me."

My expectations were high that this would be a different kind of relationship than my marriage because Dan was a

gentle and sensitive man with enormous gifts for intimacy and empathy. One day when I was downcast when we were together in Manhattan, he put on music and danced me around the living room of his apartment until I began to smile. His warmth and witty sense of humor lightened other serious moments, and friends from that time remember me often smiling in his presence and laughing at his jokes. Our open, from-the-heart rapport enabled me to be more expressive, making restraint and self-protectiveness in relationships with men seem like artifacts of the past.

After I settled down in Sharon, Dan often took the train from New York to see me on his days off from writing radio newscasts for CBS. Giving each other a great deal of attention and affection, an emotional richness flowed between us. We liked to hike with picnics in our backpacks on the hilly woodland trails outside the village. When bicycling he discovered a dirt road winding alongside a brook and through the woods, and it became a favorite place for us to walk with my cocker spaniel. We also worked together in the backyard; he would mow the grass and help me dig garden beds, removing big rocks from the ground so I could plant flowers in the loosened soil. I hoped that we could tap our creativity as writers and find a way of living and working together where the best parts of ourselves flourished. When I urged him to write more plays, he thrived on my encouragement. One night when we were apart, he put his feelings into a long poem. "When I think of you . . . I think not of endings but of beginnings," it went in part. "I think of the moonrise bold and surprising, with its own silent sound, and of sunrise and birdsong . . . You are the sunrise and the moonrise and the setting out."

After Dan departed for New York I would write contentedly until he returned, but after a year or two I wanted to turn our love affair into something more lasting. On a Valentine's Day when he arrived in Sharon with three red roses a little

wilted from the train trip, my disappointment indicated to me that I wanted more than romantic gestures—I yearned for marriage to lock in his love. Around that time, however, he described himself in a letter to me as conflicted—a man "who has learned to avoid ultimate commitment." He vacillated; one May day he was in a mood to marry, but a month later he was not, and he likened himself to the emotionless man in Camus's existential novel *The Stranger*. "I love his warm side—but it's so mercurial," I jotted down in my journal.

His sudden changes of heart aroused my doubts and caused me to repeatedly break off the relationship. After a breakup he wrote in a long letter that showed up in my mailbox on a Monday, "I thank you for my highs and apologize for my lows. I really did want to marry you but I suppose I waited too long to ask and was completely ineffectual at compromise." The next day another agonized letter arrived, admitting that he was "nothing more than an incompetent romantic." Then on Wednesday a third letter demanded that I marry him. "I have been indulgent of my own poor moods," it stated. "I love you and shall always love you. Marry me. Marry me." And on Thursday as I was working at my computer, I looked up and saw him out the window standing on the village green with a ukulele and a bouquet of flowers in hand. Stunned, I went to the door. I was unnerved by the torrent of confessional and contradictory words in his letters, but his pleas and promises raised my hopes again. It was an early spring day, so I suggested we go out and rake leaves in the garden while I decided whether or not to send him away.

About a year later he said he was imagining me as a bride in white lace and I thought he was finally ready to marry. It was May 1986, when *Newsweek* published a cover story about the difficulty of women my age finding men to marry—the ongoing misogynistic media drumbeat demeaning independent women that had accelerated during the backlash to the

women's liberation movement—and at the age of forty-four I was not immune to the message. Despite my lingering doubts, we set a wedding date in June, and I planned the perfect wedding I had always wanted, with family and friends along with a string quartet and vases of spring flowers in a lovely little Unitarian chapel in New York. The wedding was followed by months of intense happiness, when he would hold me tightly in his arms at night and say he was more in love than before we married.

It was still my dream for us to live and work harmoniously together as writers can do at MacDowell and other arts colonies. While I would nail down facts for my biography, Dan would invent fantasies for his plays, ways of working that reflected our different personalities. We created a large room for him in which to write on the upper floor of the barn under a high arched window. After the carpenters finished the renovation, we spent winter weekends staining the wide floorboards and painting the wallboard white between the heavy dark beams, work that filled me with joy and optimism about our future as writers working side by side. Before we were done, however, his mood abruptly darkened; when I asked him why, he was unable to explain, only saying that he wanted to spare me his depression by leaving for MacDowell for six weeks. I was stunned that he wanted to write there instead of in the beautiful barn room. While he was gone, its emptiness felt like a rejection of my desire to create our own little writers' colony, but I managed to ignore my hurt by throwing myself into spring gardening.

Dan had been to MacDowell twice before. He liked the long uninterrupted days with "no realities knifing through the delicate bubble of thought," he explained in a letter. At what he called the "great, big embracing Mama MacDoodle," he enjoyed the feeling "of separation, protection, and freedom from virtually all responsibilities." It was where he could turn

himself "inside out and surrender completely" to writing fic-
tion and "to create something that was not there before, to
populate my world with characters of my own creation, to
entertain, to amuse" and "to create that ironic combination
of laughter slaked with existential sadness, so as to say 'life is
tragic, yes, but how can we not laugh at it?' Laughter is the best
medicine and helps exorcise troubling demons." His explana-
tion about why he was unable to write anywhere else puzzled
me. Before he left, we had accepted an invitation to go to an
uncle's seventieth birthday party in Providence in the middle
of his residency; it was a big family gathering for my mother's
charming youngest brother, and I didn't want to send regrets
or go alone. Dan was reluctant, but I insisted, and I drove
to New Hampshire to get him. During the weekend he was
bad-tempered about confronting what he called "real life," and
afterward apologized to me for being "like the beast of the jun-
gle because of how I behaved."

After his residency at MacDowell ended, he returned to
his apartment and job in New York, while I continued to write
in Connecticut. He liked to joke that some people live together
and don't marry, while others—like us—marry but don't live
together, but I didn't think it was very funny. To be together
more I bought a desk to squeeze next to the king-size bed
and against a windowless wall in his two-room apartment.
Working there felt claustrophobic, especially in contrast to my
large sunny office in Sharon, so when I was with him in New
York, I ended up going to a library.

When his department at CBS was eliminated and he
became unemployed, I was glad that he could be in Sharon
more. Soon, however, I began noticing that he was regarding
me less as a fellow writer and more as a traditional wife. One
morning, after I had gotten to my desk by nine o'clock, he inter-
rupted me to say he didn't have any clean underwear. I was out-
raged. Why didn't he put his own underwear in the washing

machine? And why didn't he help more with the housework, the yardwork, and the household expenses? To free my mornings for writing, I was rushing around doing all the chores and errands in the afternoons and evenings. Virginia Woolf, I remembered, had warned women writers about becoming the "angel of the house," the good wife who puts everyone and everything before herself, and who had threatened to pluck the heart out of Woolf's fiction before the author had finished the imaginary creature off. This domestic female fantasy figure now had a grip on me, and when my new husband was around, I was writing less and less while telling myself that my work on the biography was only for another year, while our marriage was forever.

It amused Dan to say he liked being married but didn't like being a married man because of the responsibilities of marriage. One day he presented me with a numbered list of twenty-four matters on his mind—mostly about his struggles to succeed as a playwright—which made it impossible for him to help me around the house. I didn't understand why he had to ignore what he called "nuts and bolts reality," unlike other writers. I hoped that instead of criticizing my work ethic he would ramp up his own, but he did not. Meanwhile, he spent a lot of time trying to save a threatened theater in his Upper West Side neighborhood and organizing theatrical readings with actors in Connecticut. He also accused my morning writing routine—what he described as my distasteful "rules over romance"—of damaging our relationship. "Our times together should be the color of gold and flowers," is the way he put it. "Instead it too often is the gray of the machinery of life and the black-and-white of balance books." It was obvious that he wanted me to take care of everyday practicalities—and even protect him from them—as Mama MacDoodle did.

At a MacDowell party in Manhattan, Dan and I found ourselves talking with a startlingly intuitive woman artist,

maybe even a psychic, who remarked that I looked unhappy. After staring at me for a moment and then at him, she proclaimed that while he loved me very much, he wanted all my attention. "She doesn't have all of yours, does she?" she asked him. I was amazed by her perceptiveness since his demands were becoming overwhelming. When I was working or busy, he complained about feeling neglected and admitted that my inattention made him feel unimportant. When his complaints made me too upset to write, I would go outside to weed and water to recover my emotional ballast, and then he became jealous of my pleasure in the garden.

As I worked on my book, I became increasingly uneasy about Dan's and my diverging trajectories as writers. While he was going in circles as a playwright, I was moving straight ahead as a biographer, slowly but at a steady pace. His short comedies had been read by a number of theatrical groups without being performed; a producer had observed that he wrote the same type of one-act play over and over, and she wanted him to move on to more complex structures and deeper themes. "It could be that playwriting is something that I can do pretty well, but not quite good enough," he commented in a letter. "All I know is that I can't put the kind of sweat and concentration and sacrifice into it if there is not likely to be a response, if there is no encouragement." I suspected that a phrase in one of his plays about "a thoroughbred who wants to run" might be a veiled reference to me, and I worried that he felt outpaced. It wasn't long before I became alarmed when he remarked that I was a real writer and wondered if he was one at all.

The way for writers to be mutually supportive during the ebbs and flows of their careers is to be generous toward the other's successes and sympathetic toward the other's failures, but my ability to write angered Dan, and his failures frightened me. As he was unable to get plays written or performed, his humor darkened, and then it disappeared altogether. He

became deeply depressed and told me about his nightmares, like being forced to move to a smaller and darker apartment—the opposite of my recurring dream about discovering larger and lighter rooms. When I was unable to listen endlessly to his troubles and tirades, he angrily accused me of resisting "intimacy," but it was no longer the rich warmth of our past. Done blaming his demons, he began to rage at me, his dark eyes flashing. During those terrible times I would wake at four in the morning wondering how to recover and worrying about being unable to finish writing what had by then become an overdue biography.

One August weekend when we had houseguests—the editor of my O'Keeffe biography and her husband—we decided to take canoes down the nearby Housatonic River. That day the water was low and full of churning white water, so it was necessary to paddle skillfully to avoid the protruding rocks. As Dan got in the back of our canoe to provide power while I sat in front to steer, he awkwardly shifted his weight and tipped us into the rushing water. Although inadvertent, the accident felt like the symbol of what had gone wrong between us. Wet and angry, I refused to get back into the canoe with him. I climbed into the canoe with my former editor and her husband joined Dan, and we maneuvered downstream that way. After this misadventure, it felt dangerous for me to be with the man I had fallen in love with, and I started to ask myself if our marriage would—or should—survive.

28

Writing Another Life: Louise Nevelson

Louise Nevelson was extremely outspoken about the importance of being herself, yet during interviews when I tried to establish the facts of her life, she became enigmatic and erased or elaborated stories about her past. I discovered little written in her own hand because she didn't trust the written word; if she was unable to talk with a friend, a family member, or an art dealer in person or on the telephone, she was likely to scrawl a few misspelled words in large script on a postcard and send it off. Like many artists, she was elusive about the origins of her inspiration and iconography—an understandable instinct to protect the deepest motivations firing her creativity. Nonetheless, I discovered that she had an unconscious quest to redeem the reputation of her hardworking immigrant father: as maker of so-called junk art, venturing out with a wheelbarrow at three in the morning ahead of garbage trucks to collect debris from gutters to transform into works of art; she never

admitted that her father had been a junk dealer during his early years in Maine.

When it became difficult to arrange interviews with her, I asked my publisher to show their support for the biography by hosting a dinner in her honor; they readily agreed and arranged it at Vanessa's, at the time a fashionable downtown restaurant on Bleecker Street. During the evening, when I mentioned to Nevelson that I was interviewing her old friends, I was relieved that she seemed interested and pleased, unlike Georgia O'Keeffe. Furthermore, she said nothing at all about wanting to see the manuscript before publication, while acknowledging that the biography would be entirely a work of mine. On the one hand, the gathering at the crowded restaurant of the celebrated artist, her biographer, and several Viking Penguin executive editors was considered noteworthy enough for a *New York Post* gossip columnist to write it up. On the other, it was an ominous sign that my editor never made it to the restaurant and, to my greater disappointment, soon departed from the publishing house, leaving my biography-in-progress orphaned. My agent eventually took it to Summit Books, an imprint at Simon & Schuster.

As I learned more about Nevelson, I discovered a darker and more disturbing side—her willingness to do almost anything to survive as an artist. After entering into an essentially arranged marriage at the age of twenty to a New Yorker in the shipping business, she neglected her young son, Mike, until he was old enough to find fragments of wood for his mother and to help her in other ways. Her relationships served her or else they didn't last, an attitude that I found cold-blooded. As far as I could tell, she had never fallen in love during her numerous dalliances. After the young Louise and a friend went to watch Mexican muralist Diego Rivera work on a mural at Rockefeller Center, he invited them to be his assistants. While the friend, another young female artist, helped the plasterer, Nevelson

admitted later that she had done very little: even then she didn't want to "play second fiddle" to the renowned Rivera, believing that she could be as good an artist as he someday. Instead, she seduced him, a casual affair that wounded his wife, Frida Kahlo.

The sounds for the words "eye" and "I" in English are exactly the same, Nevelson pointed out as a justification for an egocentricity that left little room for the egos of others. When I asked her friend, playwright Edward Albee, about her unapologetic egoism, he offered as defense that it is the demand of art, not the artist, that is selfish. His was an easy explanation of an artist's ambition, but one I did not entirely agree with. Obsession is certainly necessary for devoting oneself to self-expression in the arts, but I didn't want to believe it required or excused damaging or destroying another. Writing about Nevelson and living with Dan was draining and at times debilitating, so to keep going I developed a way to focus on only one or the other. Still, I wondered where the line was between doing one's work and relating to others and how to maintain my equilibrium.

Other challenges arose, too. When I was in my thirties and writing about Georgia O'Keeffe, I still had a lot to learn about living. By my forties I had found an internal compass and had less to learn from a woman like Louise Nevelson. On difficult days I regarded what I was doing as only the worthwhile practice of the complicated craft of biography. Although my subject's trajectory was fascinating—a dramatic aesthetic evolvement that led to enormous success—I had moved beyond being drawn vicariously into the vortex of someone else's life. It became overwhelmingly evident on a spring afternoon after a long interview, when I descended Nevelson's shadowy staircase with my tape recorder and walked into a blast of late afternoon sunlight and experienced a shockingly strong desire to be in my garden, along with a sharp sense of regret and resentment, that her life was taking so much of mine.

Working on the biography was demanding in other ways as well, but I had an unexpected assist. When I was at MacDowell, word went around that a writer had brought a bulky contraption called "a word processor." It aroused curiosity, so he invited other writers to take a look. As we squeezed into his cabin, he pressed a button and paper began rapidly rolling through a printer with a loud clatter while producing perfectly formatted pages of manuscript. Intrigued, a few months later I bought a desktop computer with a monitor displaying blinking green letters on a black background. When it crashed repeatedly, I nostalgically remembered its reliable mechanical and electric forebears, but still recognized the advantage of organizing my increasing amount of research material on searchable floppy disks.

Not identifying with Nevelson, an utterly urban creature with little interest in gardens, made objectivity easier but empathy more elusive. In my book proposal I had promised a meticulous and even-handed biography, so I was determined to describe her fairly out of respect for what she had accomplished as a sculptor, a notoriously difficult area of the arts. I respected her tenacity fueled by anger at neglect by art dealers, critics, and collectors and the way she persisted despite poverty and episodes of depression. Regarding herself since childhood as both inferior and superior—elements of a narcissistic personality—was another force that fired her fierce ambition. It was impossible not to admire her energy and stamina, and I tried to emulate them as I wrote her story. She had endured and triumphed relatively late in life, around the time when she conceived and constructed *Mrs. N's Palace*, a walk-in windowless box with a black glass floor and walls encrusted inside and out with her iconic black wood fragments, now owned by the Metropolitan Museum of Art. "I feel the *Palace* is both highly sophisticated and highly primitive, and there, I feel, is the meeting place of genius and insanity," she explained. Despite

my reservations about aspects of her behavior, I remained impressed by the way she always insisted that her powerful black assemblages expressed a female consciousness—one that enlarged the concept of womanhood.

Immediately after Nevelson signed a release form in early 1988 giving me permission to see her many boxes of photographs and other materials at the Archives of American Art in Washington, DC, I went through them. Upon returning to New York, I learned that after a struggle with metastasized lung cancer that spread to her brain, she had passed away at the age of eighty-eight. At a beautiful memorial service in the Great Hall in the Metropolitan Museum of Art, it seemed impossible that such a strong force of will and vitality, who had continued to build stunning small tabletop sculptures as she aged, was gone. Afterward, friends and family members who had been reticent came forward, and there was more work for me to do. Fighting for the patience to finish, I hoped to be done before spring gardening began, but it was not until the end of summer that I finally sent off the manuscript. My stress was not over yet, however. My publisher put a legal hold on the biography until Mike Nevelson gave me written permission to publish a minuscule amount of his mother's poetry, so for a few weeks I was frantic with worry that my years of diligent writing would be for nothing.

In the spring of 1990, *Louise Nevelson: A Passionate Life* was finally in the windows of New York bookstores and reviews were appearing around the country. The editor of my O'Keeffe biography threw a publication party featuring a cake ingeniously topped with pieces of dark chocolate that looked like a Nevelson assemblage. Nonetheless, photographs taken that evening show a dispirited author with a celebratory pink ceramic rose pinned to a pale pink suit jacket but with a haggard, unhappy face. When a reviewer described my treatment of Nevelson as "a bit bloodless," I was more amused than

annoyed because by then I felt that the final years of writing had drained my blood, while at the same time my garden was neglected and my marriage had deteriorated.

It can be perilous for married writers when one is more successful than the other. Dan graciously gave me a complimentary toast at the party, but I was well aware of the rage churning inside him. When a lengthy review of the biography appeared in *The New York Times Book Review*, it represented the recognition that had eluded him as a playwright. I finally faced the fact that I had to expel him from my heart and my house if I was going to be happy again. One day I sadly climbed the barn stairs to his empty writing room, unplugged his computer and printer, loaded them into my car, and drove them to his apartment in New York. Back in Sharon, I called a lawyer to initiate a divorce. What Dan had pledged to me when I was at MacDowell—the freedom to be myself—turned out not to be true at all.

29

A Book Not a Baby

Alone, I liked living by a rhythm of my own—rising before dawn, writing what I wished, eating when hungry, hiking when restless, seeing friends when lonely, listening to music when sad, and sleeping only when exhausted. Dreaming deeply, I was aware that one thing was settling inside and laying the groundwork for something else. On a mild February day, I set out on a dirt road that wound up and down alongside forests and fields. It was muddy and rocky underfoot, and a nearby brook swollen by snowmelt was running rapidly and shining in the sunlight. Golden fields were visible through a screen of leafless trees, and everything around me felt expectant, awaiting more warmth and light to ignite an explosion of spring growth. During the following months, as grass greened and leaves unfurled in my backyard, I started raking soggy dead leaves off awakening plants and doing other garden chores. It eased my inner ache, and a sense of sureness slowly began to return.

During the winter a group of female friends, mostly authors and artists around my age, had gathered on Sunday afternoons around my fireplace. Over the years—in Providence, Manhattan, the Hamptons, and Sharon—I had turned to other women, as they did to me, for empathy and affirmation, and now I did so again. Some in the group were mothers, and some were not. Most were actively working on books or making art; a few were struggling for inspiration and ideas about how to use their abilities. We talked a lot about our conflicts between taking care of ourselves and taking care of others or, in other words, the challenges of combining creativity and domesticity when working at home. Motivation, choices, discouragement, and confidence were among our topics. One of us was struggling to write another novel. Several were sculpting. A children's-book author was discovering the pleasures of painting. An editor was trying to summon the will to write. The eldest among us, a willowy gray-haired photographer, kept reminding everyone about the importance of doing our own work. I was attempting to decide what to write next and wondering if I would ever fall in love again. It was deeply comforting to be together on the Sunday of my forty-ninth birthday, when I was trying to figure out how to be fifty.

A question often put to me those days—"Why don't you write another biography?"—irritated me unreasonably. Usually I responded by saying that biographical research had become more restricted and riskier, but the real reason I was resisting had little to do with legalities. It was because even before becoming a biographer I had wanted to write from my own experience. It was an inner urge that was difficult to explain, but it had to do with developing a writerly voice that was more meaningful to me. On Ossabaw Island I had taken some tentative steps in that direction when drafting personal essays, as I attempted to reconcile the distance between the

raw private voice in my journal and a more polished voice I was willing to publish, before realizing I had to write another biography in order to earn a living. It was that winter of 1992 in Sharon, after more than a dozen years spent as a biographer, that my longstanding desire to write in the first person became insistent.

One day, while on the long drive to southern Rhode Island for the funeral of an uncle, a brainstorm for a book about childlessness came to mind almost fully formed. I had long wrestled with the dilemma of children and creativity; the idea had been there all along and was just waiting for the right moment to reveal itself. Steering with one hand, I scribbled down a rush of ideas on a pad perched on my leg. During my childbearing years I had wanted to write about women without children, but my churning emotions about my own conflict had made me put it aside. I remained deeply interested in the topic, however, especially after reading Adrienne Rich's *Of Woman Born*, a powerful work of nonfiction she called "personal testimony, mingled with research, and theory," which made me want to investigate nonmotherhood in a like-minded way.

My path to passing up motherhood was a lengthy one. In my twenties, I had disrupted the traditional womanly path to marriage and childbearing by staying single. By the age of thirty, however, giving birth was on my mind, when the lack of an experience began to feel equal in importance to the experience itself. I asked myself repeatedly: How do you raise a small being and do your own demanding work? Most of my writer friends who had children late never got their careers back on track because of lack of focus or time. I read about other writers who had managed to keep writing steadily while bringing up a child for insights. The African American writer Alice Walker fell into a workable writing rhythm when her baby was sleeping, but when her child got older, her attitude changed, and she forbid her daughter to play with dolls

and called motherhood and domesticity "a form of slavery," according to the girl. Their relationship later ruptured when her daughter accused her mother of neglect by putting writing ahead of mothering.

As I hesitated about what to do in my thirties, I felt disapproval from young mothers but surprising encouragement about not giving birth from older parents. Without a willing husband and with a desire to write, pregnancy seemed unwise, and when my husband eventually became willing, as I approached the age of forty, I no longer wanted to raise a child with him. When it became evident I would not give birth, my mother, who adored motherhood and had hoped I would become a mother, too, was sorrowful, but kindly said nothing to me about it. It wouldn't be until another generation, when younger women writers had more role models, better job opportunities, and maybe help from husbands, that raising a child or two became more commonplace, but balancing a family and a writing life has remained a struggle for many of them despite their aspirations and accomplishments.

By the time I reached my fifties it mattered less whether I was a mother because most of my friends' children had left home and our lives were more alike. I also had more children in my life. One summer I took an eleven-year-old niece and a thirteen-year-old nephew to Ghost Ranch in New Mexico. The ranch was green and gorgeous that month, and masses of yellow wildflowers lined the roadsides. The children loved the ranch, and I liked seeing them enjoy the hiking and horseback riding. When they spent time with other children, I read and wrote in the ranch's charming little library in an old adobe building. And for six or so summers I hosted a young African American girl from the Bronx under the auspices of the Fresh Air Fund. She was an enchanting child who called me "Mom" and asked me to be her godmother. I took pleasure in taking care of her, but her visits made me acutely aware of what

mothering demanded: many hours of caretaking and many interruptions when writing as well as an outer-directedness that separated me from the part of myself that wrote. I concluded that if I had raised a child of my own, I never would have written a single book because it undoubtedly would have been my way—like my mother's—to instinctively, and rightfully, place the needs of a small son or daughter above my own.

Now I wanted to explore the topic of childlessness, explain it, and invest it with importance. My intent was to try to expand the definition of womanliness beyond motherhood because of my belief that it is so deeply rooted in the female psyche that it cannot be negated by whether or not one gives birth. It was the right age to do it, I reflected, remembering that around the age of fifty Virginia Woolf had found the courage in *Three Guineas* to write more fully about her controversial feminist beliefs. My topic felt a little dangerous to take on because childlessness—intentional or unintentional—can be regarded as a violation of epochs of female history and even of nature itself. What would it say about me that I had bypassed the ubiquitous womanly experience? And what would the research and writing be like? "Will it be painful to write or liberating?" I asked myself. Whatever it would be, I was willing to find out. My child-free friends expressed excitement about the idea, along with trepidation about my venturing into the charged theme. Despite my concerns, I began working on a book proposal and, ironically, after nine months of literary gestation, it was ready to send to my literary agent. A few months later a woman editor without children at Ballantine Books offered me a contract, making me overjoyed at being "with book" again.

Preparing to sink into writing another book, I started simplifying my daily routine to protect my time, energy, and concentration. I decided to go into the garden only before or after work, at dawn or at dusk. Throwing myself into researching

what I called "otherhood," I took the train a day or two every week to Manhattan libraries to read legends, literature, poetry, and sociological, philosophical, and psychological studies. Meanwhile I discovered different words to avoid overused or negative ones like "childless" and "barren," sometimes using "nullipara" for a woman without a child and "nulligravida" for the woman who has never been pregnant. I began using other words in new and positive ways after learning that Alice Walker advocated using "womanist" for positive and powerful female behavior—a term, she explained, that African American mothers often use to praise a daughter's behavior when it is "outrageous, audacious, courageous, or *willful*" as well as inquisitive, serious, and grown-up.

My editor and friends who read early drafts encouraged me to write more about my own experiences. A biographer writes from a safe distance, and writing about myself openly and honestly felt risky as I slowly added more memories to the manuscript. It was difficult to confront my lingering feeling about the dream daughter of my imagination, a creature necessary to mourn as if lost to death, even though I recognized that she drew her power from fantasy, and a flesh-and-blood child would inevitably be different. "The disappearance of a dream child is undoubtedly less traumatic than the loss of a real son or daughter to miscarriage, abortion, stillbirth, or early death, but it is a real bereavement nonetheless," I admitted in the manuscript. "Abandoning an unobtainable and idealized rapport with an unborn being has its own poignancy and power, particularly if it is built on an unrealized aspect of ourselves."

I now realize that while writing this book I was finally reconciling myself to my own childlessness. It happened when I read that John Stuart Mill wrote in the nineteenth century, "What is now called the nature of woman is an eminently artificial thing—the result of forced repression in some directions,

unnatural stimulation in others." And it also happened when I read about female figures in history who had passed up motherhood—biblical matriarchs, Greek goddesses, and Christian nuns. I realized that what I had regarded as a private matter wasn't one at all, and it released me from a lingering feeling of apartness from other females. From my own experience I understood that nonnatal bodily experiences rooted in the rhythms of nature by our menses, our eroticism, and other aspects of our corporeal beings can validate nonmothers as vibrant female beings. As I gardened, I noticed nature's profligate ways, its excess of seeds, its cycles of growing and dying. Those hours were nurturing and maturing as they reminded me about proportion and persistence, fragility and endurance, disappointment and fruition. Symbolically participating in the earth's annual rebirth, I realized that "nature is about more than propagation—it is also about blooming and tenacity, loss and adaptability," as I put it in the book.

I also came to understand that childlike virtues—like genuineness, creativity, potential for growth—reside within adult selves, and women without children may have an advantage in retaining these youthful traits because of their greater freedom, flexibility, and free time. I recognized that creative work that demands inspiration and inventiveness, as well as many hours alone, needs to be protected and nurtured not unlike taking care of a child. Alfred Stieglitz liked to call Georgia O'Keeffe "The Great Child," believing that her creativity would be destroyed by the cares of motherhood. During the year she reluctantly realized she would remain childless, she decided to devote herself to "magnificent beauty" and rendered rounded images of alligator pears like pregnant torsos.

Despite the difficulty of drafting the chapters because of the private revelations, I was determined to persevere, and as I did the writing became more gratifying than my worry about doing it. "The surprise of the ease and pleasantness of it is still

with me," I marveled after a morning of writing and the transition to writing in the first person about what I knew. Instead of regarding a womb as an empty inner space, by the final draft I was viewing it as a symbol of internal fecundity and richness. I could tell my readers that a body that has never been pregnant is potent, still in anticipation, invested with self-potential and self-possession. And I could tell them that it is important for those of us who have never given birth to experience our bodies as womanly, sensual, strong, energetic, and even eloquent.

30

A Writer and an Artist

After a year or so, my quiet life of writing and gardening was not enough. Restless, I yearned for the same sense of rightness in a romance that I had felt about moving to Sharon. The man in my daydreams was mature, maybe older than me, as well as both steadfast and openhearted; he would have his own engrossing profession—maybe as a doctor—but whatever he did, he would understand the discipline that writing demanded, and he would respect its difficulty, too. Most important of all, he would be a man I trusted enough to love wholeheartedly, who would want to encourage and enhance my ebullience rather than robbing me of it as other men had done. Yet I remained a little apprehensive about the risk of getting involved in a relationship again, recognizing that it would not be easy to relinquish my newfound freedom.

One May evening the husband of a longtime friend telephoned to ask if he could give a man my telephone number. "Who is he?" I asked. "An artist," was the reply. Ever since art

lessons in childhood, I had been drawn as if by a magnet to artists, people whom I regarded as inspired individuals living independent lives—an affinity that had led me to write biographies of two of them. So I told my friend's husband that he could give the artist my telephone number. A few weeks later, after a day at the New York Public Library, I met the man for a drink at his club a block away. I had prudently gone to the library's art room to look him up in *Who's Who in American Art*, where I learned that Robert Kipniss, a widely exhibited printmaker and painter, was sixty-one, divorced, with four children. When I arrived at the club and shook his hand, it was with a smiling man with warm brown eyes and a head of thick dark hair. Sitting together on a red leather sofa in front of a burning fire in the bar, he gently took my hand, turned it over, and examined it thoughtfully as we talked. I immediately liked his directness, quick understanding, and aura of purposeful strength. Concerned about our almost twelve-year age difference, he later admitted he had been worried about my youthfulness until I told him I was about to turn fifty. When he drove to Sharon the following week and walked into my house, his first words were about how much he liked its peacefulness as well as the pastoral landscape around it. That evening he presented me with a pastel lithograph he had made of a house nestled amid soft hills, and I autographed a first edition of my O'Keeffe biography for him.

A week or so later, when I went to his apartment in Westchester County near New York City, he took me to his darkened upstairs studio, where a spotlight illuminated a work in progress on an easel. The painting, the slight smell of turpentine, and all the finished canvases of landscapes stacked against the walls made me feel as if I had entered an enchanted space. All around me was a visual forest: grayish-green twigs and stately tree trunks, fluttering leaves floating in the air, pellucid pale skies, mysterious spooky shadows, moonlight

shining on silvery branches, and much more. Immaculate smooth surfaces were made by delicate feathering that rarely revealed brushstrokes. Isolated or paired or grouped stands of trees were foliated, or leafless, rounded, delicate, slender, twisted, sharp, or sturdy. As we talked, Robert referred to his imagined trees as "dancers" or "lovers," and then he confessed that "all the trees are me." I felt very glad that we shared a passion for nature: one he rendered with paintbrushes and oil paint, and one I expressed with clippers and trowels and rakes.

My attraction to artists was affirmed by meeting this expressive and emotionally open man. We were both eager to tell each other everything about ourselves. The tabletops in his apartment displayed ancient Asian sculptures of serene meditating gods and voluptuous dancing goddesses. When I asked him what philosophies they represented, he replied that the emotions they evoked were more important to him than the beliefs they personified and, furthermore, he was more interested in aesthetics than ideas. Astonished because of my tendency toward intellectuality, I was interested in his approach to art but said nothing. Another time in Sharon when he turned to look at me and bluntly asked, "Who are you?" it was my cue to find old photographic albums. Looking at the black-and-white snapshots of me around the age of six after my mother remarried, he was moved by the pain and confusion on my face, he told me, and I was gratified by his perceptiveness and touched by his empathy.

Along with my attraction, however, an inner alarm went off about the possibility of being wounded again in love and losing my serene and safe way of life in Sharon. He indicated that he gave a lot and expected a lot, so I knew that maintaining a guarded emotional distance from him would be impossible. On days when I felt anxious, I tried to calm down by taking long walks in the woods or weeding until dark in the garden, while reminding myself that I would be fine without

him, a reassuring thought that made me less fearful. I decided to live with my dread of disappointment to see if it was justified or not. Once, sensing my apprehension in a restaurant, Robert reached across the table, took my hand, called me his "courageous lady," and told me not to be afraid. As spring turned into summer, I felt more and more confidence in our newfound love.

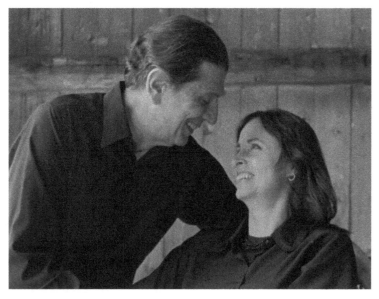

Robert Kipniss and Laurie in 1994, the year they married. Photo credit: Martha Porter

My euphoria dissipated a little by autumn when he revealed that he had never gone out with a feminist or a woman who took her work as seriously as I did, or who did not regard falling in love with him as the most important event in her life. One time he blurted out that he wasn't sure he wanted to marry me because he doubted that authors and artists made good wives. Apolitical, he had ignored the women's liberation movement and all the other protest movements of the 1970s, so I attempted to bring him up to date about what had happened

while he was spending long hours in his studio absorbed in imaginary landscapes. In response, he admitted trusting the goodness of my heart more than the ideologies in my head, and then he told me that my heart should better inform my head. Another time he shocked me by stating that there had never been any great women artists; incredulous, I pulled one art book after another from my bookcase until he conceded that he was wrong. Initially alarmed by his retrograde attitudes, as we got to know each other I came to trust his good-natured willingness to listen and his open-minded sense of fairness.

Right after meeting Robert, my head became so full of what I wanted to tell and ask him that it was difficult to remember what I was supposed to be writing about. When I confessed that a thousand inner adjustments were destroying my ability to focus on my book, he matter-of-factly told me to relax; he knew as a committed artist that if I was unable to bring intensity to my work, it would damage our relationship. To my surprise, since he had never gone out with anyone like me, he also said that he liked my self-discipline; I was grateful that he respected my writing hours and didn't telephone until I was done at one o'clock. On Sunday afternoons after a weekend together I felt bereft for a few hours after he departed for Westchester County, but then awakened on Monday mornings glad to be by myself for a few days of absorption in writing.

Living eighty miles apart remained a painful logistical problem, and before long Robert began talking about living together in his apartment on weekdays and in my house on weekends, but I wasn't ready. When we were together, I felt much more attuned to him than to my work, so I worried about moving my big desktop computer to his apartment until I was sure I could write well there. Neither did I want him to bring a copper plate to etch on my kitchen counter on weekdays, as he had suggested. One day he wondered aloud if I would ever be willing to live with him; furthermore, he said he couldn't

believe I had ever been married before because I seemed to think that living with a man was unnatural. When I explained that I had always found ways during my marriages to be alone and write, he proclaimed, "I was right! You've never lived with a man." And when he teased me about being a spinster at heart, I told him the right words were "free spirit." As we decided not to talk about living together for a while, my apprehension about what seemed like an irresolvable conflict between love and work diminished.

Well aware that my book was about a threatening or even toxic topic, I was glad that Robert, the father of four grown children and three grandchildren, was bothered neither by my childlessness nor by my interest in exploring the subject. He observed, in fact, that I had an appealing "clarity" compared to mothers. When I confessed that as an essentially fatherless daughter, I was moved by the father in him, he sweetly said that the parental part of himself was available to me, too. Indeed, his loving psychological embrace was beginning to heal that old wound. I felt fulfilled by something else between us, too. If he was uneasy about my feminism, it was evident that he enjoyed my femininity—he once called me "very, very feminine"—and I liked his liking it because it had rarely been appreciated in my relationships with men before. In fact, his attitude was deeply reassuring and made me braver as I presented myself in my manuscript in a nontraditional womanly way.

One Sunday a close friend in my women's group startled me by suggesting that it might be easier for me to write about the emotionally charged topic of childlessness when living with a nurturing man like Robert. Intrigued by the idea about writing *better* by his side than by myself, I decided to give it a try by editing a chapter with a pencil at his desk in his apartment. One day, after working in the morning and making love in the afternoon, there suddenly seemed no requirement any

longer for a rigid separation between love and work. A few weeks later, when I found myself weeping about being apart from him on weekdays in Sharon, I bought a laptop computer so I could do more writing in his apartment. As our relationship developed and deepened, I found everything to welcome and nothing to fear. Realizing I could say and do almost anything I wished around him, I experienced a sense of freedom along with emotional engagement at the deepest level. It was a time of astonished elation, when I felt embraced by a man who at various moments was lover, brother, or father, and when I was able to grasp the sensation of happiness in all its fullness.

After my manuscript was edited and ready for publication, it was time to set a wedding date. First, Robert and I had to settle something else. When my husband-to-be asked me to take his last name, it surprised and then amused me; I replied that if it was important to him for us to have the same surname, he could change his name, and the ridiculousness of it immediately ended the discussion. Then, a few days before the wedding, when filling out a change-of-address card in the Sharon post office, I felt a moment of anxiety about leaving my sunny writing room and life in the country, but I was so eager to be at Robert's side that I ignored my trepidation. My overpowering feeling was of being extremely lucky to be beginning another life in middle age with a man to whom I could entrust my heart. When I arrived at Robert's apartment door a few days before the wedding with a suitcase and clothes bag, the laptop computer, and an unbound galley of my book, along with my cocker spaniel on a leash, I was deeply moved by the loving look on his face. A woman judge married us in the presence of a few friends and family members—including my eighty-year-old mother and my stepfather, who made the trip by train from Rhode Island, despite quietly worrying about my marrying again—at the club in New York, where we had met two and a half years earlier.

31

Writer or Wife

Living in Robert's apartment after the wedding, I felt drenched in happiness as I looked out its western windows overlooking the Hudson River and framing an enormous view of water and sky. The high perch made me feel as if the perimeters of my existence had dramatically expanded. Sailboats with shining white sails, two-tiered sightseeing boats, and startlingly large cargo ships moved slowly and silently up and down the river day and night. On gray dawns, lying in bed after my new husband had gone to the gym, I watched tugboats with red lights pulling or pushing barges along the wide expanse of undulating water. Trains going south to New York City and to points north also passed under the windows, sometimes blasting their horns as they approached the Ardsley-on-Hudson station. And when I took the elevator down four floors, walked to the riverbank, and looked south, I could see the looming skyscrapers of Manhattan.

My life enlarged in another way, too. As the author of a book about to be published about women without children, I found it amusing that suddenly, overnight, I had become the stepmother of my husband's four adult children, and the step-grandmother of a toddler and twin babies. Was I now a little bit of a fraud? As Robert talked to me about his children and showed me photographs of them when young, I gradually got to know and like them very much. They never challenged me for being child-free and, in fact, were probably relieved not to have more step-siblings. For me, joining the family was like adding more younger siblings to the three I already had, so I naturally fell into the role of an older sister rather than a maternal figure. There was something else, too. Since I hadn't been well fathered, I took vicarious pleasure in Robert's paternal warmth toward his children, and I vowed never to interfere with it, so over the years my loose bond with his children became a loyal and loving one.

While the apartment was getting a new coat of beige paint, Robert let me discard dusty valances and draperies that blocked daylight, but he wanted to leave the translucent purple plastic shades that protected his valuable collection of prints on the walls from ultraviolet light. After the painters were done, I set up my laptop computer on his desk in his den and arranged my pads, pens, pencils, paper, and other supplies in its cubbyholes and drawers. Then I told him I needed space for bookcases and filing cabinets, which meant removing a sofa and a television set. "You want everything of mine out of the room?" he asked me incredulously. "Yes," I replied, explaining that a writer needs a room of her own, so he amiably went along and bought another desk to use in the large living room. Then I settled down to proofread the galley of my forthcoming book, *Without Child: Challenging the Stigma of Childlessness*.

As I read the galley, I was glad the voice in the book was outspoken and in places as personal as the one in my journal.

"Why else write?" I asked myself, joyfully believing that by finally writing in the first person another life for me as a writer had begun. Prepublication reviews were excellent, but to my dismay after publication *Without Child* was ignored by most of the mainstream media. At first I told myself with a bit of bravado that it was an only uneasy silence about a touchy topic. I also tried to regard the lack of reaction to my newfound writerly voice as a form of freedom that enabled me to now be unafraid to write about anything at all. In midlife Virginia Woolf had also discovered how to say something in her true voice, and she found it so interesting that she thought she could go on as a writer without any praise at all. As the months passed, however, I found the book's invisibility increasingly discouraging. "My writing is genuine, brave, and what I really want to do, but in the eyes of the world it's virtually worthless," I lamented. "The world isn't waiting for my words—why do I think I want to use them—or I *must*?"

The world could get along without my words, but could I get away without expressing them? I loved searching for the right words—"startling words, defiant words, gorgeous words, challenging words"—as well as the purposefulness of arranging the rich and abundant variety of synonyms and antonyms in the English language into phrases, sentences, and paragraphs. Writing exercised my mind and imagination and also enabled me to understand everything better. I decided there was nothing to do but respect my written voice and my efforts to articulate it. "And, of course, the only way I can keep it alive is by using it," I reflected. I pinned a promotional postcard showing *Without Child*'s book jacket—a female figure wearing red surrounded by an empty white expanse—on my bulletin board, where it looked to me like a little jewel.

Watching Robert eagerly head upstairs to his studio in another apartment every morning reminded me about wanting to do with language what artists can do with paint:

express an intensely felt idea or emotion in an individualistic way. He did it with an outpouring of exuberance and ecstatic energy, making myriad images—like his explosions of floating and falling leaves—with pigment and pictorial gestures as effortlessly as making love. While painting was pure pleasure for him, writing was more difficult for me. My attempts to express and then logically order black words on white paper contrasted with his ease with a paintbrush and a palette of colors, as if the demands of producing pages of prose differed fundamentally from the act of painting recognizable images. And unlike the years it took to compose and complete a book, he had the satisfaction of finishing a painting or print in a matter of weeks or months. Early on I had turned to verbal instead of visual expression, but now I wanted to make writing as pleasurable as painting, and as enjoyable as everything else in my married life.

I also noticed that Robert created a work of art for its own sake, with no guarantee of exhibiting or selling it. I had rarely written anything, certainly never a lengthy book, without an agreement with an editor or publisher about paying for it and publishing it; in the past it had always been impractical, but now it seemed possible to imagine, and I wanted to give it a try. In a bookstore I picked up a copy of the annual *Best American Essays* and found it thrilling to sample the richness of a range of literary styles and subjects in a wide variety of nonfiction essays. I began eagerly reading more essays, as if starved for inspiration, and the best of them excited me as much as seeing passionate little paintings. I wanted to use words in a more sensuous way, so I was glad to discover Cynthia Ozick's introduction to the turquoise 1998 edition, "She: Portrait of the Essay as a Warm Body," in which she called the essay closer to poetry than to any other kind of writing. As an essayist perhaps I could compose short pieces like a poet or like a reporter or like a memoirist, depending on the topic. Maybe I could also

write an essay a month, at the same pace as Robert created a piece of art.

Dawn became the time of day to pay attention to the part of my mind that imagined before the dominant part that organized took over. After awakening, I prepared to write essays by trying to waylay perceptions after a night of dreaming, a time when I opened my journal and sudden phrases and surprising insights often came to mind. As I wrote in longhand, I would wait more patiently for ideas than at my computer, when a lengthy pause would make the screen go blank in silent rebuke. Still, I had discovered that the handwritten curlicue and eager cursor coexisted very well, the former for jotting down rough sentences and the latter for refining them.

I drafted honest and heartfelt essays about what I was doing and experiencing, including "Heart" about the human and animal relationship as well as the larger matters of life and death. After viewing my own heart and the aging heart of my beloved dog, Daisy, on sonograms, I wrote: "As I watched my auricles and ventricles moving on the small gray sonogram screen, the organ looked like a black primeval mass— flickering, wet, restless, nervous, urgent—a dark shiny organ, a heart of darkness. I remembered the sight of my dog's big motionless pale heart against the light box, a muscle that had stretched large to compensate for its aging valves. It was another mammalian heart that moved like mine, I realized, a brave one that was unthinkable to stop. How could I still the quivering spasm of life in another creature, especially in a heart more loyal than my own? Mine had been too eager at times, I knew, and it had gone coldly dead at others. Whatever the merits of our two hearts, however, I wanted hers to keep beating alongside mine."

Many of my other essays were about art, including Christo's *The Gates*, when in 2005 he installed thousands of bright saffron flags in Central Park for two weeks, making walking

on miles of its paths like participating in a playful parade, a mysterious procession, or a medieval pageant. The day I saw the installation, the fabric flashed and shimmered in the soft February sunlight and brisk winter breeze, creating undulating orange reflections in ponds, and adding fiery voltage amid the branches of the leafless trees. The artist refused to say what it was all about, but in my essay I declared that it was about going nowhere and everywhere and taking time for joy.

Our sixth wedding anniversary marked a passage between the exhilaration of early love and the reality of working alongside each other. When Robert announced he had made his one-hundredth mezzotint after recently taking up the black-and-white etching technique, I was glad for him but sorry I could not say I had written a hundred essays. After finishing twenty or so, I had published a few in newspapers and literary journals but not, in my opinion, enough; even though he had not sold all his mezzotint editions, this bothered me. In my thirties and forties, I had written more steadily and successfully than my novelist and playwright husbands. Now in my fifties the tables were turned, and I could not keep up with the dedicated and driven artist I had married. It also turned out to be more difficult to write an essay without a promise of publication than with one. Once Robert had worried about writers making good wives, but now I wondered whether prolific artists were poor husbands for writers. Over time I deliberately decided not to compare our careers, telling myself that writing and painting were dramatically different. For one thing, the accessibility of the work differs: while a viewer can take in a painting at a glance, a reader must spend many hours absorbing a writer's work.

After spending all day alone in his studio, Robert would come downstairs in the early evening with an understandable desire to talk. As a result of writing biographies of O'Keeffe and Nevelson, I was alert to the fact that artists could be

ferociously driven and knew not to get between them and their studios, but he didn't know that I was in a way still working. Sometimes I wanted to be quiet, fearing that vocal words might get in the way of written ones. I didn't want to listen too much, either, especially to talk about his past and future exhibitions. He observed that my politeness gave narcissists the mistaken impression that I would listen to them endlessly, and I wondered whether he was talking about himself. When he remarked that when my mind was elsewhere, he felt ignored, uninteresting, and even as if he didn't have a wife, it alarmed me because it was an accusation I had heard before. I knew very well the way a writer's rhythm of living and then withdrawing to express him- or herself can damage a relationship. "Do you really love me?" he pleadingly asked me one evening, confessing that his heart was a little broken, an excruciating question that broke my heart a little, too. How could I give him enough attention without violating the writer within me?

My desire for marital harmony was competing with my introversion as a writer and also, as I would soon discover, my need for more time alone for another reason. Hot flashes were making me disturbingly distractible, oddly depleted, and often not up to the demands of socializing and writing; I began taking an antidepressant to offset my emotional fragility. It comforted me to remember that when Virginia Woolf began to write her masterly novel *The Waves*, she had written in her diary: "I feel no great impulse; no fever; only a great pressure of difficulty. Why write it, then? Why write at all?" Some mornings I felt wordless in front of my computer as I searched for ways to get past a strange reluctance to write. "Is my paralysis a natural waiting for an idea or self-indulgent procrastination?" I asked myself. "Or healthy withdrawal from the masochistic writing life?" Some days I even thought about going into "drift," or defining accomplishment differently than by writing. When a well-meaning psychoanalyst friend suggested that I give up

the struggle, my fury told me that I still wanted to express myself "fiercely, willfully, and daringly" with written words. My mantra became "make it mine," or making my prose so personally meaningful that I would become motivated by tapping an inner vein of pleasure. Doing this, I reminded myself, was a matter of making morning writing hours inviolate while waiting for an inspiring idea or the momentum of craft to get me going. It worked, and eventually my morning writing routine again became less a matter of discipline than desire.

During those menopausal days I craved what I visualized as white air around me, the stillness and silence necessary to weave my psyche back together again. I read earlier entries in my journal to remember when it had been easier to write, when it had not, and why. It was when I was alone, I reminded myself, so I thought it might be better to be apart from Robert a little more, and then be more intensely attuned to him when we were together; if I withdrew to rest and revive my spirits, I reasoned, I would have more to give. If my natural solitary self was allowed to exist, I was sure I could be happily married. When I brought it up with him, he surprised me by suggesting that I stay in Sharon during the week, and he would arrive on Thursday or Friday afternoon for long weekends. Perhaps he understood because he had illustrated a handsome limited edition of Rainer Maria Rilke's poetry with tiny lithographs, and it was Rilke who described genuine love as "utterly considerate, gentle, and clear [in its] manner of its binding and releasing" in a relationship undertaken by "two solitudes" who "border, protect, and greet each other."

While staying in Sharon might help my writing, I worried that it would hurt our marriage, so initially I settled on being by myself one day a week. Leaving the apartment before daybreak on Fridays, I took fast flights up the Taconic Parkway as daylight appeared, making me feel free; one October dawn I was thrilled to see an orange sunrise electrify the bright foliage

clinging to the trees and illuminate the white frost coating the ground. My gravitation to sunlight had always made me feel as if I were part plant—absorbing it, responding to it, and even getting a little high from the lingering light on long summer evenings. While the protective purple shades darkened the apartment, daylight flooded my writing room, especially in winter, making me elated to open my laptop in the brightness before a morning of work.

Oil painting cannot be interrupted at certain moments—for example, in Robert's case, when rendering a pale gray sky over and between treetops—but sometimes a painter can talk on the telephone while working on a routine part of a painting, while a writer can never chat and compose at the same time. When Robert sweetly telephoned me three or four or five times in the afternoons and evenings, the interruptions were sometimes irksome, but he was always so warm—often ending calls by telling me to be sure to feel loved—that I never ignored the ringing of the telephone. We were able to be eighty miles apart a day a week and eventually longer because of our trust in each other—what he called a "reliable, honest monogamy," one that gave him "peace and energy," while giving me a gift essential to a wordsmith. In later years I would stay in Sharon for a week or a month or even an entire summer if I was facing a deadline.

Around that time, Robert and I took a trip to Italy, and as we drove around the lovely Umbrian and Tuscan hills looking at architecture and art, including Assisi where Uncle Billy had once lived, I felt deeply happy at being together all the time. It made me realize without a doubt that it was the writer in me, not the wife, who needed solitude and, furthermore, that I would not like being apart from my husband for very long. After a day at the Uffizi museum in Florence, I woke up the next morning remembering the vibrant reds representing religious ecstasy in the gorgeous Renaissance paintings. It was the same

color red my step-uncle had chosen for the dripping blood of the crucified Christ. It reminded me of the bits of rubescence in Winslow Homer's paintings, the ubiquitous and insistent reminders of the life force in his dour and wintry New England landscapes. And while I reflected on the meaning of red, my love for Robert blossomed all over again.

Afterward, at the opening of a large exhibition of Robert's paintings at a prestigious midtown Manhattan art gallery, he half humorously remarked that he didn't have to talk about himself all the time anymore because now everyone else was doing it. I understood that despite his self-congratulatory riffs and my lack of them, he was less sure of himself than he sounded, while I was becoming more so. One day he graciously suggested that we regard each other's imperfections as endearing traits, an idea I liked very much. In a print or a painting he was likely to portray a hillside curving in one direction and a stand of saplings bending in another, suggesting a workable tension between the two. It wasn't all my attention he wanted, he remarked another time, it was more expressions of affection, which was a relief since I had much more of them to give. Around that time I gave up the antidepressant, and my edginess and energy returned, along with a readiness to write. A few months later I jotted down in my journal, "I hardly dare say it, but at last I'm writing well."

I felt fortunate being married to a painter after becoming aware of so many tormented marital pairings of writers, like Sylvia Plath and Ted Hughes, and of artists, like Diego Rivera and Frida Kahlo. Still, some of these relationships worked, at least for a while. I was reminded of the happiness of Georgia O'Keeffe and Alfred Stieglitz during their first decade together, when she developed rapidly as a painter and he returned to photography. I also remembered Virginia Woolf's dependence on what she called the "divine goodness" of her writer husband, Leonard; he made sure they lived quietly in the country,

guarding her fragile mental health and enabling her to write regularly in the mornings until she killed herself. An editor and a writer mostly about politics, he was the first reader of her novels while they were still typewritten manuscripts. She received enormous relief from his reliable praise: he told her *Jacob's Room* was "a work of genius" and *Mrs. Dalloway* was even better, she noted in her diary, while *To the Lighthouse*, a "psychological poem," in his words, was a "masterpiece," and *The Waves* was "the best of your books." She likened writing *The Years* to a long difficult childbirth, so she was elated at his reaction. "Miracles will never cease—L. actually liked *The Years!*" He thought it "extraordinarily good," she noted. "It may be simply that I exaggerated its badness, and therefore he now, finding it not so bad, exaggerates its goodness."

As the decades went by, Robert and I became more bonded than ever because of our desires to do creative work. He liked having a wife as involved in hers as he was in his, and I certainly enjoyed being embraced as a fellow creator. We gradually established a partnership that enabled both of us to be as prolific as possible. He remained amazingly productive of prints and paintings and art books about them, and he wrote a memoir, too. Our marriage became a delicate balance between intimacy and independence, when at times I tolerated a little too much togetherness and he put up with a little too much apartness. It turned into an exquisite dance toward and away from each other, infused with loyalty and love, that allowed us to flourish as artist and author. And it was exactly the kind of relationship with a man I had always dreamed about and then finally achieved. On our twelfth anniversary, Robert thanked me for giving him the dozen years, and I replied that I was very grateful for them, too.

32

My Mother's Garden

When I was growing up in Providence, my mother used to pore over lavish color photographs of flowering plants in the thick Wayside Gardens catalogs every spring, turning down page corners and underlining what she wanted to plant in her small garden behind the house on Angell Street. After the children were grown, she and Dad moved year-round to the village on the Rhode Island coast, Little Compton, where we had spent summers, and her hands became muscled from planting more gardens with intensity and ingenuity. Within the wings of their contemporary house, she created a Japanese garden where water trickled over a boulder into a little pond with fish, frogs, and water lilies. In the evening electric lights in the ground illuminated nearby leaves and left others in darkness, and the nighttime garden became a mysterious shadowy place full of fragrant blossoms and humming insects. During the day she excitedly photographed the latest peony, lily, or rhododendron blossom—closeups like Georgia O'Keeffe's renderings of

hearts of flowers—and then mailed color prints to my siblings and me. The world of nature was where my mother was happiest and more knowledgeable than anywhere else, and endless hours spent pruning and planting gave her the endurance to withstand the tensions and troubles in her marriage.

During my years in Manhattan I had seen little of her. It was difficult for me to find the time to go to Rhode Island, and she disliked visiting the big city. The moment I emerged from my car on visits, on long weekends and near her July birthday, she would take me to see her borders of extravagant blooms, rare flowering trees, and espaliered evergreens, while commenting on how they were doing as if each one were a person, praising those that were flourishing, and scolding those that looked listless. Her nonstop talk camouflaged the distance between us. It was her effort not to hear anything about my incomprehensible life in New York that would arouse her anxiety or anguish.

My mother was overjoyed when I moved into a house in a village like hers where, she remarked, I could remain if a husband made me unhappy again. As I began to garden, we developed a language to speak together, and we never ran out of words again. In letters and telephone calls she passed on bits of advice, we discussed what plants in our gardens had bloomed or died, and we suffered together during droughts and after damaging storms. If I asked how to tell if a plant was in the right place, she would reply, "If it looks happy," meaning the uprightness of leaves, shade of green, and amount of new growth. After my visits to Little Compton, I would return with a car full of perennials from her garden, and gradually mine became filled with the same flowers—bearded irises, tall meadow rues, mauve chrysanthemums—as hers. When she came to Sharon, we would weed, deadhead, water, prune, and rake together; after one summer visit, large boxes containing

a sturdy new steel shovel and rake arrived from her for my birthday.

As a writer it seemed natural and even necessary for me to keep detailed notes in a loose-leaf notebook about what I was doing in the yard, and they eventually gave me an idea for another book: integrating entries from the garden notebook with passages from my personal journal about gardening as a metaphor for living. I would call it *Garden Days* for the sunny yet cool days when gardening was irresistible and it was impossible to stay inside. What I especially liked about the book idea was the way it would transform my hours gardening instead of writing into, well, literary research. While working on the book proposal I became so highly motivated that the creativity of writing and gardening felt aligned, and I passed up days of perfect weather to work indoors. Still, there were moments of hesitation. "I always wonder if my little garden adventures will mean anything to anyone else, then remember that I'm really writing for myself," I jotted down, revealing a reason for writing. My doubt didn't stop me because I was so eager to look at life through metaphorical green glasses, the eyes of a gardener, and translate the practicalities of gardening into thoughts about a writer's need for nature. As I turned sixty, I signed a book contract to write a gardening memoir in eighteen months for the Scribner's imprint at Simon & Schuster.

I wanted to write about the way the sedentary act of writing was balanced by the strenuous activity of gardening, as one exercised the brain and the other the body. And the way gardening took time from writing but gave it back in other ways. For one thing, if I felt like a neophyte while working on a disorganized draft in the morning, I would feel like a heroine while deadheading and weeding in the afternoon. For another, it was inspiring. Watching plants sprout every spring made me wish that writing was more like gardening, where nature did most of the work. Was there an inner force like photosynthesis I could

tap while at my desk? And while gardening gave me stamina, it also provided the stability necessary for the writing life. Virginia Woolf knew writers needed routines, "so that nothing may disturb or disquiet the mysterious nosing about, feelings round, darts, dashes and sudden discoveries of that very shy and elusive spirit, the imagination." The predictable rhythm of the growing season—as flowering bushes and perennials bloomed in sequence at the same time every year—provided a regularity that encouraged me to take risks with words.

As I began researching the book, I encountered kindred spirits among the many other authors who gardened. Emily Dickinson found writing poetry and cultivating flowers intimately intertwined and mutually inspiring. "This is a Blossom of the Brain," is the way she began a poem. She called her imagination "the garden within," where flowers were anthropomorphic personalities that represented friends and family: her mother, for example, was the tall, deep red, late-summer wild cardinal flower, and she was the daisy turning toward the sun. The budding and blooming in her botanical cosmos gave her insights about life and death. Likewise, Edith Wharton likened her creativity to "a secret garden," a place of inner fecundity where ideas for novels took root. She claimed she was as proud of winning first prizes in a flower show in Lenox, Massachusetts, as having *The House of Mirth* sell well in New York, and she told a friend that she was "a better landscape gardener than novelist."

When working on the garden book, I began going to Rhode Island more often to see my mother and stepfather, now moving through their eighties. As they aged their dependence on each other had deepened and, astonishingly, they developed more tolerance and, at times, even tenderness toward each other. My mother's memory had faltered, and she had forgotten the ways her husband had hurt her in the past. The only one among her women friends who was not a widow, she told

me she felt fortunate to still have a husband. A decade earlier she had refused to observe their fortieth wedding anniversary, saying bitterly that there was nothing to celebrate, but as their fiftieth wedding anniversary approached, she wanted to give Dad a wide gold wedding ring, and he was glad to wear it.

On one visit Dad took me aside to tell me that a silent heart attack had weakened his heart, and asked me to write his obituary. He had mellowed as he aged, and we had a respectful arm's-length relationship. Shocked, I agreed, saying I hoped it wouldn't be needed soon. When I returned a few months later, I saw by the look in his eyes that he knew he had little time left. One afternoon he threw back his head gasping for air so I called the village's volunteer ambulance; when he came back from the hospital tethered to an oxygen line, my mother whispered to me that she was walking on tiptoes so he wouldn't die. On my next trip, in December, with Robert, Dad was so weak that on Christmas Eve he needed my help to undress and get into bed. The next day I played a cassette of his beloved Handel's *Messiah*, remembering the many recordings he had played during my childhood that incubated my love of classical music, while wondering if it would be the last time he would hear it. A few days after I returned to Connecticut, my mother telephoned to say that Dad had died of a heart attack early that morning.

A few weeks after the funeral, I packed my manuscript and returned to Rhode Island to be with my mother. In all her eighty-eight years, she had never lived alone. A blizzard snowed us in by ourselves, evoking for me the cherished years we had lived together on Williams Street before she married again. Early on she had called me Lulu, maybe because of Little Lulu, the inquisitive comic-book girl with black ringlets, or maybe I liked the cartoon character because of the affectionate nickname—but whatever the case, it was what she still called me. When at fourteen I heard myself being rude to her while

hating my wounding words, she was forgiving as always and would lovingly write on an eighteenth-birthday card: "Thank you for being you." After the snow stopped and the sun came out, I tried to dispel her depression about Dad's death by taking photographs out the window of the softly mounded snow shining on the dark boulder in the garden. The shock of his death had changed her handwriting overnight from strong and upright to small and shaky, and before long she could only move around the house on weak, wobbly legs; sadly, she was unable to get to her greenhouse, where her red and pink camellias were blooming in the soft winter light.

On following visits I would immediately go sit next to where she would be in a yellow armchair with a view of the garden; where we would hold hands, look into each other's eyes, and smile. When she struggled to stand, I steadied her, and we would often end up in an embrace. Once when she lost her balance and lurched against a table, she wailed, "I *hate* being old!" When I replied that I hoped to make it to her age, she quickly became maternal and quietly said, "I hope you do, too, dear." She observed that now I was the mother and she the daughter; she had always been a little girlish, but now the girl inside was trapped in a feeble body. While helping her shower and rubbing lotion on the fragile skin of her thin legs, I realized I was looking at my own legs in a few decades. And when I combed her wispy white hair, I knew I was seeing my own head of hair someday. Bodily alike but mentally unalike, I marveled at the strength of our bond.

One day she asked why I was around so much more than in the past. I didn't mention that the atmosphere of the household was now more pleasant than when Dad was alive. It was because she needed me, I explained. "That's right," she acknowledged, but the truth was that I needed her, too, because there were wounds to heal. I wished I had been a better daughter—one who had fulfilled her wish that I marry and live nearby, and

one who had given her more grandchildren—so I was grati-
fied when one day she remarked that she was lucky with her
children, "especially you." In *Without Child* I had mentioned
her less-than-perfect mothering, and even though I had done it
gently, it had felt a little like committing literary matricide, so I
was glad to be able to tell her that she had given me a mother's
most valuable gift—the certainty of her love—and that I was
dedicating my gardening memoir to her.

My mother startled me another day by saying that it must
have been tough on me when she married Dad; after a moment
I acknowledged that she was right. "I needed him then, just
the way I need him now," she quietly explained to me. She had
always been very dependent; at the age of fifty she had written
her husband an angry letter when he was on a business trip
that ridiculed self-reliance as "farcical." Despite my incompre-
hension of her intense longing for him, and for death so she
could be with him again, I placed a framed snapshot of the two
of them on their honeymoon near the yellow armchair where
she could easily see it. In my mother's wish to die, my child-
hood trauma of losing her to my stepfather was being played
out all over again, but because of our newfound closeness the
old wound was nonetheless healing.

A few months after Dad's death, a vascular surgeon told
my sister and me that our mother needed an aortic bypass
operation to restore circulation in her legs. My elderly mother,
the doctor assured us, had a young heart and good lungs, so
we worriedly let him go ahead. Afterward, in intensive care,
she developed delirium tremens as alcohol drained from her
body; evidently in mourning she was drinking heavily, and her
doctor was alarmed. As the pale lavender lilacs from her own
mother's garden began to bloom around the house, she trust-
ingly allowed me to drive her to the geriatric ward of a psy-
chiatric hospital to recover from her alcohol dependency; after
twelve days, I brought her home again.

Glancing at her walker and her bottles of pills, I felt anxious about meeting my book deadline a few months away. I tried working on the manuscript at my stepfather's large walnut desk, but I had to be at her side most of the time. It was necessary to leave her to be able to write, to be a wife, and to tend my garden. Reluctantly I made plans to move her to an assisted-living establishment. As I packed her suitcase, she said sadly that she had slept in her own bed for the last time; it was an elegantly carved, four-poster canopy antique of her grandmother's for which she had stitched a bedspread with Adam and Eve frolicking with birds and animals in a flower-filled Garden of Eden. Gathering framed photographs of Dad to take with her, she confided to a visitor that she wanted to cry but would not because it would upset me. That evening in the empty house, I became tearful at the thought of my mother living like a cut flower in an institution instead of like a flowering plant rooted in her own ground. By morning I had decided to bring her home again, where she might be able to draw her last breath in her beautiful bed.

Near the anniversary of Dad's death, I was afraid that if her raw grief didn't dissipate, it would kill her. Although she was glad to be back home, tended by friendly village women, during the following months she still talked about wanting to die. When I protested, she asked me, "Wouldn't you?" I said I didn't think so—I'd stay as long as possible, especially since she had such nice children. She chuckled but replied that it might be a reason if the three of us lived closer. Whenever she mentioned the allure of death, I would talk about celebrating her big birthday in July. "Ninety! I can't believe I'm almost ninety," she would exclaim in astonishment. I would tell her she couldn't depart before the party, and she would exclaim, "But it's not until next summer!" It was her will versus mine, and hers was very strong. I told myself that I should be glad

she didn't dread death, but I wanted to tether her to life—and to me.

As I worked on my manuscript, I asked my mother about her mother's and her grandmothers' gardens, and she tried valiantly to remember them for me. Meanwhile, observing her garden and talking with her about it was changing the way I thought about living as well as writing. When we spoke about what to plant and why, she reminded me that roots must go deep to withstand times without rain, and that plants grown in rich soil are more likely to thrive. I studied her groupings of plantings to understand why they were so impressive, noting what perennial she had put where and near what and the flowers she had allowed to sprout charmingly in unexpected places. Impressed by tangles of exuberant plants enclosed within edged borders, I got an idea about placing spontaneous phrases within orderly paragraphs. And like her inventive and expert placement of flora, I looked for the perfect places for anecdotes and observations within my manuscript.

As another spring got underway, masses of crocuses around my mother's house gave way to beds of daffodils at the time a doctor prescribed a new medication for her memory made from daffodil bulbs; it was only after her death that I learned it caused more fatal heart attacks than a placebo. During the days she talked about Dad with smiles and in the evenings with sadness. On warm mornings I liked to park her wheelchair near a plant with faded flowers, where she would contentedly clip off browned blooms. Sometimes I would shake a tendril or branch that was beyond her reach and ask whether or not to clip it. I cut buckets of blossoms to bring inside for her to arrange in the silver trophy urn underneath her portrait as a blue-eyed, pink-cheeked little girl. That April she ordered a summer dress with a floral print and two flowering shrubs, a blue Endless Summer hydrangea and a Chinese spice bush with red blossoms, both to be delivered for autumn planting. As the peonies

bloomed, her garden-club friends stopped by to cut them for village events, and then the woman who tended her garden gathered armloads of flowers for her wedding. Words about my mother's happiness appeared in the caretakers' notebook, making me hope that she had changed her mind about dying.

At her ninetieth birthday party she reigned in her wheel-chair like a queen on a throne, greeting her children and grandchildren, then cut into a big cake before kissing every-body goodbye at the end of the day. As I got ready to return to Connecticut to work on my manuscript, due in a few days, she indicated that my departure was more troubling than usual. Ordinarily she was sweetly but sadly aware that I had to return to the man she referred to as "your Robert," the husband she had decided was finally "worthy" of her daughter, but this time seemed different. As always, we said we loved each other, and I promised to telephone every day and be back soon. A few days later she complained to a caretaker about a burning sen-sation around her heart and was taken to the hospital; she was in a state of excitement, her eyes sparkling and face flushed because, my sister and I later surmised, she sensed her heart was finally giving out. Back home she got into her four-poster bed feeling unwell and told the caregiver she was dying, but refused to let her call the ambulance. The caregiver telephoned my sister and brother, who were vacationing nearby, and they were with her when she peacefully let out little puffs of breath until they stopped altogether.

During the first few miles on the drive back to Rhode Island, I felt anguished about not being with my mother when she died, but I admitted to myself that I would have wanted her to stay, while she wanted to go. By the time I arrived and drove up the driveway, I understood that she had held up her end of our bargain: I had asked her not to depart before her birthday party, and she had obliged me. And, I reminded myself, she had passed away in her beloved bed. When I parked beside a

large hibiscus bush she had planted, which was enveloped in pure white blossoms, my sadness was about her being unable to enjoy its magnificence more than anything else. Inside the house, her yellow armchair looked horribly empty, but when I sat in it and wept, I sensed her telling me to stop being so silly. She was that way about weeping.

At the graveside burial service, a Unitarian woman minister read a poem, "Crocuses," with a line about a chaplet of flowers adorning the silvery hair of an elderly woman's "dear old head." It was the image of my mother's white hair crowned by a garland of flowers that stayed with me during the following months. I was grateful that I had told her that by mentoring me as a gardener she had given me the gift of gardening, but I was sorry about being unable to hand her my book when it was published in the spring. Meanwhile, her mail was being forwarded to me, and when the flowering shrubs she had ordered in April—on a spring day when she didn't want to die—arrived at the Sharon post office, I brought them back to my garden and wept again because my mother had managed to give me gifts even after dying.

My editor granted me a few weeks' extension of the deadline, and then I sent off what would be titled *Four Tenths of an Acre: Reflections on a Gardening Life*. In its chapters I believed I had made the transition from biographer to essayist, something I had always wanted to do. "I love it," I quietly said to myself. "Every word has been worked over so carefully." A longtime friend said its first-person voice had dignity along with being revelatory—"Like you," she said—but challenges remained. My editor was gone from Random House, where the manuscript had moved with her from her previous position, before she could shepherd it to publication day. Despite pre-publication praise for the book as "elegant" as well as "a little edgy," without an engaged editor it had a quiet launch.

In its pages I had wrestled with my most important and troubling question about my compulsion to garden. "Like the plants with their biological code that programs them to germinate, grow, bloom, and set seed, I felt as strongly encoded to water and weed during the growing season," is the way I described it. My concern was exacerbated after reading Simone de Beauvoir's observation in *The Second Sex* that nature is both a "kingdom and a place of exile" for women. Her words made me worry about having fallen into the homebound existence of my female forebears—a capitulation to outdoor domesticity—or what Eleanor Perényi called in her book *Green Thoughts* "a floral cage." Was giving so many hours to an unpaid, private, and underpraised activity escapism or a form of female exile?

Learning about garden history, remembering my grandmothers' gardens, and watching my mother in hers, gave me an understanding of what the growing world has meant to women for so long. It has to do with creating ephemeral beauty, but it takes effort, energy, and determination. "Some doubt remains, I admit, about whether or not I have exiled myself in a floral cage," I wrote. "But instead of worrying about my lack of free will in the spring, I try to focus on how liberating it feels to follow the dictates of nature. The garden is like a taproot that grounds me but, paradoxically, makes me feel freer. Whether women are relegated to flowery bowers or linger there by choice, the green world is where many of us find solace and strength. When Simone de Beauvoir wrote that nature is to woman both a kingdom *and* a place of exile, she was suggesting, I see now, our need to withdraw into the world of nature to replenish ourselves, but not to remain there too long." By the time I had finished drafting the manuscript, I understood more strongly than ever that for me gardening was not a captivity: I remained sure that it was good for my writing.

While working on the book, I had a disturbing dream about strangers invading my property, and I wondered if after

publication I might want to move away from Main Street. To my relief, only once did a reader show up on the sidewalk shyly asking to see the garden; when I gladly showed it to her, she perceptively observed that the dramatic opening of the big bearded irises described in the first chapter as the reason for my "capitulation to the gardening life" were blooming again that day. And when a radio interviewer asked me if I had regrets about writing so personally, I heard myself saying that I had none because nothing negative had happened. Nevertheless, as my garden became a private place again, I was relieved to no longer have to reveal what I was doing in my backyard. After spending many hours writing about the garden, now it was time to go outside to pull the weeds and prune the vines that had grown wild behind the house.

33

Becoming My Own Biographer

The idea of New Mexico had vividly caught my imagination at a younger age, and it became a wide and luminous landscape I loved and would return to repeatedly. One August I traveled to Ghost Ranch for a week to walk and write with a group of women. We hiked up to a rocky overlook above Georgia O'Keeffe's vast valley and saw the Pedernal—the mesa with the slanted top she claimed was hers because she had painted it so often—in the far distance. On other days we made our way along a little stream running through a dark canyon lined with steep reddish rock walls that opened up to a slice of pure blue sky; walked across flat pale sandstone rocks and through arroyos beneath cliffs she called "the White Place"; followed a path that passed a rattlesnake with a chipmunk in its fangs, inched along a narrow sandy slope alongside a sheer drop, then crawled hand over hand over boulders to the gypsum top of a mesa resembling the surface of the moon, from where a hiker had recently fallen at dusk to his death.

On the last day a van took us north toward the Cumbres Pass on the Continental Divide trail in the high mountains of southern Colorado. At an altitude of more than ten thousand feet, a wild wind was blowing. It was like an elemental force, as if caused by the spinning of the earth itself as the orb moved through endless black space. It felt as if our little band of six or eight was moving across the top of the world. Walking single file against the wall of wind in the thin air made my lungs pump hard and my heart beat rapidly. It surprised me that I was the slowest and ended up last in line since I hiked so much in Connecticut, until I realized that at the age of sixty-six I was a decade or two older than most of the others. Still, my steps were springy because of the elevation as well as my exhilaration at being enveloped by all the bright moving air. After a few hours we settled down with our picnics in a patch of warm sunlight on a sloping meadow among waving grasses and nodding alpine wildflowers while puffy clouds raced low overhead and created sudden dark shadows. I felt as if I could reach up and touch one of their bulbous cottony bottoms. A dark forest encircled us, where even the tops of towering evergreens were swaying in the unrelenting gale, and where earlier winds had ripped bark off trunks and blown large limbs to the ground. Everything around me was in rapid, unrelenting motion except for the patch of ground I was sitting on.

After eating my sandwich and apple, I took a pad and ballpoint pen from my backpack and began to compose a letter to my younger self. Looking back, I thanked her for decisions she had made over the years that led to the thrilling hike. Then I rebuked her a little—for times of wordlessness and loving the wrong men too long—but liked the way she had never given up on the written word, feeling grateful for material that, like a dream, had led her toward an exciting issue or idea to explore. I had always enjoyed the ordering of thoughts, the beauty of language, and the daringness of insights. Arranging

and rearranging words on the page until they were right had taken time, a lot of time, over the years. So had gardening, and I ruefully recognized that without a garden I might have written more, but I would not have been as happy. It was the quiet things—writing, gardening, reading, walking—that allowed my mind to follow the thread of a thought, and I had enjoyed them all, realizing that I relished written words on paper more than verbal ones moving through the air. Words were only signposts, however, black-and-white symbols, and they required research, perception, and arrangement to give them resonance. It was not entirely evident to me whether I had wanted to be a writer because of an introverted nature, or if the writing had demanded introspection. Most likely it was a little of both.

As I remembered and asked myself why I had wanted so urgently to write, my answer that windy day on the mountain was about the importance to me of a writerly voice, a voice with volume and velocity. Author Louis Menand described it poetically in a robin's-egg-blue edition of *Best American Essays*: "What writers hear, when they are trying to write, is something more like singing than like speaking . . . [It] is not your speaking voice, it is your singing voice—except that it comes out as writing." Over the years I had evolved from a teller of other women's stories into one who told her own, after I outgrew the need for vicariousness after writing about O'Keeffe and endured the lack of it when writing about Nevelson. Giving up a third-person for a first-person voice had felt natural, if a little dangerous, a way of using the extemporaneous words in my journal when writing about childlessness and, even more, about gardening. Eventually trusting what I knew, it was deeply gratifying to begin to express myself in a personal voice.

Returning to Sharon, I felt a little reluctant to begin writing another book because of the unsettling way the digital revolution was upending the publishing world. I worried how

authors, especially biographers, would work in the future without the existence of handwritten letters, diaries, and other words on paper. Nevertheless, I pulled from the back of a file cabinet my abandoned book proposal about writers Neith Boyce and Hutchins Hapgood. As I read it again, my excitement returned about writing a literary biography against the background of an earlier Greenwich Village, not unlike the one I had known on West 11th Street two generations later. Although I liked writing in the first person, I still relished the intellectual adventure of investigating primary materials; also, three decades after I wrote the proposal, the couple's extensive papers, including their letters to each other, had been organized and indexed at the Beinecke library in New Haven.

I had been able to learn relatively little about Neith in the 1970s, before the days of personal computers and internet searches, when it would have taken years—long after a book contract was signed—to discover the details of her life. Two decades later, after digitized books and databases revolutionized research, I was able to read in a matter of months almost everything that had ever been published about the couple. Two books of excerpts of their work edited by feminist scholars had also been published. As I read, I discovered that Hutch resented Neith's attention to writing and neglect of housework and the family. I also learned that while he had a number of affairs, when she did, too, he became tormented by the fear that they meant more to her than his flings did to him. When she fell in love, then reluctantly gave up her lover for the sake of the children, she suffered a nervous breakdown from which she never fully recovered. And in a collection of Eugene O'Neill's letters, I was very dismayed to find a description of Neith lying on the floor in an alcoholic stupor "as always."

After her last two books were published in 1923—the novel *Proud Lady* and *Harry: A Portrait*, a nonfiction account about her eldest son who died in the 1918 pandemic—she wrote and

published very little. I was disturbed that a memoir, which she called an autobiography, was written in the third person, under a pseudonym; most appalling, it ended abruptly on her wedding day, as if she didn't want to face what came afterward. When I was in my thirties, I had known about a few of Neith's disappointments, but her failure to publish her autobiography and any novels after the age of fifty-one, when I had begun to write in a personally meaningful way, had not been as important to me then. I was no longer the same young woman in an unhappy marriage who had imagined that Neith and Hutch's was a thrilling romantic relationship.

Instead of Neith's being an inspiring life, I realized it was a cautionary tale for women writers, especially for those who want to become wives and mothers. It was the same conflict between career and children I had wrestled with, and which many young writers still valiantly struggle with today. As I learned the truth about Neith's life, I developed the *crise de confiance* I had experienced in the middle of writing my biographies, when I was forced to reconsider my innocence or idealism about my subjects' imperfections, but then I had contracts with publishers, and I was motivated to work my way through my disillusionment to degrees of understanding. It wasn't long before I developed a sickening feeling in my stomach about the prospect of thinking about Neith's tragic life every day for the next few years. I vacillated for a while, unwilling to undertake a pathography or give up the biography again.

When I talked about my dilemma with a friend, he remarked that at our ages we should not do anything without passion. Not just interest or pleasure, he emphasized, but passion. As my seventieth birthday approached, I found myself asking how many more writing years I had left, and I was startled to realize there were only twelve until I turned eighty. "Twelve precious, productive years, if I'm lucky. How to best spend these precious years?" I asked myself. Biology, and mortality, too, suddenly

appeared as different kinds of deadlines. I remembered that Neith's daughter, Miriam, had been in her midseventies when she worried aloud to me about whether she had enough time and energy remaining to publish some of her parents' prose, and it turned out that she did not. By the time I finished writing another biography, I recognized that I would probably be her age, and there was something else I also wanted to do.

When I had delved into my garden notebook and my journal to write about gardening, it had made me want to reread the entire journal and write a fuller memoir someday. Would there be enough time to write another biography and then a memoir? While a biographer's time is finite, I knew very well that biographies often take more time than anticipated. I asked myself if I should search the forty-eight boxes of another family's papers or read my forty handwritten journals. Spend my days researching in an archive in New Haven or working at home near my garden? One sunny spring day, while looking through a box of letters at the Beinecke library, I finally acknowledged that it wasn't passion motivating me as much as curiosity and eagerness to get back to work. Maybe I would settle for meaningfulness, but I wasn't finding enough of that either.

Looking inward more deeply than ever might be a powerful—even a passionate—experience for an introvert like me. For a while the urge to write personally went underground in my journal, but it never went away. In her era Virginia Woolf had said that women writers had yet to tell the entire truth, and during the women's liberation movement Adrienne Rich had observed that many young women still needed to find their voices. When writing my biographies of strong women while enduring the opposition of men I had married, I had kept working, in retrospect readying myself for telling my own story. I had begun, but was I ready to do more? When I asked myself if it would be presumptuous for me to write a memoir, I knew the question was an old one. In 1655 Margaret Cavendish, the

English Duchess of Newcastle-upon-Tyne, a prolific writer and childless wife, had hoped readers would not think her "vain" for writing about herself; her memoir might not be important to them, she admitted, "but it is to the Authoress, because I write it for my own sake, not theirs." Her defiant words reminded me that writing for oneself was often a writer's motivation, but I hoped what I learned might be meaningful to others, too.

Finally, on a summer day I put the book proposal about Neith and Hutch back in the file cabinet with a mixture of regret and relief and went to look for my handwritten journals. I gathered them together, numbered them, and arranged them on a bookshelf—from the college spiral notebooks to the more recent hardback Moleskine volumes—and then opened the fragile first page of the 1963 journal. When I had read passages in the past at a crossroad or a time of confusion, it had made me feel skinless, so I had stopped. Now I vowed to ignore the feeling of vulnerability and to read every one of them, most for the first time since writing them.

Laurie at home in her house Sharon in 1996. Photo credit: Judith Petrovich

Many of the journal passages were about writing, so that seemed a natural focus for a memoir. When I told a longtime writer friend, who had gone with me to the protest at *The Ladies Home Journal* years before, she emailed me that she was "very excited to hear that you're tackling The Writer's Life. All through our correspondence over the years, this has been your theme, and without fail, you have commented on what this means for you: the interiority, the research, the solitude, the discipline, and the richness of remaining focused on your topic." She continued, "I've felt from the beginning, when you started on O'Keeffe, that what mattered to you was how a woman finds the strength to make art and also make her own life. I have felt the great heart and emotion behind these reflections. So, this seems like a perfect topic for you, at this stage of life." Even more encouragingly, she added that it was "sheer genius to do a book like this now that everyone wants to 'be' a writer," and it would enable me to enter into a dialogue with younger writers.

As I began to look back, I wanted to return to my hometown and walk along Williams Street, Angell Street, and other streets in Providence that were as familiar to me as the bones in my body. At the downtown branch of the public library I worked my way through worn index cards to find and read scratched microfilm reels of newspaper articles published in *The Providence Journal* during my years in the city. It was an attempt to jog my memory, arouse old emotions, and discover more about the place where I was born and brought up. I found a posed photograph of the recalcitrant teenage debutante who dreamed about becoming a writer. I read that a few years after she left for Manhattan, the debutante balls had ended after the evening long-haired ushers bolted from the Grand Ballroom. There were startling revelations outside the library, too. When walking past the massive marble bank where an uncle had worked, I noticed youths passing in and out the big doors with

portfolios under their arms, and learned in astonishment that it had become a dormitory and art library for students at the Rhode Island School of Design. And when I heard that artists had taken over abandoned downtown department stores for studios, I realized that my staid old hometown had become a city for artists, making me pleased about the place I was from.

After leaving Providence, and nearing the bridge over the river between Cornwall and Sharon, I was glad to see the lovely rounded mound of a little mountain that always looks to me like a greeting and a guardian of what is on the other side. As I settled down to read my journals, gradually a compulsion took hold to comprehend the past. "Who was the girl whose timidity and bravery had shaped my existence?" I asked myself as the weeks and months went by. It was as if she were someone else, as I viewed her from a later life stage of stability and maturity. At moments I became so absorbed in what had happened to her that I forgot my age until I passed a mirror and remembered with a shock that I was over seventy. All my writing life I had been working toward telling my story truthfully, and it felt as though the memoir would be my most meaningful book. As my birthdays passed and I read obituaries of contemporaries, it felt as if I were racing against the alarming possibility of something happening to my brain or body before I was done.

As I read and remembered, searching for dialogues and descriptions, what had been lost in memory became alive again. Former emotions rushed back, and I was astonished to experience the exact same indignation or hopefulness or pain I had felt many years earlier. "How can that be?" I asked myself. "It was so long ago." It was as if everything I had ever thought or felt remained imprinted deep in my memory. As I deciphered the handwriting on page after page during my decade in Manhattan, the erratic penmanship and outpouring of turbulent feelings enabled me to inhabit a younger self who had struggled for energy and exuberance while also looking

for love and security as well as a way forward. At moments I applauded her daring or despaired at her hesitancy, gyrating from exhilaration about an insight to excruciating sadness about the loss of love. Some days I was afraid of what I would read next.

"When the fear is upon you, write for yourself," Richard Rhodes had written, I recalled. "You and your fear, wrestling like Jacob and the angel." I interpreted this angel—not at all like the angel of the house—to be a more honest and brave part of myself that refused to free me from its grip until I addressed it. It was the self who recognized my flaws, when I was thoughtless or insensitive or wrong. It was an especially fierce struggle when reading old letters and journal passages about boyfriends and husbands, when what they regarded as love didn't feel like love to me at all. When reading Arthur's letters, I felt sorry that I had met him and then sad that I had to leave him. One morning at my desk my throat tightened and I thought I was having a heart attack, but in the emergency room of Sharon Hospital a sedative dissipated my difficulty breathing. A doctor diagnosed stress, but I knew the feeling near my heart had been caused by a toxic brew of anger and grief. My violent reaction to what I was reading, I realized, meant that I was getting down to memories that mattered.

Where was the fine line between reticence and revelation? Even though I liked writing in the first person, I worried at moments about the greater amount of self-exposure I was risking in the memoir. I was experiencing an inexplicable aspect of authorship: the contradiction between concealment and disclosure, when a writer of revelatory prose does not want his or her privacy invaded. Philip Roth is said to have boasted about how difficult it was to find his farmhouse on a quiet back country road despite the alter ego in his novels and details about himself and his family in his memoir, *The Facts*. Evidently many authors are more comfortable with controlled openness

in their books than with strangers' unexpected intrusions onto their property and into their lives. I worried whether I would recognize the line or overstep it.

"Why am I doing this?" I asked myself some days. "Why am I remembering the past?" As I searched for answers, I recalled that even the extraordinary women I had written about had not risked remembering everything. Georgia O'Keeffe had said don't look back. Was she right or wrong? Her few self-portraits—pinkish watercolors of female nudes with no distinguishing facial features—were evidently done because she needed a model, not because she wanted to reveal herself. Early on I had wanted to be like her, but as I got older and became more myself, I became more open. Was my urge to understand an act of recklessness or a matter of fearlessness? "Why not just try to enjoy myself like everyone else my age?" I asked myself another time. I hoped that examining my earlier years might excavate and expel something, but I wasn't sure it would. At a panel discussion about memoir in Manhattan, none of the memoirists claimed that writing their books had given them catharsis, only a sense of creative satisfaction. At the end of captivity narratives, whether told by black slaves or white women abducted by Native Americans, there is often what is called the "telling," a story of survival that results in recovery, so I continued, hoping for a sense of closure.

Continuing was more interesting than frightening; after discovering a nursery school report that described my temperament as it is today, I recognized that my essential nature— revelatory and responsive, but with a touch of reserve—had changed little even as I gathered experience, giving weight to the genetics of nature over the events of nurture. Ideas and insights arrived when they wished; when I had a flash of an idea or an explosion of understanding, I would reach for the pad of paper and ballpoint pen beside the bed, near my exercise mat, in my pants pocket, or a place in the car. Sometimes

it was the middle of the night when I woke with a phrase float-
ing in my head, and then I would turn on a light and scribble
before it vanished. It felt more adventurous than stopping. "I'm
on fire about the memoir," I remarked to Robert one day. I liked
the newfound clarity, even if a few disturbing memories would
probably never be forgotten again. Luckily, if some moments
were darkening, they were merely times of temporary distress,
not ongoing depression.

As I worked my way through fifty years of journals, try-
ing to read a month a morning, I didn't want the past to ruin
the present. I resolved that remembering would be for week-
day mornings, and afternoons and weekends would be for
everything else. It was a journey I was on alone, but my rela-
tionship with Robert—and his reliable emotional embrace—
made it possible. On difficult days, when I asked him whether I
should stop, he would say it didn't sound like me, gentle words
that encouraged me to keep going from the man who had
urged me to write from what he called the white flame in my
heart. While at my computer I could see his love tokens on
bookshelves—a red glass heart, a heart-shaped red wooden
box on which he had painted our initials. As he entered his
eightieth year, we were together all the time. One day, the art-
ist who was usually so full of optimism and bravado held me
close and said with a fierce look in his eyes, "I'm getting old.
And I don't want to leave you, I love you so much." And I didn't
want him to leave, either.

Remembering became less painful as I began writing
and putting memories and other material into orderly sen-
tences and paragraphs, then organized them into chapters,
and the dynamism of composing took over. As this happened,
it became easier to accept my mistakes, which I eventually
decided were not more misguided than anyone else's. And if
I had not always acted wisely, I always had the resiliency to
go on. Fortunately, there were moments of closure after all:

one afternoon I removed two former wedding rings of mine from my bank safe-deposit box and took them to a jeweler, who placed them on a little gold scale and gave me a few dollars for them. While working on the memoir was depleting at moments, it was also deepening. At the fiftieth high school reunion of my day school in Providence, a childhood friend remarked on my aura of intensity; I wasn't exactly sure what she meant, but I imagined it had something to do with writing the memoir.

When resting in the windy field of flowers in the mountains north of New Mexico while writing a letter to my younger self, I had thought I was unlucky until around the age of fifty, when my life was more than half over, but then my luck had dramatically changed. Miraculously, I realized, I had found my way back to the happiness of the earliest years of my life. After writing the letter to my past self, I wanted to write a letter to my future self, too, but she remained an indistinct figure in the form of an elderly woman, whom I could not quite visualize. At the thought of her I felt trepidation because of watching my mother move into old age, and then my husband, too, as they inhabited bodies that no longer worked as well for them as before. All I could do was to ask that older self to remember my endurance while walking in the wind on the high mountain that August day, and the way I kept putting one foot in front of another in the thin radiant air.

ACKNOWLEDGMENTS

I'm deeply grateful to all those who have enabled me to write this memoir. My deepest thanks go to my husband, Robert Kipniss, who gave me ongoing loving support and encouragement along the way.

One of my oldest friends, Valerie Andrews, was extremely generous with her frank, full, and even passionate advice. I also appreciate others who helped me refine my thoughts and words, notably Jennifer Browdy, Rosemary Ahern, Jane Rosenman, and Nancy Green.

My friends Carol Ascher, Martha Zimiles, and Trudy Kramer loyally listened and advised as I made my way through difficult moments when reading old journals and letters.

I am very glad that my sister, Abigail Congdon, who shared many of my early experiences, agrees with my interpretation of them.

And, finally, I give special thanks to the friends and relatives who saved my letters and returned them to me, especially Sally Keil and Christopher Simonds.

ABOUT THE AUTHOR

Laurie Lisle has been a professional writer and published author for most of her adult life. Prior to publishing *Portrait of an Artist*, her best-selling biography of Georgia O'Keeffe, Lisle worked in journalism for newspapers and magazines. Her other books include *Louise Nevelson: A Passionate Life* and titles about women without children, gardening, and educating girls. Her work has been described as "an act of courage" and "elegantly written yet also edgily realistic." Lisle lives in Sharon, Connecticut, with her husband, artist Robert Kipniss, and when she isn't writing enjoys working in her garden. For more information, see www.laurielisle.com.

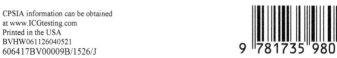